Herbert K

Laterna magica

Magic Lantern Guide to
Canon EOS A2E/A2
(International model designation - **EOS 5**)

A Laterna magica® book

First English Language Edition June, 1993
Published in the United States of America by

The Saunders Group
21 Jet View Drive
Rochester, NY 14624

From the original German edition by Herbert Kaspar
Translated by Bob Shell
Edited by Bob Shell
Editorial Assistant, David Hess
USA Production Coordinator, Marti Saltzman
Printed in Germany by Kösel GmbH, Kempten

ISBN 1-883403-00-6

Herbert Kaspar/BobShell
Canon EOS A2E/A2/5

Contents

Introduction

[**Note to the reader**: *Throughout this book I have employed the awkward name EOS A2E/A2/5 because the same camera (with some very minor differences made clear in the text) is called EOS 5 in most world markets but EOS A2E in North America, and there is a variant North American model called EOS A2. Do not be confused by this terminology, it is simply the only way in which all name variants could be easily included in a single text.*]

The EOS A2E/A2/5 is a very complex and sophisticated camera. However, like all Canon EOS cameras, this complexity and sophistication has been harnessed to make the camera as simple as possible to operate. The Canon EOS cameras are "transparent" in modern parlance, they do not interfere between the photographer and the image, and the EOS A2E/A2/5 is the most "transparent" EOS camera to date.

I can relate to the logic of the camera's controls and operational sequences, because I was provided with a pre-production prototype of the EOS A2E/5 to work with some months prior to the introduction, and before the instruction manual had been written. I had to learn to operate the camera with no specific information, by intuition and long experience with the other EOS models. The fact that this was not all that difficult speaks volumes for the care with which the EOS A2E/5 has been de-signed. I frequently get such pre-production samples in for testing without instructions, and other manufacturers could learn some lessons from Canon about making cameras intuitive and easy to learn to operate.

Hopefully you have thoroughly read the instruction manual supplied with your camera prior to purchasing this book. If so, you will already be familiar with the camera in general and can fill out your knowledge from this text. If you have just purchased the camera and have not yet read the instruction book, I advise you to read this book first, as there are some ambiguities and omissions in the Canon instruction manual. I have tried to make the arrangement of this book as logical as possible. I have tried to keep the chapters short and to the point, and not too technical, and I hope that this book will serve you well. I wish you good photography with your EOS A2E/A2/5 camera!

Basic Camera Information

In the Canon EOS series of cameras, the EOS A2E/A2/5 is a professional caliber camera, coming one step down from the EOS 1, Canon's original professional EOS model. It is equipped with nearly all of the features that any professional could desire, while it also offers a host of new features not even offered in the EOS 1. To use the camera you will not need to memorize all of the multitude of features it offers, but you should go through them one by one with this book in hand so that you will learn which ones will be useful to you in your own personal style of photography.

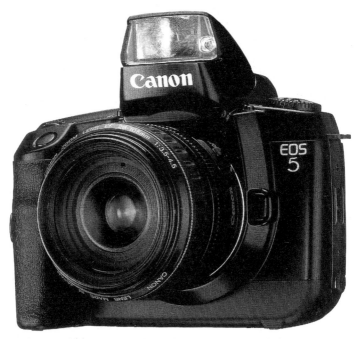

The EOS 5/A2E —With built-in flash, built-in motor and full automation. Photo courtesy of Canon.

If you choose the "Green Zone" on the main control dial, put a lens on, put the battery in, connect the carrying strap, and load a roll of film, then you can immediately begin to take pictures. The Green Zone is denoted by a green rectangle on the control dial on the left side of the camera's top plate. To set the camera to this Green Zone you simply press the release button in the middle of the dial, and rotate the dial clockwise until the green rectangle lines up with the index mark. In this position the camera is set for fully automatic operation, with all modes set to those most commonly picked. I.e.: Light metering is set for integrated measurement using all sixteen measuring fields, autofocus is set for automatic Servo AI or one-shot switchover with automatic selection of

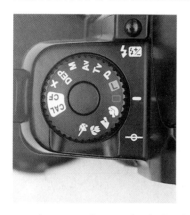

one of the five sensors, film advance is set to single-frame advance, and shutter speed and aperture are selected by a program. In dim light, an autofocus assist light will be projected from the red LED on the front of the camera. The camera will determine from subject motion, or lack thereof, whether to operate in the Servo AI autofocus mode, in which focus follows the movement of the subject, or in one-shot autofocus mode, in which the focus locks and holds on a static subject.

By taking light measurements from sixteen sensors covering the entire image area, the camera is able to compare levels of light and dark within the image and determine if a "straight" exposure or a compensated exposure is required. The camera is pre-programmed with a very large number of photographic examples which allows it to make an "intelligent" choice of exposure based on the distribution of light and dark. This pre-programmed information is referred to as algorithms. For example, when you are photographing a landscape, the camera knows to disregard the bright sky and expose correctly for the rest of the image.

During exposure calculation, all of the known factors from the camera's algorithms are taken into account in computing both

shutter speed and aperture; and the focal length of the lens, maximum aperture and distance to subject are also entered into the calculation.

The built-in small flash can be used in the Green Zone and will provide either a reduced fill-flash exposure, or a total flash exposure, based on the overall level of illumination. If a dedicated flash unit is fitted to the camera's hot shoe, the built-in flash is automatically switched off. The built-in flash also offers red-eye reduction through a bright beam which causes the subject's pupils to contract prior to the exposure. This red-eye reduction beam may be shut off if not desired, by employing the bottom button on the camera back and the main control wheel. If the eye symbol appears on the camera's main LCD panel the red-eye reduction is active, if it disappears the feature is shut off.

For the beginner who has no wish to learn anything about photography, the Green Zone setting is adequate. For the balance of this book I am going to assume that you have purchased, or are contemplating purchasing, an EOS A2E/A2/5 because you are serious about your photography and want to learn more about photographic technique and how to exploit the many features of your camera in advancing this interest.

A snapshot from the flea market. Thanks to the Green Zone automatic mode, such photos are very easily done.

EOS Camera History

While the EOS A2E/A2/5 is a brand new camera, most of the features it offers were developed and tested in previous EOS models. Only those features which proved to be of interest and use have been carried forward to the EOS A2E/A2/5. Some of these features have been improved for the EOS A2E/A2/5 while others are completely new. Although not generally known, Canon has been experimenting with autofocus in various forms for many years and actually showed working prototypes of autofocus cameras in 1963 and 1964 at Photokina.

Canon briefly experimented with early TTL autofocus sensor systems in their T80 camera. Although it functioned adequately, it was not a commercial success. Canon also experimented with a self-contained autofocus lens, the FD 4 35-70mm zoom, which had the autofocus system and motor in the lens and could be fitted to any FD or FL mount Canon camera.

The great advantage of the Green Zone automatic mode offered on most EOS models is that you can instantly begin taking photographs without having to first learn about the technical aspects of your camera.

Canon engineers did not want to produce a fully system-integrated autofocus SLR camera until all of the systems involved were at high levels of performance, so they bypassed the early generations of autofocus sensors and developed their own BASIS (BAse Stored Image Sensor) autofocus sensor for the first EOS cameras. Importantly, their experience with the T80 had convinced Canon that they were on the right track and that the autofocus motor belonged in the lens, not in the camera body. I think they have been proved right in this, since other makers are now forced to put autofocus motors into at least some of their lenses to get fast enough autofocus performance. Once they had decided to use motors in the lenses powered by the battery in the camera, it was only a short leap of logic to see the avantage of using an electrically-driven stepping motor in the lens to power the automatic diaphragm. This allowed Canon to produce the world's first 35 mm lens mount with no mechanical connections between body and lens. (For those interested in history, Rollei had introduced the first lens mount with totally electrical connections in its SLX. However, this was not a 35mm camera.)

The major advantage of this type of lens mount is that it is less subject to damage than mechanical designs with protruding pins and levers, and it is very economical to manufacture. This is one of the things which has allowed Canon to introduce a series of low-cost EOS lenses which give up very little in performance to their more expensive brothers.

Camera Body

Camera Body Overview - Controls and Functions

The camera body is basically a light-tight "tank" to protect the film from unwanted fogging and a housing to protect and conceil the internal working mechanisms. If the camera body has been well-designed, with thoughtful and logical placement of controls, the use of the camera can be a joy. Canon's designers spend hundreds of hours going over every aspect of the camera body's shape, and the precise placement and operation of all controls, in an effort to make the camera as easy to operate as possible. The best cameras are those which are the most "transparent," which is to say those which get in the way of the photographer's intentions the least.

When the Canon EOS-1 came on the market, it received international praise for its "transparent" nature, and the comfort of its integral handgrip. The form had become near-perfect, the grip shaped to perfection, and the whole body streamlined into smooth curves. However, the EOS-1 is still operated by push buttons, which must be operated singly or in combination to change operating aspects. With the EOS 10s and now with the EOS A2E/A2/5 cameras, the push buttons on the camera's left side have been replaced with a control dial which most users find much more convenient to set. Now almost all camera functions are controlled by this dial either alone or in combination with the camera's two control wheels.

You can always tell what you are doing with this camera by simply referring to the large LCD panel on the camera's right top deck. Every important operational function is indicated here either with numerals or by stylized operational icons. See the illustration for a complete explanation of the LCD indications.

In addition to providing a firm and stable hold, the large handgrip on the EOS A2E/A2/5 also serves as the battery housing. By unfolding and turning a key on the right side of the grip, the front section of the grip may be lifted off revealing the battery compartment. The camera is powered by a Lithium 6 volt battery, type

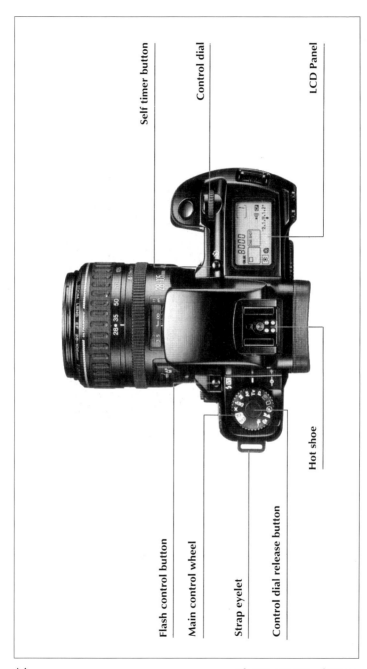

Self timer button

Control dial

LCD Panel

Flash control button

Main control wheel

Strap eyelet

Control dial release button

Hot shoe

14

Photos courtesy of Canon

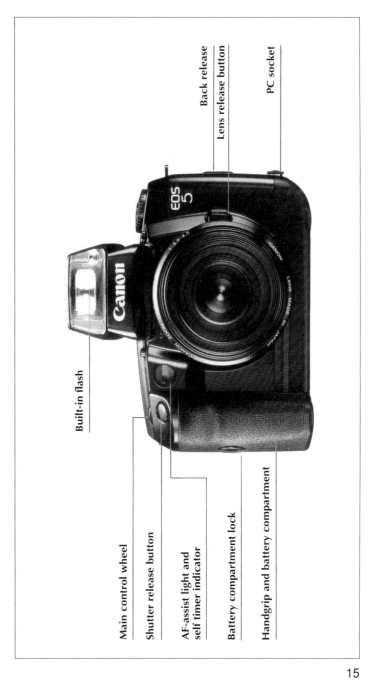

Built-in flash

Main control wheel

Shutter release button

AF-assist light and
self timer indicator

Battery compartment lock

Handgrip and battery compartment

Back release

Lens release button

PC socket

15

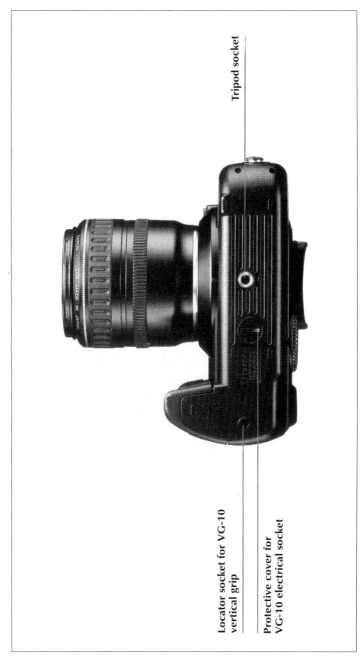

Tripod socket

Locator socket for VG-10 vertical grip

Protective cover for VG-10 electrical socket

Photos courtesy of Canon

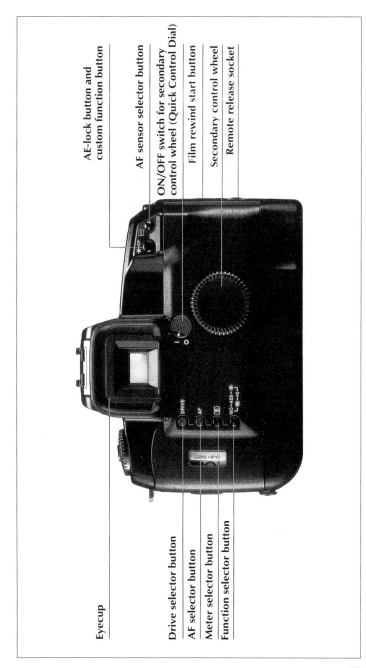

AE-lock button and
custom function button

AF sensor selector button

ON/OFF switch for secondary
control wheel (Quick Control Dial)

Film rewind start button

Secondary control wheel

Remote release socket

Eyecup

Drive selector button

AF selector button

Meter selector button

Function selector button

2CR5 or equivalent. Because of the camera's very efficient belt drive, battery power is conserved during operation, and I have been able to fire off about 60 rolls of 36 exposure film on one battery, when not using the built-in flash. This is excellent for a modern electronic camera; some others I have used barely make it to half that number.

Just behind the handgrip on the right end of the camera is a small black recessed button. This button is the manual film rewind button, and may be pressed at any time to initiate immediate rewind of the exposed portion of the film. The button is recessed into a relatively narrow slot to prevent it's accidentally being pressed, and is most easily reached with a fingernail, coin or the point of a pen. Just below this button is a screw-off protective cap. Under the cap is the socket for connection of an electronic remote control cable.

On the rear side of the camera handgrip, at the top, are two buttons easily operated by the photographer's right thumb. On the left is one marked with an asterisk and "CF." This button activates the auto exposure memory lock when pressed and held, and also operates the camera's custom functions in conjunction with the main control dial when the latter is set to the "CF" position. More about this later. The button on the left, marked by a rectangle enclosing five tiny white rectangles, controls the autofocus sensing mechanism. When this button is pressed the indication on the LCD panel will display five rectangles corresponding to the five autofocus sensors in the camera. The main control wheel can then be turned to manually select one of these sensors, which will then remain the active sensor until changed by again pressing this button and turning the main control wheel. This is useful when confronting situations which confuse the camera's automatic sensor selector, or the eye-controlled focus does not work, such as vertical compositions.

On the camera back, toward the left, are four buttons in a vertical row. The upper button, colored blue, is marked "DRIVE." When it is depressed in, the main control wheel may be used to change the drive modes. Below this is a second button, gray in color, marked AF, and this one, again in combination with the main control wheel, allows selection of the autofocus modes. The third button, colored black, controls the light metering modes in the same manner, with the main control wheel. Last, at the

bottom, is a fourth button, also black in color. This button allows you to set several functions. Pressing it once allows you to access the manual ISO setting; pressing twice accesses automatic exposure bracketing; pressing three times accesses red-eye reduction feature switch for "on" or "off"; pressing four times accesses the multiple exposure control; and pressing it five times gives access to the audible focus confirmation and self timer beeper. The focus confirmation beeper feature is found only on the EOS 5 and not on the EOS A2E/A2. On these North American models the same control turns off the self-timer beeper only.

In the case of all of these buttons, once you have pressed a button the LCD panel will indicate the mode you have accessed and you have six seconds to make a change by way of the main control wheel. After six seconds the camera switches back to its previous operating modes, and if you have not made the desired change you must press the button again. When using the bottom button to access one of the features, the camera will retain in memory which mode was last accessed and return to it when that button is pressed again at a later time, even if the camera has been turned off in the meanwhile.

To the left of the four buttons just described is a vertical transparent window. This allows you to confirm at a glance whether or not there is film in the camera, and also lets you confirm the film type and ISO speed on most brands of film.

I have previously mentioned that the main control dial for the camera is on the upper left top deck. This dial has fourteen positions on the EOS A2E/5 and thirteen positions on the EOS A2. When the camera is not in use, the dial should be turned to the position indicated by a red box with an L in it. This stands for LOCK and in this position the camera's electronics are shut off for minimal battery drain and to prevent accidental exposure. The control dial locks in this L position and can not be accidentally turned to another position.

To turn the dial to one of the operating positions, it is first necessary to press the black locking button in the center of the dial and then turn the dial. The dial can be turned both clockwise and counter-clockwise from the L position. In the clockwise direction there are eight different positions, the last two of which are in black letters on a silver background, marked CF and CAL. These positions are used, respectively, to access the EOS A2E/5's

custom functions and to calibrate the eye-controlled focus feature. Since the EOS A2 lacks eye-controlled focus, the CAL position is missing from its control dial. The other six positions are operational modes designed to give the photographer a great variety of operating techniques with ease. Namely, they are P for Program, in which the camera takes total control and sets both shutter speed and lens aperture based on a pre-programmed sequence which is adequate for most types of photography. Next comes Tv, standing for Time Value, in which the photographer selects the time value, in other words the shutter speed, and the camera will automatically select the appropriate aperture to provide correct exposure. Then comes Av, standing for Aperture Value, and here the photographer selects the lens aperture and the camera will select the appropriate shutter speed for correct exposure. Following this is M standing for Manual. In this mode the photographer has chosen to select both aperture and shutter speed manually, either using an external light meter or the camera's built in meter to determine the correct settings. Next comes DEP which stands for Depth of Field. This operational mode is unique to Canon, and allows the photographer to precisely control depth of field by pre-selecting the close and far limits of the desired depth of field. The camera then sets the correct lens aperture, shutter speed and hyperfocal distance to provide the desired depth, within the limits of the lens in use. Following this is X, a new mode for Canon making its first appearance on this camera. This is the position to set when using studio flash or when flash is the only light source. When set to the X position, the camera can only be set to shutter speeds which will synchronize with electronic flash. It is similar to the M mode in most other respects.

In the shade of a market stall or in an old church the light is dim. A ⇨
tripod will stabilize your camera for long exposures, particularly when
you want to use a small aperture to provide plenty of depth of field.

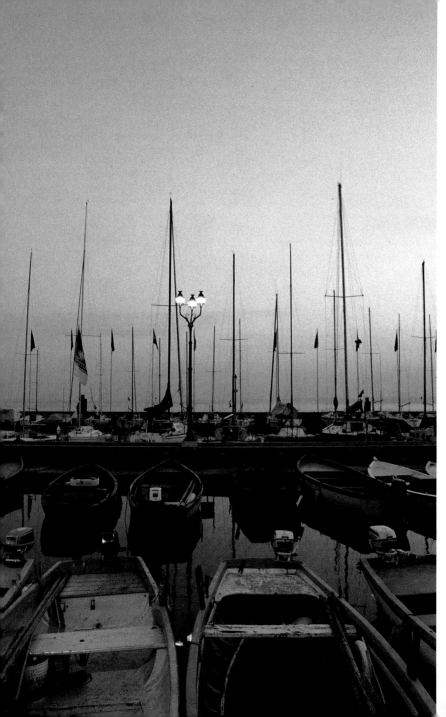

To facilitate use with electronic flash, the EOS A2E/A2/5 camera has a PC socket on its lower left end, under a screw-on protective cap, in addition to the standard dedicated Canon hot shoe on top of the camera. This makes it easy to use the camera with most makes of studio electronic flash, although I generally recommend the use of infrared remote triggers instead of PC cables to provide more sure synchronization and to prevent damage to the camera from overly high synch voltages used in some flash equipment.

If the main control dial is turned counter-clockwise from the L position, the first position encountered is the Green Zone which is an "auto everything" setting designed for situations in which the photographer does not have time to think through which mode to use. It is also ideal for use when handing the camera to a non-photographer to use. Following this are some special modes indicated by stylized logos. The first one has a picture of a face, and is the "portrait" mode, ideal for closeup photos of people. Following this is a stylized drawing of some mountains, and this is the "landscape" mode, ideally suited to these subjects. Next follows a tulip, which is a special mode for closeup and macro photographs. Last is a sprinter, and this is obviously for use when photographing sports or other fast-moving subjects.

If you look down on the top of the camera, with the camera in shooting position, you will see just to the right of the main control dial, somewhat toward the camera back, a circle with a long line through it. This is a precise film plane locator. In most cases it does not matter, but in some technical applications it is important to measure from the subject to the film plane. If you encounter such sitations, use the line on this mark as your point from which to measure.

Directly in front of this, on the front edge of the camera you will find a lightning bolt flash symbol together with a rectangle with +/- in it. Just in front of this is a button. The EOS A2E has

The sophististicated metering system of the EOS A2E/A2/5, which reads sixteen different segments, makes pictures like this easy. The metering system will expose correctly to provide sufficient detail in the foreground boats, while not making the sky unrealistically dark.

automatic flash on demand in the Green Rectangle, portrait and macro modes, which means that the built-in flash will automatically erect itself if the camera's metering system senses that flash is needed. In situations in which the camera does not automatically erect the flash, such as for outdoor fill flash, the button is used to erect the flash manually. Just push it and the flash will pop up. The EOS A2E/A2 does not have flash on demand so you will have to manually erect the flash whenever it is required. The camera will indicate to you when flash is required with low-light warning beeper (which can be shut off with one of the custom functions if you find it annoying, or innappropriate in certain situations). Flash readiness is indicated by a lightning bolt symbol inside the viewfinder on the lower left.

The reason for the rectangle with +/- in it is that you can decide to alter the automatically computed output of the built-in flash if you wish. Once the flash is erect, whether manually or automatically, pressing the flash erection button again will display a +/- on the LCD together with a graduated scale. You may then use the main control wheel to set the built-in flash to either less or more than the computed output in 1/2 step increments.

The built-in flash is a zoom type in which the flash head automatically adjusts its angle of coverage to correspond to the angle of coverage of the lens in use. This prevents dark corners in photos taken with wide angle lenses and allows greater flash distances with telephoto lenses. When no longer needed, the flash may be stowed back out of the way by simply pressing down on it. It will re-erect as needed in certain modes on the EOS 5 and can be erected as needed on the EOS A2E/A2 by pressing the button.

In photographing people, one problem often encountered is called red-eye: red colored pupils in people's eyes in photographs caused by light reflected from the retinas inside their eyes. This can be overcome or decreased by causing the subject's pupils to contract prior to taking the photograph. When the red-eye reduction feature mentioned above is turned on with the bottom button on the camera back, a bright beam of light is emitted by the flash head before the actual flash is fired during the taking of the picture. This bright beam does, in my experience, greatly reduce red-eye. However it also greatly decreases battery life, and should be shut off when the camera is not being

used to take photos of people. Household pets also have the problem of red-eye (or in cats green-eye would be more appropriate, because they have a reflective layer behind their retinas which is green or blue-green in color), so you may want to also use the red-eye reducing light when taking animal photos. I have found, however, that many animals are "spooked" or frightened by the bright light in their eyes.

Looking at the camera body from the front, the only operating control which is seen is the lens release button, to the right of the lens. Pressing this button allows the lens to be turned counterclockwise through about 1/3 turn and then pulled straight out from the camera body. While the lens is off the camera take great care to keep dust and foreign material out of the camera by either putting another lens on immediately or fitting the camera with a protective body cap. Never touch the electrical contacts or the camera mirror, as both can be harmed by the oils from your fingers. Similarly, do not touch the rear glass surface or electrical contacts on the lenses, and always protect them with front and rear caps when not on the camera.

Grips for Vertical Format

On the bottom of the camera is a standard 1/4"-20 threaded metal socket, which accepts standard tripod screws. When mounting the camera onto a tripod or stand, make sure that the mounting screw is not too long, as it can be run all the way through and out the bottom of the tripod socket damaging the camera seriously. The bottom of the camera also accepts the VG-10 vertical grip. Since the majority of my photographs are taken for publication, which means that they are taken in the vertical "portrait" composition rather than the horizontal "landscape" composition, I would not think of using the EOS A2E/5/A2 without the VG-10 grip. Unless you never, or very rarely, take vertical photos, consider the VG-10 as essential equipment, not an optional accessory. When this grip is mounted, it has its own main control wheel, spot metering button and AF sensor selector buttons, making vertical operation precisely the same as horizontal. Before mounting the VG-10 onto the camera you must remove a small round cover from the bottom of the camera with a coin.

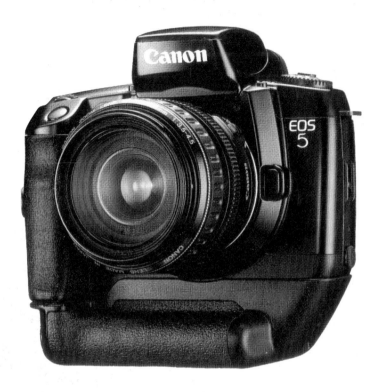

The EOS 5/A2E with the VG-10 vertical grip—a very handy working package. Photo courtesy of Canon.

This little dust cover could easily be lost, so there is a storage slot for it on the VG-10, although personally I can't imagine taking the VG-10 off the camera once it has been mounted. With the VG-10 grip in place, this is the first camera which has allowed me to work in the vertical mode and retain all operations without having to practice some sort of weird yogic contortions. I congratulate Canon on this singularly useful achievement, and hope that similar vertical grips are made available for all their future

The VG-10 grip makes taking vertical photos like this a snap, and allows the photographer to work for extended times without strain on arms or hands.

cameras. My only disappointment in the VG-10 is that Canon did not go all the way and make it also a battery holder, so that either the camera could be powered optionally by AA cells or so that a spare 2CR5 battery could be stored in it.

Another important point about the VG-10 grip is that it has its own neck strap lugs on each end. This means that the camera with VG-10 in place has four attachment points available for the carrying strap, allowing you to hang the camera in normal shooting position, hang it from either end, or hang it upside down! Don't laugh at that last, it makes some sense when carrying two cameras around your neck to hang one right way up and one upside down so that they will knock into one another less frequently. Also, when out shooting with black and white in one camera and color in the other, it makes it very easy to remember which camera has which film in it. I tried this myself while testing the EOS A2E and A2 cameras at the same time so that I could easily keep track of which camera was which, since they look exactly alike.

Although the most significant difference between the EOS A2E/5 and the EOS A2 is that the A2 lacks eye-controlled autofocus sensor selection, there is another difference. The EOS A2 does offer built-in eyesight diopter correction, by means of a sliding bar above the eyepiece, under the eyecup. Since eyesight correction was not possible in combination with the eye-controlled autofocus, some photographers may find that built-in eyesight correction is more significant for their personal needs, and may thus prefer the less expensive EOS A2 camera.

Secondary Control Wheel or Quick Control Dial

One of the first things which catches the eye when seeing the EOS A2E/A2/5 camera is the large round wheel on the camera back. This secondary control wheel, which Canon calls the Quick Control Dial (but I will continue to call, secondary control wheel, which is more accurate and descriptive of its function), is not brand new, it was first seen on the EOS-1 and had since appeared on the EOS 100/Elan (but not on the EOS 10/10s, and also not on the lower priced EOS models). On all of the EOS cameras which have this wheel, a small two-position switch sits

just above and to the left of it, and turns its operation on and off. When this switch is in the "O" position, for off, the wheel will still turn but it will not have any effect on the camera operation. With the switch in the "I" , or on, position, the wheel has different functions depending on the mode to which the camera has been set.

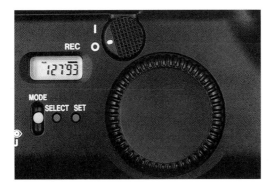

This secondary control wheel operates only in the P, Tv, Av, M, DEP and X modes, and has basically two functions. If the exposure is automatically regulated, as in the P, Tv, Av and DEP modes, the wheel then operates to bias the exposure toward either over or under-exposure. A bar graph appears on the LCD panel in these modes, and turning the wheel moves a pointer along this graph in 1/2 stop increments. Overall exposure may thus be biased as much as 2 stops in either direction. In the P and DEP modes, use of this exposure bias alters both shutter speed and aperture while in the Tv and Av modes it alters the camera selected value, changing the aperture in the Tv mode and the shutter speed in the Av mode. Turning the dial in a clockwise direction always increases exposure (+ compensation) while turning in a counter-clockwise direction always decreases exposure (- compensation).

Since the correction factors are always graduated in 1/2 stop increments, it is possible to quickly and precisely fine tune the exposure based on personal experience or the desired results. The technically correct light meter reading is not always the artistically correct exposure to achieve the photographer's desired end. As you take many photographs you will learn from practical

A quick turn of the secondary control wheel and you can adjust the exposure for photos like this without taking the camera from your eye.

experience when you should bias the exposure to produce an effect more close to your visualization of the photograph. As will be explained in detail later, all camera light meters have to make a compromise when setting exposure and are programmed based on a variety of "average" scenes. When confronted by a non-average scene, or by a photographer who wants a non-average photograph, intentional bias of exposure is the only way to achieve the desired result.

The secondary control wheel also controls the lens aperture when the camera is set to the M mode, and in this case the main control wheel controls the shutter speed, so full manual operation is possible with only one hand holding the camera. The right forefinger controls shutter speed while the right thumb controls aperture, and since the camera is autofocus, the left hand can remain free to hang on to precarious perches, or do other things.

In the X mode, chiefly used in the photographic studio, the secondary control wheel changes the shutter speed through 1/60, 1/90, 1/125, 1/200 (the only shutter speeds available in that

mode) while the main control wheel regulates the lens aperture. The narrow range of shutter speeds deliberately limits you to only those speeds at which electronic flash will properly synchronize, thus preventing accidental setting of speeds too high and spoiled photos, or speeds too low in which ambient light blurring may be a problem.

In the Green Zone mode and all modes indicated by pictorial icons, the secondary control wheel does nothing.

The Viewfinder

Even if you decide to trust the EOS A2E/A2/5 to provide the correct focus and exposure all of the time, you should be aware of what the camera is doing. The camera provides a full information output on its top deck LCD panel, and a more condensed information output inside the viewfinder underneath the viewing screen.

Originally, we used to always refer to the frosted glass or plastic screens on which we view our image as focusing screens, but these days with most cameras providing automatic focus, it seems to make more sense to call them viewing screens. In the EOS cameras, these screens are made of an acrylic plastic onto which a very fine pattern has been laser etched. This special pattern provides an image which is very bright, but at the same time quite contrasty. The importance of viewing screen brightness is easily appreciated by looking through the viewfinders of older cameras, particularly when they are fitted with zoom lenses of relatively small maximum aperture.

The image on the viewing screen is not very large, measuring about 24 x 36mm or about 1 x 1 1/2 inches. This image is made to appear larger through the use of magnifying lenses in the viewfinder eyepiece. Different cameras use different degrees of magnification, and Canon has not chosen to try to make their apparent finder image the largest in the industry. I have always found that their compromise between image size and brightness is just about perfect for my own use.

Canon has invented a new technology for displaying some information directly on the viewing screen. This has been referred to as a "heads up" display, borrowing the military jargon for dis-

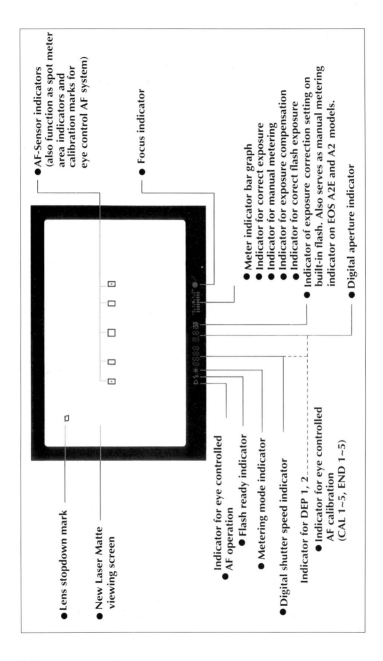

- AF-Sensor indicators (also function as spot meter area indicators and calibration marks for eye control AF system)

- Focus indicator

- Meter indicator bar graph
- Indicator for correct exposure
- Indicator for manual metering
- Indicator for exposure compensation
- Indicator for corect flash exposure

- Indicator of exposure correction setting on built-in flash. Also serves as manual metering indicator on EOS A2E and A2 models.

- Digital aperture indicator

- Lens stopdown mark

- New Laser Matte viewing screen

- Indicator for eye controlled AF operation
- Flash ready indicator
- Metering mode indicator

- Digital shutter speed indicator

Indicator for DEP 1, 2

- Indicator for eye controlled AF calibration (CAL 1~5, END 1~5)

plays which are projected in front of pilots apparently onto the window of their cockpit. In the case of the EOS A2E/A2/5 this takes the form of small rectangles indicating the relative positions of the five autofocus sensors, and a system which makes the active sensor appear to light up in red and flash to confirm focus. This advanced display system was first used in the EOS 10/10s, but at that time could not be combined with an interchangeable viewing screen. These initial limitations have been overcome, and it is possible to change the viewing screen in the EOS A2E/A2/5 to customize the camera to the photographer's needs.

In addition to this special display, there is a back-lighted LCD band underneath the image area in the viewfinder on which important exposure and operational information is displayed. Autofocus is also confirmed there, by means of a green dot on the far right. This dot will appear and remain steadily lighted when the camera has achieved proper focus. If the green dot flashes it means that the camera can not find a sharp focus automatically and manual focus will have to be used instead of autofocus.

The second display icon is the traditional lightning bolt symbol for electronic flash, at the far left of the LCD strip. This illuminates to indicate that the flash is fully recharged and ready to fire, and works with either the built-in flash or with any accessory dedicated Canon flash.

Just to the right of the flash symbol is an asterisk which lights up when the similarly marked button under the right thumb is pressed. This indicates that exposure information has been stored and is retained. As long as the button is kept depressed this star will remain illuminated and the same exposure information will be used for all exposures.

Again, moving to the right is a digital display which indicates the shutter speed set and this is followed by another digital display which indicates the lens aperture set. If one or both of these indicators flash, it is an indication of exposure trouble. If, for example, the shutter speed display shows 8000 and flashes, it means that overexposure will occur and that the lens aperture is too large and must be stopped down.

To the right of the shutter speed/aperture display numbers is a bar graph scale which appears in most modes in the EOS 5. In the EOS A2E and A2, this bar graph is replaced with a +/- display

in the M mode. This indicates over or under exposure, and is used in the manual exposure mode as an indicator when setting the shutter speed and lens aperture.

Alltogether, 46 different pieces of information can be displayed on this LCD strip, but fortunately only those of importance in each exposure mode are displayed at one time. This avoids confusion and irritation on the part of the photographer.

The viewfinder display is intended as a quick reference while taking the photos, while the LCD panel on the top of the camera provides a full reference for those times when more detailed information is essential.

Basic Camera Operation

Getting Started

Needless to say, the first thing you want to do after buying a new camera is to get out and start taking pictures. I have that same feeling myself, and it has sometimes gotten me in trouble when I have taken a brand new camera out to work with and not bothered to read the instructions or familiarize myself thoroughly with the operation. Every camera is different, and even if you are already using Canon EOS cameras, you will need to spend at least a few minutes going over the basics of operation of the EOS A2E/A2/5.

Most modern cameras are electrically powered, and the EOS A2E/A2/5 is no exception. Before doing anything else be sure that you have the proper battery, a six-volt Lithium 2CR5 or equivalent. Do not assume that just because a battery looks the same that it is the right one. If it is not coded as a 2CR5 or as a replacement for that battery, do not attempt to use it. Additionally, it is

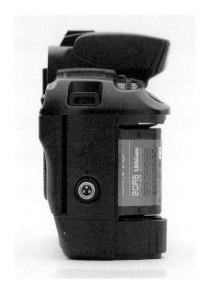

The 6-volt Lithium battery (type 2CR5) fits inside the handgrip.

important to have fresh batteries. Even Lithium cells go bad if stored too long or improperly, so it is always best to buy your batteries from a shop with a rapid turnover, which usually means a busy camera shop. Pharmacies and other battery sources may not sell them rapidly enough to keep fresh stock always on hand.

To put the battery into the camera, first unfold the round handle of the key on the side of the handgrip surface and turn it counter-clockwise one-quarter turn until it clicks. Then, using the key, pull the front cover off the handgrip by swinging it slightly toward the lens mount. This will reveal the battery compartment. Insert the battery with the contacts toward the inside of the camera. You may want to first carefully wipe the battery contacts with a clean dry cotton cloth if there is a chance that oil from your fingers has gotten on them. Do not touch the contacts inside the camera. The battery simply slips into place. Once the battery is in place, put the hand grip cover back on by reversing the removal procedure and locking the release key. The camera body is now ready for operation.

If you now turn the camera on by moving the main control dial to any position other than L, you should see a battery indicator on the LCD panel in the upper left. If this shows a full battery in black, the battery is good and you are prepared for many exposures. If it shows only half of a battery in black, the battery is not in very good condition, and will only be suitable for a few rolls of film before it goes dead. If the battery symbol shows completely empty and flashes, you may be able to take a photo or two, but you should replace the battery as soon as possible.

Should the battery go dead during film rewind, all of the film may not be taken back into the film cassette. If this happens, do not open the camera back, but first replace the battery with a new one and then press the manual film rewind button on the right hand end of the camera to insure that all of the film is rewound. Then you may open the camera and remove the film safely.

If the low battery symbol on the LCD panel continues to flash after you have inserted a new battery, do not dispose of the old battery just yet. Sometimes the camera will indicate a malfunction of its electronics with this blinking battery symbol. To determine if this is the case, first gently clean the electrical contacts on the battery with a clean cotton cloth, and also carefully clean the contacts in the camera. This is easily done by wrapping the cotton

cloth around the eraser end of a pencil and pressing it gently but firmly against the battery contacts and turning it back and forth. After doing this, try both batteries again, and if you still get the low battery indication it may be that you have a camera malfunction, or that the new battery was bad when you bought it. It would be good in this case to take the camera and both batteries back to your Canon dealer who can try the camera with a known good battery, and send it for service if necessary.

Lithium batteries perform very well at normal temperatures, but begin to perform less well at lower temperatures. My assistant found that she could not get one of our Canon EOS cameras to perform properly in freezing weather. In very cold weather you can put the battery into one of your inside pockets to warm it, then put it into the camera for a while for photos and then return it to the inside pocket when it begins to get too cold. Another option is to have two batteries, keeping one in an inside pocket all the time, and switching them every few minutes as the one in the camera cools down too much.

Canon is very conservative in their claims for battery life. They claim 40 rolls of 24 exposure film from one battery, but I have never gotten that few. I have averaged 60 rolls of 36 exposure film per battery on the EOS A2E since I began using the camera. Remember, though, that if you use the built-in flash for a significant percentage of your photographs this will greatly reduce battery life. Also, I have done everything possible to extend battery life on my cameras, even setting the LCD displays so that they are only turned on when I am actually pressing the shutter release button (this is done through Custom Function # 13. See the section on Custom Functions for details).

Once you have equipped the EOS A2E/A2/5 with a battery, you need only mount a lens and load film to be ready to take photographs. To mount a lens, press in on the lens release button which is to the right of the lens mount and turn the body cap counterclockwise by 1/3 turn and lift it off the camera. Then remove the rear protective cap from the lens by turning it 1/3 turn counterclockwise as well. Fit the lens onto the camera making certain that the red dot on the lens barrel lines up with the red dot at the top of the lens bayonet directly under the Canon name. The lens should go smoothly straight into the camera bayonet without force or roughness. Once it is fully seated, with the rear flange of the

lens in contact with the camera's bayonet mount, you turn the lens through 1/3 turn in a clockwise direction until you hear a click. Check to make sure the lens is locked in place by trying to turn it back counter-clockwise. If it does not turn it is properly mounted. To change to another lens, simply repeat the process described. Always put front and rear caps onto lenses when they are not on the camera, and avoid touching the rear surfaces of the lenses.

All Canon EOS lenses have a slide switch on the lens barrel marked with "AF" and "M" positions, signifying autofocus and manual focus respectively. If you intend to use the camera's auto-focus system in your photographs, make sure this switch is in the "AF" position after you have mounted the lens. It is sometimes possible to accidentally change the position of this switch when changing lenses, so I make it a habit to check it each and every time I make a lens change. This avoids missed pictures when I might think I was getting autofocus but had the lens set for manual focus.

Now, everything is ready for photography except for the film. To load film into the EOS A2E/A2/5, you must first open the camera back by sliding down the back release button on the left end of the camera. This pops the back open, and you can pull it open the rest of the way. You will then see a film chamber on the left with an orange rewind shaft on the bottom, and a row of gold electrical contacts running vertically. These contacts press up against the film cassette when it is loaded in place and pass DX coded information to the camera's computer, telling it the ISO speed of the film, the type and latitude of the film, and the number of frames on the roll. It is not a bad idea to gently wipe the shiny contact strips on the film cassette prior to loading, I always wipe it on my shirt just a little.

You insert the cassette by tilting the bottom of it (the end with the protruding shaft) in to the camera first and then sliding the film cassette down and into the camera. It is very quick and smooth once you have the knack, but hard otherwise, so you may want to practice a few times. Once the cassette is firmly seated in place, pull out enough of the film leader to reach the red mark on the right side of the camera, and put the end of the film down inside the takeup chamber. Once this is done, simply close the camera back and the film will be automatically loaded and advanced to

the first frame. You will hear a soft whir as this is done. After this motor sound stops, look at the LCD panel where a picture of a loaded film cassette will be displayed at the bottom. If this cassette symbol flashes it means that the film has not loaded properly and you must open the back and try again, making sure that you have pulled out sufficient film to reach the red mark.

Most brands and types of film today are packed in DX coded cassettes, which means that the information about the film is encoded into the cassette by means of conductive and non-conductive areas. However, a few types of film are packed in non-coded cassettes. If you note that the letters "ISO" are blinking on the right side of the LCD it means that you have loaded such a non-coded cassette and must manually input the ISO. To do this, press the bottom button on the camera back until ISO appears alone on the LCD with numerals, and use the main control wheel to change the numerals until they correspond to the ISO speed of the film you have loaded.

Congratulations! You have graduated from the basics and are now ready to begin taking photographs with your EOS A2E/A2/5.

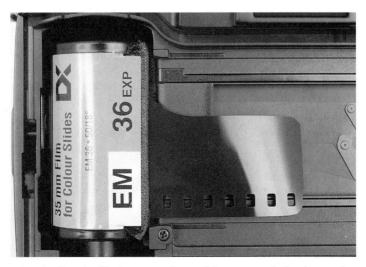

When loading the film be extremely careful not to touch the shutter, the shutter blades are easily damaged.

Getting Sharp Photos

Many beginning photographers think of sharpness as the ultimate photographic goal. Sharpness is important, yes, but it is not alone nor is it often the most important characteristic of a fine photograph. Many great and famous photographs are not all that sharp when viewed at close hand. Also, the word sharpness bandied about so much in photographic circles is actually not a single characteristic, but a combination of a number of factors which combine to create the apparent sharpness of the final image.

Primary determining factors of sharpness are the resolving power of the lens and the resolving power of the film. Both of these determine just how small a group of line pairs per millimeter can be distinguished, the standard test for sharpness. The contrast of the lens is also quite important as it determines whether black and white lines in a test target are actually rendered as distinctly black and white, or whether both shade into gray at the demarcation. Contour sharpness is another important characteristic, determining whether the boundary between a black and a white line is a smooth edge or an indistinct zone. Mass produced lenses can suffer from sample to sample deviation from the desired characteristics, and the best lens makers seek to keep these sample variations to a minimum.

There are many optical aberrations which a lens maker must seek to correct. In the past this was done by making lenses with multiple elements from different types and curvatures of glass, so that the aberrations of each lens element would cancel out those of other elements, and the lens as a whole would have very little remaining aberrations. However, earlier lenses were restricted by the fact that only spherical lens surfaces could be economically mass produced, and these are incapable of correcting for all aberrations. Recently Canon has pioneered in the technology of glass molded aspheric lenses, in which elements with non-spherical (aspherical) surfaces are intermixed with traditional spherical surfaces to produce the maximum reduction of aberrations in mass produced lenses. Many of these Canon lenses of low price significantly outperform the most expensive lenses of only a few years ago.

Film affects sharpness because there is an inverse relationship between grain and resolution. Films with very fine grain can pro-

duce incredibly sharp images, but such films tend to be low in sensitivity (low ISO numbers) and thus require a lot of light. The best compromise today is in the medium speed films, films with ISO speeds of around 100 to 200. These films have adequate sensitivity for general photography while at the same time offering very fine grain and good resolution. Combined with Canon's first class lenses, such films are capable of very sharp images.

The largest single cause of degraded image sharpness is camera vibration. Using too slow a shutter speed when hand holding, using a cheap and wobbly tripod or monopod, these all cause unsharp photos. Perhaps you will want to make a test sequence of photos, using the camera in the Tv mode, and using the next slower shutter speed for each photo in the sequence. This will let you know from examining the photos just how slow a shutter speed you are personally capable of holding still to produce sharp images. If you have several lenses, you do not need to try this with every one, but you can use a general rule to extrapolate from one test. Say, for example, that you did your tests with a 50 mm lens but now want to use a 100 mm lens. If you found that your hand held limit with the 50 mm lens was 1/60 second, you will have to double that speed to 1/125 second to get the same results, while you should also find that you can hand hold a 25 mm lens at 1/30 second. This is a very approximate ratio, and it is always best to set the speed a little faster.

It used to be always said that the shutter speed to use for hand holding was the approximate reciprocal of the focal length, for example a 50 mm lens would require at minimum 1/60 second while a 135 mm lens would require at minimum about 1/125 second. I have found that this works out for many people, but would still recommend investing a roll of film and some time in testing for yourself.

Naturally, depth of field also plays a roll in sharpness. Depth of field is the amount of depth in an image which appears in sharp focus, and follows the rule that 1/3 of it will be in front of the plane of focus and 2/3 will be be behind the plane of focus. In actuality, only the exact plane of focus has maximum sharpness and it deteriorates as you move away from that plane either toward the camera or away from the camera, but in practice there is a zone which looks sharp. This depth of field varies only with the lens aperture and image magnification, so when the lens is open wider

(large apertures) the depth decreases and when the lens is closed down (small apertures) it increases. Remember that large apertures are denoted by smaller numbers (e.g. f/1.8, f/2.8) while small apertures are denoted by larger numbers (e.g. f/16, f/22). This apparent contradiction is because the marked apertures are the bottom half of a fraction, f/1.8 is actually 1/1.8 while f/22 is actually 1/22, and seen in that light it makes more sense.

Lens apertures are a ratio of the focal length to the size of the opening the light passes through. For example a 50 mm f/2 lens would have an opening of 1/2 X 50 mm at f/2, or 25 mm. A 100 mm f/2 would have a maximum opening of 50 mm. That is why fast telephoto lenses, those with large maximum apertures, are also physically large—a 400 mm f/2 lens would have to have a diaphragm opening of 200 mm (about four inches!) wide open!

A common misconception concerning apertures and depth of field is that wide angle lenses have more depth of field at a given aperture. Actually, this is not true. To prove this to myself I did a series of photographs of the same scene with a variety of lenses, always at the same aperture setting and varying the distance to my subject for a similar area of coverage. When I looked at the finished images, I could see that the depth of field at any given aperture setting was the same in all of them, proving that depth of field is determined only by lens aperture and subject magnification.

Telephoto lenses seem to have less depth of field because the image magnification is greater, but if you move back with your telephoto until it encompasses the same image seen through your wide angle lens, at the same aperture you will get identical depth of field.

Under many circumstances it is impossible to obtain a correct exposure ⇨
by simply trusting the light meter. In such cases a correction factor
must be applied, and the EOS A2E/A2/5 makes this particularly easy to
do.

Autofocus Operation

Autofocus In General

Manual focusing is basically a simple, fast and sure matter, but autofocus makes it just that much more simple, faster and more certain. It is no miracle then that autofocus has quickly conquered the hearts and pocketbooks of most photographers.

Automatic exposure determination by the camera has become so commonplace that we now take it for granted that any high class camera will offer one or more modes of exposure automation. Beginning in the mid 70s, nearly all major makers of cameras produced automatic exposure cameras. The very first 35mm single-lens reflex camera to offer automatic exposure was the Konica Autorex (Autoreflex) which was quickly followed by models from Canon (Canon EF), Minolta (Minolta XS-1), Nikon (Nikkormat EL) and Pentax (Electro-Spotmatic or ES). The various refinements in auto exposure have occupied camera designers since that time, and even today they are still making design changes to increase the accuracy and flexibility of auto exposure systems.

Automatic focus has been a dream for quite some time. Canon actually showed working prototypes of autofocus cameras at Photokina in the years 1963 and 1964, and announced at that time that they would soon be in production. This announcement turned out to be somewhat premature! Canon's first autofocus system camera appeared in 1987, the astonishingly advanced EOS 650. A short lived T-80 autofocus camera had preceeded this, but was not very successful and was abandoned as an approach. The actual autofocus technology used in today's SLR cameras evolved from a design prototype invented by Leica (the Leitz Correfot) and was refined and developed by Honeywell.

◁ In the case of this photo, the photographer wanted to render this iron tower as a silhouette. A slightly reduced exposure darkened the sky and made the ironwork stand out starkly against it.

Autofocus System

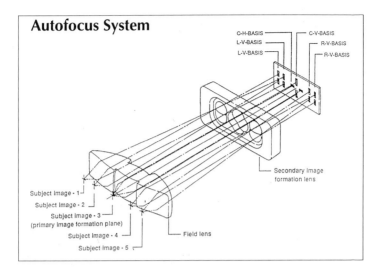

C-H-BASIS — — C-V-BASIS
L-V-BASIS — — R-V-BASIS
L-V-BASIS — — R-V-BASIS

Secondary image
formation lens

Subject Image - 1
Subject Image - 2
Subject Image - 3
(primary image formation plane)
Subject Image - 4 — Field lens
Subject Image - 5

Today we are beginning to take autofocus SLR cameras for granted, since all of the major brands have one or more models on the market. Like all other autofocus SLR cameras, the EOS cameras use a passive autofocus system. This uses the ambient light to provide information for the autofocus sensors in the camera, as opposed to active autofocus systems in which the camera generates its own focusing beam (usually infrared). Passive systems are more flexible and allow easy lens interchange, but are totally reliant on there being sufficient light on the subject to make focus determination possible. In addition to requiring a certain brightness level to operate (expressed in EV numbers), passive systems also require that the subject have a certain amount of contrast for the sensors to operate. That is why even the best passive systems cannot focus on a blank smooth surface with no texture.

For a passive autofocus system to work, the lens on the camera must be sharp and contrasty. That is one reason for generally recommending that the EOS photographer stick with Canon brand lenses, since many "off brand" lenses may not have been computed for absolute sharpness and contrast and may not focus as well.

Basic operation of passive autofocus systems is as follows: The light from the lens passes into the camera body, where a small amount of it passes through a semi-silvered central section of the camera mirror, strikes a secondary mirror, and is reflected to a

Fog can often confuse the autofocus mechanism but, in this case, the tree branches offered enough contrast for it to function properly.

sensor array in the bottom of the camera's mirror chamber. The light passes through lenses which focus it onto the sensors, and separate it into two components coming from opposite sides of the lens' exit pupil. The image projected by a lens always shows its highest contrast when that image is in focus. The autofocus sensors are in segments, and if the outer segments register high contrast values the camera causes the autofocus motor to shift the lens slightly until the central segments of the sensors register high contrast. Similarly if the inner segments register high contrast, the lens is shifted the other way, until high contrast is registered on the central segments. The sensors also compare the image information from both sides of the lens exit pupil, because when these coincide the lens is in focus as well. All of this information is processed in the camera's computer to determine in which direction and by how much the lens needs to be moved.

The system constantly compares information coming in through the lens with stored information values in the computer to monitor the accuracy of focus. In the AI SERVO mode the lens will be continually refocused as the subject moves to allow focus tracking and predictive autofocus operation.

Canon EOS cameras use a unique type of autofocus sensor developed by Canon and called BASIS, for BAse Stored Image Sensor. The BASIS sensor has a built-in micro amplifier which increases signal strength from each segment of the sensor prior to readout, making the signal to noise ratio from Canon's sensors higher than that from other brands.

The original BASIS sensors used in the first EOS cameras were horizontal arrays, which made it impossible for them to accurately measure subjects with only horizontally arrayed bands of contrast. The most familiar example of this is a thin-slatted venetian blind, upon which these cameras cannot focus. To solve this problem, a new type of sensor was devised which has both a horizontal and a vertical array, a cross based sensor. This was first used on the EOS-1, and quickly proved itself superior to other systems. The EOS-1 however, was limited somewhat by the fact that the sensor was placed dead center in the finder, somewhat inconvenient for certain applications. Further development resulted in a three-sensor array, with a cross based sensor in the central position. This was a great improvement, but still needed refinement, and some considered the three sensors (used in the EOS 10/10s) to be too close together.

With the EOS A2E/A2/5 the system is now expanded one step beyond, with five sensors, again with a cross based sensor in the central position. The expansion to five measuring fields with the outer two well away from center corresponds to the wishes of many professional photographers.

More details of the actual operation of the autofocus system in the EOS A2E/A2/5 will be provided in following chapters.

Autofocus Modes

The Canon EOS A2E/A2/5 camera has two different autofocus modes. These are called One Shot and AI Servo, and are switched by pressing the AF button on the camera back and using the main control wheel to switch from one to the other as indicated in the central gray rectangle on the LCD panel. It is important to note that this switching can only be done if the lens mounted on the camera is set for autofocus operation. Otherwise, nothing happens when the button is pressed.

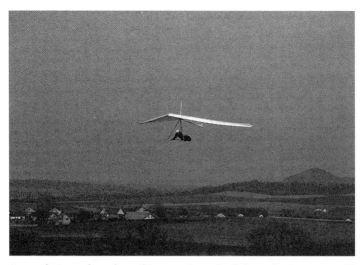

For a photograph such as this one of an ultralight enthusiast, you will probably find that the AI-Servo AF mode will work best.

The One Shot autofocus mode causes the camera to activate the autofocus system and bring the lens to focus when the shutter release button is pressed halfway down. Once the system has come to focus, that focus will be retained as long as the shutter release button is kept in the partially depressed position. As an example of a way to use this, let us consider a landscape with the horizon at infinity. If you wish to take a photograph only of the sky, you can point the camera at the sky and press the shutter release button halfway down, but since there is no contrast in the sky the camera will be unable to focus and will search for focus, running the lens back and forth between its closest focus and infinity and you will not be able to take the photo since the camera will not fire until it has found focus. Of course, you can always switch the lens to manual focus and then set it for infinity, but there is a faster way. Simply point the camera down so that the autofocus sensors are on the horizon line or a very distant object. Press the shutter release button halfway down, and maintaining pressure on the shutter release, while pointing the camera up at the sky and taking the photo. The focus found by the autofocus system will be retained.

49

When working at closer distances you will sometimes encounter a subject on which the autofocus system cannot focus. This may be a featureless subject with no contrast, a reflective subject which is sending too much glare to the sensor, or a red subject since the autofocus sensors are essentially blind to red. In such cases you can use the alternate subject method of autofocus. Just as with light metering when you use an alternate subject with the same light falling on it, you can autofocus on another subject which is at the same distance as the desired subject. Hold the focus with the shutter release button while you recompose, and take the picture.

Since the camera will not fire unless the autofocus system is able to attain focus, you could say that the One Shot AF mode means "No focus, no picture".

On the other hand, in the AI Servo mode the camera will fire whether focus is achieved or not, and the autofocus system will constantly monitor and correct focus. This mode is intended for the tracking of moving subjects, such as encountered in sports and wildlife photography. One important point is that the autofocus system in the AI Servo mode is able to track and maintain focus on subjects coming toward or going away from the camera.

Technologically this is a very impressive achievement, since the shutter must fire after the reflex mirror has been raised and can not monitor focus right up to the point of exposure. Instead it must track subject motion, compute its speed and acceleration, and then predict where the subject will be when the shutter fires and set the focus accordingly. It took quite a lot of man-hours in the engineering department to make that work!

But, in fact, it does work, as I have determined in careful tests with subjects moving at different rates of speed to the camera. This feature is particularly useful for those who photograph auto racing, or any other sort of racing in which the subjects move toward the camera rapidly. A unique feature of the EOS A2E/A2/5 is that a moving subject will be tracked by the camera as it moves from one autofocus sensor area to another, across the image area.

Obviously this ability to track a rapidly moving subject works particularly well in combination with the EOS A2E/A2/5's high speed drive motor, all the way up to three frames per second. The camera itself is capable of five frames per second, but the automatic tracking of the subject movement can not be made to

operate at this speed. Not everything we might want is technologically possible. If you wish to quickly access the high speed drive and the Servo AF mode, you can simply turn the main control dial to the icon of the runner, which provides these modes as well as a program biased toward high shutter speeds for stop action shots.

When the camera is set to the Green Zone, you will note that a special indicator marked AI Focus appears, which is a combination of One Shot and AI Servo functions, with automatic switching from One Shot to AI Servo when subject motion is detected by the autofocus system. This may be the best setting for ordinary snapshots of the kids who always decide to move around when they are told to be still.

For those situations in which there is insufficient light for the autofocus system to function, the EOS A2E/A2/5 has a near-infrared focus assist light which projects a pattern of bars onto the subject and makes focus possible. For situations in which this projected light will be an annoyance or hindrance, it may be switched off with Custom Function #7. The range of the autofocus sensor is light levels from EV 0 to EV 18 (computed at ISO 100, with a lens of 50 mm f/1.4). It is unlikely that you will be troubled by having too much light, as an EV of 18 corresponds to a shutter speed of 1/8000 second with a lens aperture of f/5.6 with ISO 100 film.

Eye Controlled Autofocus

The EOS A2E/5 is the first camera in which the autofocus sensor can be chosen and activated without delay. This produces a greater "transparency" than ever before, and a relief to the photographer for not having this one thing to worry about. When word about the new EOS first began to leak to the photo press, we were told that this new camera would be able to direct its focus where the photographer's eye looked. This sounded like science fiction, something not quite plausible. For quite some time there have been instruments which could track the movements of the subject's eyes, but these were gigantic and quite expensive, and were available only for very special applications. One such system had been developed to operate a computer by eye movement and could be used by paralyzed people to communicate and operate anything which could be coupled to a computer.

As explained in the text, Canon's eye controlled focus system is so accurate that it can track the photographer's eye to any part of the image. Presently it is used only to pick out the five AF sensors and the lens stopdown control. (Drawing courtesy of Canon)

Many questions were asked about how such a system could work and how easily it might be confused by the photographer who looks momentarily down at the LCD display, for example. In 1992 all speculation came to an end when the EOS 5 was shown at Photokina. The North American EOS A2E and A2 models were introduced shortly thereafter. The new autofocus sensor system is not so very different from that used in the EOS 10/10s, except that two additional sensors have been added in the outer areas of the image field, which increases the versatility even more.

The five sensors lie in a horizontal line across the middle of the viewing field, with the central sensor being a cross based sensor for sensing both horizontally and vertically arrayed contrasts, and

The IRED infrared emitters are located as shown on the lower frame of the viewfinder eyepiece. (Drawing courtesy of Canon)

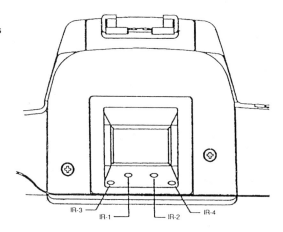

the outer four sensors being more standard sensors responding to vertically arrayed contrasts. For many applications it is possible to simply leave the choice of sensor to the camera's computer, and I have found in practice that it picks the one I would have picked most of the time.

However, it is also possible to use the eye controlled focus system, and select the desired sensor by looking at its indicator in the viewfinder. Mounted in the lower edge of the camera's eyepiece frame are four special LEDs known as infrared emitting diodes (IREDs) which produce infrared light. The inner two of these project beams of infrared into the photographer's eye where the infrared beams bounce off ghost images inside the eye (called Perkinje images) and are reflected back into the eyepiece. There, a beamsplitter reflects the beams through a condenser lens which focuses the beams onto a CCD infrared area sensor detector which informs the camera's computer of the location of the Perkinje images. This data is translated by the computer into information about where the eye is looking on the viewing screen.

The choice of autofocus sensor is confirmed by the red lighted outline appearing in the viewfinder as an indication of the selected sensor, and focus is confirmed by flashing of this sensor indicator and an audible beep (in the EOS 5 only, the EOS A2E lacks this beeper). If you are disturbed by the beeper or the red indicator, both can be switched off. The beeper is controlled by the bottom button on the camera back, while the red indicator is controlled

The eye controlled focus allows the photographer to compose the scene and then direct the camera to focus at the proper point, regardless of where that point is in the frame.

by Custom Function #10. Not only is the advanced IRED eye tracking system able to detect which of the five autofocus sensor indicators you are looking at, it is possible for this system to track your eye to any point on the viewing screen, which opens great possibilities for future developments with such systems.

Even though there are four IREDs, only two are used at any time to track your eye. The inner two are angled so that they will work with the naked eye, and the outer two are angled so that they will work with the eye of someone wearing eyeglasses or contact lenses.

It is not possible to just unpack a new EOS A2E/5 camera and begin using the eye controlled focus. First the system must be programmed for the characteristics of your eye. Eyes vary consid-

erably in size and shape, and there is a difference in the direction in which the eye points and the actual direction of sight which varies by an angle of 5 to 7 degrees toward the nose. The calibration procedure feeds these individual variations of the photographer into the camera's computer to be entered into the computations used to track the eye. The camera can be programmed for up to five different eyes by means of the CAL setting on the main control dial.

To calibrate the eye controlled focus system for your eye, simply turn the main control dial to the CAL position. The LCD panel will then display a number from 1 to 5, and unused numbers will flash. Remember which number you use so that you can return to that calibration if someone else uses the camera. You can also use different calibration numbers for different situations, for example if you sometimes wear eyeglasses and sometimes wear contact lenses.

Once you have selected an empty calibration channel (one with a flashing number) you can begin to program the camera for your eye. In bright ambient light look through the camera. You will see the autofocus indicator on the far right flashing. Look directly at that flashing indicator and press the shutter release button as if you were taking a photo. The camera will make a cheeping sound, the blinking red indicator will light continuously for a moment, and then the far left indicator will begin to flash in red. Look again intently at this flashing indicator and press the shutter release button again. Again the camera will cheep, again the indicator will cease flashing and remain illuminated for a moment, and then the LCD indicator in the viewfinder and the LCD panel will both read "END-1". This completes the basic calibration, and if successful the camera should now be able to track your eye. Test this by switching the main control dial to the P, Tv or Av setting and looking in turn at the various autofocus indicators in the viewfinder to see if the camera correctly follows your eye. Also try setting the camera to Av mode and selecting a small aperture (f/16 or so) and then after allowing the camera to focus and still maintaining pressure on the shutter release button, look up at the diamond-shaped indicator in the upper left corner of the viewing screen. Doing this should cause the lens to stop down and the viewing image to noticeably darken. If all of this works correctly, you need not worry about any additional calibration procedures.

For those times when you prefer not to use the eye controlled function, simply set the main control dial to CAL and turn the main control wheel through the calibration numbers until "OFF" is displayed on the LCD panel.

Unfortunately the original English language instruction book for the EOS 5 and EOS A2E omits important information about the calibration procedure. The book is being revised, but if you have trouble getting the camera calibrated, follow the procedures outlined below and you should be able to get the eye controlled focus to work.

If you find that the eye controlled focus follows your eye correctly only part of the time, you may need to fine tune the calibration. You do this by repeating the calibration procedure on the same calibration number several times. Simply follow the identical procedure above to overlay additional calibrations onto the original one. I have found it best to wait about fifteen minutes between calibrations, as the camera will not immediately accept additional calibrations, and to perform the additional calibrations at different light levels. For example, I calibrated my EOS 5 first outdoors on a very bright day; I then added additional calibrations in outdoor shade, indoors in my office during the day, and in my office after dark. After this fine tuning of the calibration, the camera performs flawlessly.

Remember that you must have a separate calibration number for each change you make in your eyewear. If you have calibrated the camera with your normal eyeglasses, most likely it will not work on that same calibration number if you switch to sunglasses or reading glasses. Keep a separate calibration number for each different type of eyeglasses or contact lenses you wear. If you wear photoactive eyeglasses which darken when you go outdoors, you will probably need to use two calibration channels, one for your glasses when they are clear and one for when they are darkened.

Now that all of that has been said, it must be noted in all fairness that there are some people for whom the eye controlled focus simply will not work. Human eyes vary greatly, and some will be outside the limits within which this system was designed. If you find that you are one of these people, and that repeated calibration will not make the camera work for you, then you may be better served, if you live in North America, by buying the EOS A2 camera

instead. The A2 offers all of the features of the EOS A2E/5 except for the eye controlled focus. I know of one photo magazine editor who has tried repeatedly to get the EOS A2E/5's eye controlled focus to work for him with a total lack of success. Also, I have been told by Canon that some types of eyeglass coatings will interfere with the operation because some of these coatings do not pass infrared. If you have difficulties in getting the eye controlled focus to work and are unsure about this, I would suggest consulting with your optician to find out if your eyeglasses have this sort of coating.

If your camera is subject to use by others, it is a good idea to switch it to the CAL setting each time you intend to use it to make sure that the correct calibration number is set and that the eye controlled focus has not been switched off.

Unfortunately, for both technical and cost considerations, the eye controlled focus works only when the camera is held in the horizontal picture orientation. As a magazine and book photographer, I find that the great majority of my photographs are taken in the vertical orientation, which substantially reduces the usefullness of this feature. I sincerely do hope that a future Canon model will offer eye controlled focus which will work in either orientation. Perhaps the new professional camera will offer that feature.

As I was working on this book I was told by one of my friends at Canon USA that the EOS A2E/5 can be calibrated for vertical operation for some people's eyes. You can give it a try and see if it works for you. It did not work for me. To do this activate the camera in the horizontal mode and then rotate it to the vertical while looking through it at the lighted indicator prior to pressing the shutter release button. Then look at the lower lighted indicator and press the shutter release button again. If the calibration "takes" you may be one of the lucky few whose eye is exactly the right shape for this to work.

Some people have expressed concerns over the safety of eye controlled focus since they are troubled by the idea of having infrared beams shot into their eyes. Rest assured that Canon has investigated this thoroughly and uses IREDs which produce very low power output, and are only activated for a brief interval when the shutter release button is pressed (approximately 1/5 second). The longest exposure would be five seconds if the shutter release

is held down after focusing is completed in the One Shot AF mode. The intensity of the infrared beam entering the photographer's pupil is approximately 0.3 milliwatt, which is in full compliance with an ANSI safety standard (Standard # Z136.1-1986).

Although dioptric eyesight correction lenses are available for the eyepiece of the EOS A2E/5, the eye controlled focus will not work if they are fitted because they block the infrared beams emitted from the IREDs in the eyepiece rim.

Camera Selected Autofocus

In addition to its innovative eye controlled autofocus, the EOS A2E/5 also offers camera selected autofocus, similar in operation to the focusing system of the EOS 10/10s. While this is a user-selected option on the EOS 5 and EOS A2E, it is the standard operational mode on the EOS A2. To activate the camera selected autofocus operation on the EOS A2E/5, turn the main control dial to the CAL position and use the main control wheel to turn through the calibration numbers until "OFF" is displayed.

In this operational mode, the camera will use an internal program to determine which subject is of most importance and activate the appropriate autofocus sensor and indicator. If it is judged that the important subject overlaps several of the sensor fields, more than one sensor will be activated, up to the full compliment of five sensors.

It is amazing to me how well this feature works. It would seem impossible for the camera to know which of the autofocus sensors to activate, but the camera's computer has been programmed by Canon based on a careful analysis of thousands of typical photographs and this analysis has yielded algorithms which do allow the camera to select the proper sensor or sensors in the vast majority of cases. In practice I have found that the camera selects the same sensor I would have selected in almost every case. In those cases in which I disagree with the camera it takes only a moment to switch to manual focus or to manually select the desired autofocus sensor (see following chapter).

Unlike the eye controlled focus, the automatic selection of autofocus sensor will work as well in the vertical shooting position as it does in the horizontal position. Again, I have been surprised

In a busy picture like this it is often easiest to just let the camera automatically select the AF sensor. You can always manually override if you don't like the camera's choice.

with the accuracy of this operation in predicting the sensor I would have chosen.

In either horizontal or vertical orientation, the camera indicates the sensor or sensors chosen by illuminating their indicators in red in the viewfinder and blinking them to indicate that focus has been found. In the EOS 5 this focus is also confirmed with an audible beep.

Manually Controlled Autofocus

With the eye controlled focus and camera selected autofocus working so well on the EOS 5/A2E, what reason could there be for offering manually controlled focus as well? At the time of writing this book I have been using the EOS 5 and EOS A2 cameras for more than six months, and during that period of time I have used the eye controlled focus almost all of the time on the EOS 5 and the camera selected autofocus on the EOS A2, particularly for my outdoor photography.

However, in the studio I have found that I often prefer to set the autofocus sensor manually. I do a lot of glamour photography with models, and when working with a reclining model I have found that I generally want the active autofocus sensor to be the one on the model's face. Similarly when working with a standing model, or a model in a vertical pose, I generally want the sharpest focus on the model's face. To accomplish this is quite easy. On the back of the camera, conveniently placed for quick right thumb operation, is a small black button identified by a white rectangle with five white dots inside it. When this button is pressed, all five of the autofocus indicators inside the viewfinder light up and remain lighted. If I then turn the main control wheel, I can selectively light each sensor indicator in turn. For a reclining nude in which I want focus on the face, I can pick either the far right or far left sensor, if that is where the model's face will be, or one of the inner two sensors if that falls on her face instead. Similarly, in the

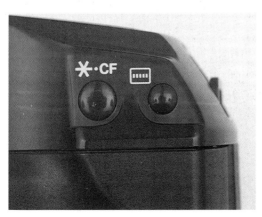

The right hand button in this photo is the one which is pressed to activate manual AF sensor selection.

The depth of field for this photo had to be great for the whole photo to be sharp from front to back. This can be done by selecting a small aperture, or by using the unique DEP mode, for automatic depth of field control.

vertical mode, I can do the exact same thing, picking either the top sensor or the one below it, as I require. To return to eye controlled autofocus, I need only press the button again and turn the control wheel until all five sensor indicators light. This is a very quick operation and becomes "instinctive" after you have used the camera for even a short time.

Since the central sensor is a cross based type, remember to switch to it if you encounter difficult subjects which the outer four sensors can not lock onto.

Autofocus in Practice

There are many different ways to use autofocus, just as there are many ways to use auto exposure. The camera can not do the thinking for you, and you must have enough of an understanding of the options available so that you can make an intelligent choice appropriate to the situation at hand.

Since the central cross based autofocus sensor is able to find focus on most difficult subjects, you can simply turn it on manually and proceed to use the camera just as you would use the EOS-1. If you do this all the time, you will get a good percentage of sharply focused photos, but you will be wasting much of the versatility of the advanced autofocus system of the EOS A2E/A2/5 camera.

With these cameras five autofocus sensors are available with three variants of autofocus sensor choice. It is no problem to set the camera manually for any given situation if you have the time, and in such cases you may prefer manual selection of autofocus sensor. However, in many other cases you will not have time to do this manually and in such cases it is best to use eye controlled autofocus or camera selected autofocus to give you the best chance of coming away with sharply focused photos.

An interesting combination is AI SERVO autofocus used in combination with high speed motor film advance, an excellent combination for snapshots of subjects which are not likely to hold still. Since the camera can follow a subject and maintain focus up to as fast as three frames per second, few photos will be missed because of camera or autofocus not being swift enough.

No matter how good an autofocus system is, and Canon's is the best in my opinion, there will be subjects which the system simply

A "gray on gray" photo does not cause the light meter any problems.

can't focus on. In my own experience, I have found that many times in close-up portraits of models with smooth, even skin, there is not enough texture for the autofocus system to work with. In such cases you can move the camera until one of the sensors falls on the subject's eye, which always has enough focusing contrast, and, while holding the established focus by keeping the shutter release depressed, recompose and take the photo. If I find that I am going to be taking a series of photos from the same position, and with a model who will not be moving with respect to the camera, I will put the central sensor on the model's eye and let the camera come to focus. Then I will switch the lens from auto-focus to manual focus, and shoot the sequence of photos, only switching the autofocus back on when the model moves to a new pose or I move to a different vantage point. When shooting nude photographs in which there is no face, often there is nothing for

the camera to focus on, and in such cases I will switch to manual focus and adjust the focus by eye. To assist in such cases, a small flashlight which projects a narrow beam may be used to provide a spot of light on which to focus. There are also laser focusing aids available from some supplier which use a low-power laser to project a red dot or star onto the subject for ease in focusing.

Of course, at moderate distances the camera's built-in focus assist light will be projected if the autofocus system can't find focus and this will often enable the camera to focus without the need to switch to manual focus.

The important point to grasp about autofocus is that no one autofocus mode of the EOS A2E/A2/5 is right for every subject or situation, and you must have a basic understanding of what each mode does so that you can select the appropriate one for your own use at any given time.

For the telephoto shot of the windsurfer (taken with a zoom at 300mm ⇨ focal length) the Program mode provides a short shutter speed. The same Program mode will provide a small aperture when required, such as in this wide angle photo of a beached boat.

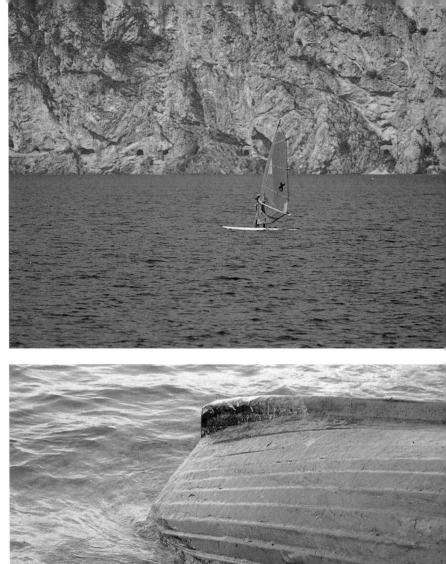
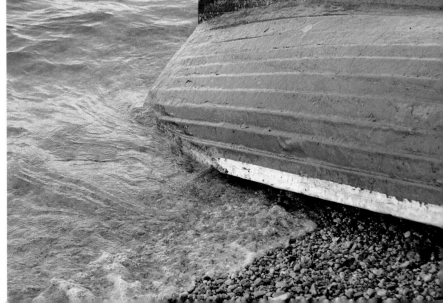

Exposure Metering

Exposure Metering for Beginners

Exposure metering allows us to adjust the camera so that exactly the right amount of light strikes the film and the developed image looks correct to us, neither too light nor too dark. Most modern cameras, including the EOS A2E/A2/5, have sophisticated light metering systems which can measure light with great accuracy and then provide that information to the camera for automatic exposure setting or to the photographer for manual exposure setting.

Before going into the details of how this works, it is important that the reader have a basic understanding of just what goes into a proper exposure. Basically the proper exposure is controlled by three factors, the lens aperture, the shutter speed, and the film speed.

Let us visualize how these interrelate by using some simplfied learning aids. A young fellow is sent to a faucet to fill up a bucket with water. When he reaches the faucet and places the bucket underneath, there are three factors which determine his success. These are the degree to which he opens the faucet, the length of time he lets the water run, and the size of the bucket. In this analogy the degree to which he opens the faucet corresponds to the degree to which the lens aperture is opened, just as the faucet valve controls how much water can get through, so the size of the lens aperture determines how much light can pass through.

The length of time the young man runs the faucet before shutting it off corresponds to the shutter speed, which shuts the light on and after a specified time shuts it off again.

◁ **Selective sharpness was obtained in this tulip photo by restricting the lens to a large diaphragm opening and minimizing the depth of field, while the lower photo of Sumac was taken with a somewhat smaller aperture to allow depth of field to fully cover the main subject but still keep the background out of focus.**

The size of the bucket corresponds to the film speed. Just as a large bucket requires more water to be filled, a film with a slower speed (lower ISO number) requires more light for proper exposure.

Obviously if you have a very big bucket (slow film) you will need a longer running of the faucet and a larger flow, while a tiny bucket will allow you to fill it in a very short time with a smaller flow. Proper exposure is likened here to a full bucket which does not overflow. A partially filled bucket is underfilled, just as a partially exposed film is underexposed.

The photographer's trick is thus to select the proper lens opening (amount of light passing) and shutter speed (duration of light flow) to achieve the correct amount of light reaching the film.

Apertures are marked in numbers which may seem odd at first but the sequence is both natural and logical. Starting at f/1.0 the sequence runs f/1.0, f/1.4, f/2.0, f/2.8, f/4.0, f/5.6, f/8.0, f/11, f/16, f/22, f/32, etc. Moving from any one of these numbers to the next one in the sequence, such as from f/1.4 to f/2.0 cuts the amount of light which can pass through the aperture exactly in half. Moving the other way, from f/4.0 to f/2.8 for example, doubles the amount of light. These numbers look odd because they are a geometrical progression, and are the lower half of a fractional ratio. Properly we should express them as 1:1.4, 1:2.8, etc. They are a relative measure of the diameter of the opening through which the light passes, and have their progression based on doubling and halving the area of the diaphragm opening. If you have trouble remembering them, notice that every second number is doubled or halved, depending on which direction you are going in the sequence. As you change lens apertures on the EOS A2E/A2/5, you will find other numbers appearing, such as the sequence: 2, 2.5, 2.8, 3.5, 4, 4.5 etc. These intermediate numbers are half stops, f/2.5 is halfway between f/2.0 and f/2.8 for example. Half stops are offered for fine control of exposure.

Just as the apertures run in a doubling sequence, so do the shutter speeds, but this is easier to follow. Obviously 1/30 second lets in twice as much light as 1/60 second and half as much light as 1/15 second. Again the EOS A2E/A2/5 provides intermediate values for fine tuning.

Once you determine the correct exposure, for example f/4 at 1/60 second, there is a whole sequence of combinations which will provide identical exposure on the film. If you increase the

shutter speed to 1/125 and at the same time open the lens aperture to f/2.8, you have maintained an identical exposure on the film. If you decrease the shutter speed to 1/30 second and close the lens aperture down to f/5.6, you have again maintained proper exposure. Obviously, under this particular lighting situation, if you were photographing a moving subject you would want to select the faster 1/125 second shutter speed. Not so obviously, since depth of field increases as the lens is closed down, if you wanted maximum depth of field and could hold the camera steady, the combination of 1/30 second at f/8 (or even better 1/15 second at f/11) would provide greater depth of field which translates into more of the photo appearing to be in sharp focus. It is all very much a balancing act!

On an automatic camera like the EOS A2E/A2/5 you can let the camera select both values, the Program mode, or you can select one of the values yourself and let the camera pick the other (Av and Tv modes), or you can manually pick both values (Manual mode). So long as the proper balance between the two is maintained, you will have correct exposure.

Remember, however, that perfect exposure does not insure good photographs. You can get perfect exposure with a small aperture and a long shutter speed, but if you are photographing moving subjects you will end up with perfectly exposed blurs! You must pick the lens aperture and shutter speed values based on the requirements of the image. Again, just as with autofocus, you can't simply let the camera do all your thinking for you, you must think of what you want to achieve and set the camera accordingly.

Now how does it all work? Light meters use photosensitive substances to measure the relative amounts of light striking the sensor. Early light meters used Selenium cells, which generate electricity directly in proportion to the amount of light falling on them. These require rather large sensor surfaces and are not suited to behind-the-lens use in cameras. The first cameras with behind-the-lens meters used CdS (Cadmium Sulfide) cells, which do not generate electricity but vary their electrical resistance based on the amount of light falling on them. Most modern SLR cameras now use Silicon photo diodes as their sensors. Like Selenium, Silicon cells generate a small electrical current which increases as the amount of light falling on them increases. This electrical current is far too small to be used directly to power any sort of

meter, so it is passed through an amplifier which produces a large enough signal for the camera's computer to use in calculating exposure. Such cells have a sensitivity range within which they work, below a certain level the electrical current they generate is too small to use, and above a certain level they no longer increase their output. In the case of the Canon EOS A2E/A2/5 cameras this usable range is from EV 0 to EV 20 at ISO 100. This means that the low end cutoff is reached at a shutter speed of 1 second with a lens aperture of f/1.0. The high end cutoff is reached at 1/8000 second at an aperture of f/11. In practice, this means that you are unlikely to encounter a situation in normal photography which is outside the range of this light meter.

The reason for offering films with a variety of different ISO speeds is that no one film is perfect for everything. For photos in bright light when ultra fine detail is important, very slow films like Kodachrome 25, Ektar 25, Agfapan 25, etc., will be the films of choice. However, at a slow ISO of 25, these films will only be usable in brightly lit surroundings, and with relatively slow shutter speeds. These days most photographers have standardized on medium speed films of around ISO 100 - 200 for general shooting. Such films as Fujichrome RDP, Ektachrome 100X, Panther/Lumiere 100X, Kodak Gold 100 and 200, Fuji Super G 100 and 200, Ilford Delta 100, T-Max 100, etc. are usable for most types of photography. These days I rarely find myself using anything other than these films, only loading something else when contemplating some unusual sort of photography.

Faster films, those with ISO speeds of 400 and up, are usually a compromise, and are best reserved for low light shooting when the slower films simply won't work. As film speed increases, apparent grain increases and sharpness and resolution decrease. Today's fast films are greatly improved over those of the past, but they can't quite reach the quality level of the medium speed films.

There are a few exceptions to this rule. I've recently been working quite a bit with Fuji's NHG color negative film, which is very remarkable in delivering very fine grain, exceptional sharpness and excellent color saturation. I have made some really amazingly large prints from this film and have yet to be able to even see the grain in the images. At press time Kodak had just announced a new professional 400 speed color negative film of their own, but I have not had an opportunity to test it yet.

Another interesting exception is the black and white film Ilford XP-2. This is a highly unusual black and white film which is processed in color negative chemicals, so any one-hour or mini lab can process it. At its normal speed of ISO 400 it produces negatives with much finer grain than most medium speed films, with exceptional image characteristics. It can be exposed at speeds from EI 200 up to about EI 1600 with excellent results and no change in processing. It deserves a book of its own to explain all that it does, but if you plan to do any black and white photography at all you owe it to yourself to at least try a roll or two.

To return now to exposure metering: Years ago it was determined that if you take most photographic scenes and average out the values of light and dark you will arrive at a mean value of 18% reflectance. This 18% reflectance, a medium shade of gray, has become the photographic standard. You may sometimes hear a phographer speak of using a "gray card" and this is a piece of card or plastic made up to be precisely 18% reflective. Some photographers determine exposure for all photos by putting one of these gray cards into the scene and taking a light reading from the surface of the card. This will work in every case, so long as the light falling on the card is the same as the light falling on the subject. You can hold a gray card at arm's length and take a meter reading from it, and the correct reading for a distant mountain will be the same so long as there is nothing shading the card or the mountain.

Now, we begin to encounter problems when we want to photograph subjects which reflect less or more than 18% gray. As an example, if you want to photograph someone outdoors after a snowfall in a white fur coat and hat, the overall reflectance of the scene will be much greater than 18%. Similarly, the proverbial black cat in a coal bin will reflect much less than 18%. Canon's designers have realized that such subjects cause problems, and have designed the most sophisticated light meter yet for the EOS A2E/A2/5.

This meter actually looks at the image you are preparing to photograph, takes sixteen different "spot meter" readings around the scene, compares them to stored readings based on thousands of example photos Canon has analyzed and converted to algorithms, and calculates the exposure. Within broad limits, this system can automatically correct for subjects with other than 18% overall reflectance. For most subjects you can simply leave the

Both very light and very dark subjects mixed in a photo cause no problems for Canon's metering system.

camera set for its normal evaluative metering mode and trust it to deliver the correct exposure.

However, for difficult situations such as the above examples, it is usually better to switch to an alternate metering method. By pressing the third button down on the camera back, you can use the main control wheel to set any of three metering modes. The first, and normal, mode is evaluative, and is indicated by a dot and two semi-circles in the rectangle in the lower left corner of the LCD panel. Second is a spot or partial metering mode, indicated by just the dot on the LCD panel. Third is the center-weighted averaging mode, indicated by nothing showing in the rectangle on the LCD panel.

When the camera is set for the spot metering mode, the light meter reads only from the center of the viewfinder, approximately 3.5% of the viewing area. This metering method uses the central autofocus sensor area. It is also possible, through custom function

15 to link the spot meter to the selected autofocus sensor so that the spot reading is taken at the same point as the focus. (However this only works when the autofocus sensor is manually selected).

In the example above of the person in the snow, I would handle that by switching the camera to spot metering and manual exposure. I would then take an exposure reading from the subject's face, making sure to meter from a smooth area of evenly illuminated skin. Caucasian skin is about one stop more reflective than 18%, so if I take a spot reading from someone's face like this and then open the lens aperture by one stop (or slow the shutter speed by one full setting), I will have the correct exposure. If you are a fair to medium skinned caucasian, you can use the palm of your hand as a substitute subject, making sure it is in the same light as your subject and then opening up one stop. If you like, you can "calibrate" the palm of your hand by taking a reading from a gray card and then comparing a reading from your hand. Once you know the correction factor for your palm, you can use it as a substitute subject whenever you encounter a particularly difficult situation.

The third metering mode on the EOS A2E/A2/5 is the center weighted averaging mode. Personally, I do not recognize much of a need for this mode except that it is the one used on most older cameras, and long-time users of those cameras might welcome it because of familiarity. Other than testing it to make certain that it worked, I can't say that I have ever used this metering mode for picture taking, nor do I see any likelihood that I will. Basically this type of metering reads the entire image area and averages it out while taking more of its emphasis from the center.

Multi-Point Integrated Metering

For many years after the introduction of built-in through the lens (TTL) metering systems in SLR cameras, most such metering systems simply took an overall averaged light reading of the total image area. Meters of this sort work well only when the subject being photographed has an overall average reflectance of 18%, which is often not the case in actual photography. In the mid-80s Nikon advanced the cause of in-camera metering with their FA, which used discrete metering sensors to read several areas of the

C13				C12
B8	B6	B5	B7	B10
A3	A1	A0	A2	A4
B9	B6	B5	B7	B11
C14				C15

C13				C12
B8	B6	B5	B7	B10
A3	A1	A0	A2	A4
B9	B6	B5	B7	B11
C14				C15

C13				C12
B8	B6	B5	B7	B10
A3	A1	A0	A2	A4
B9	B6	B5	B7 ·	B11
C14				C15

The metering emphasis in the EOS 5/A2E/A2 cameras is linked to the AF sensor which is activated, as explained in the text. Diagram courtesy of Canon.

image, and then used a program to determine the correct overall exposure. Since that time, most camera makers have added such multi-point integrated metering systems, although each manufacturer tends to have a different trade name for their individual system, and a different number and placement of the sensors. The number of metering segments has been increased with each new generation of cameras.

Now, with the EOS A2E/A2/5 cameras, we have the most advanced such system so far. This system has sixteen separate sensors, each measuring a discrete area of the overall image field, and for the first time adding emphasis based on the autofocus sensor output. By placing metering emphasis by way of a variable algorithm onto the active autofocus sensor, the camera insures that the main subject will always receive the most correct exposure, regardless of background illumination. Unfortunately, even though the autofocus sensors are essentially Silicon photo diodes, just as the metering sensors are, they are a totally different type of diode and can not themselves be used as metering sensors. Instead, the sixteen-field measuring sensor which sits just above the eyepiece inside the camera has five sensors which correspond exactly in position to the five autofocus sensors.

The three central measuring fields each have one more sensor overlapped on top of them, extending both above and below, while the outer two measuring fields each have separate sensors above and below which wrap around the ends (L shaped). This produces a total of twelve sensors reading the central portion of the image field.

To this are added four more sensors, each reading an L shaped field in the four corners of the image area, making up the total of sixteen sensors. How greatly the measured value of the central five fields affects the overall reading depends on where the point

The reflection of the sun on this glass would cause underexposure if the meter reading emphasized that area.

of focus is, in other words the zone of importance of exposure moves around based on which autofocus sensor is active. The sensor which corresponds to the active autofocus sensor and its neighbors on either side and above and below are used to calculate the base light reading, while the results of the outer metering sensors above and below are combined into the readings with less emphasis.

In operation, the exposure data from the active autofocus sensor area is computed and stored in the computer's memory as the main component of the exposure. Information from the surrouding areas is also fed to the computer, and factored in with the main emphasis on the subject which has been focused on. This means that you can count on your main subject getting proper exposure so long as one of the autofocus sensors is on that subject and the camera has focused there. If you wish to compose the photograph differently after focus has been achieved, you must press the button marked with an asterisk under your right thumb and hold it down while recomposing the photograph. You will also have to maintain pressure on the shutter release button, at the same time, to hold the focus.

So long as you are photographing subjects of average reflectance, a meter which reads and integrates many areas like this is of little advantage. Almost any meter will suffice for these average situations. It is when your subject deviates from average that the advanced metering system of the EOS A2E/A2/5 will prove its advantage. Through its sixteen metering sensors, the camera can measure not only how light or dark individual subject components are, it can also recognize how large the light and dark areas are and their relationship to one another. In practice this means that the EOS A2E/A2/5 can self-correct for other than average subjects.

For example if your point of focus is on a light subject against a dark background, the dark background is not given so much weight in the overall exposure, which would cause overexposure of your main subject. An example of this would be a portrait of a person in front of a dark curtain. However, if the light area is not at the point of focus, but instead over in a corner, it is not given emphasis in determining exposure, and the data from it simply is added into the computation of overall exposure. An example of this is children playing on a lawn, and in the corner of he picture is a wading pool with sun reflecting brightly from the water. If a bright subject in the picture corner is much lighter than the balance of the picture, it will be ignored in overall exposure computation. For example the sun in a landscape photo taken with a wide angle lens will be ignored and the photo will not be underexposed as a result. While the combination of sixteen area integrated metering with the camera's computer and algorithm control will work correctly with most subjects you are likely to encounter, no program can possibly contain every possible sort of picture. For difficult situations the EOS A2E/A2/5 also offers the spot metering mode, which can be linked with manual selection of the autofocus sensor. This, as well as the center weighted averaging metering option, is detailed in the following chapters.

Center Weighted Averaging Metering

For more than two decades, the center weighted averaging type of light meter was the standard on most SLR cameras. This was for two reasons; one because it was easy to build into the cameras of the day, and two because it was thought to offer advantages over

a simple full area averaging meter. As meter technology progressed and advanced cameras offered multiple area integrated metering, the old center weighted averaging metering began to disappear. However in 1992 three of the most advanced cameras ever appeared, the Canon EOS A2E/A2/5, the Minolta Maxxum/Dynax 9xi and the Nikon N90/F90, and all of these cameras featured center weighted averaging metering as an option. There must be a good reason for this.

The new multiple area integrated metering systems do an exceptional job of looking at the distribution of light and dark zones in a subject, considering the measurements of some areas as more important than others, and in determining the correct exposure. The result is usually correctly exposed in a technical sense, and also usually artistically correct as well, which is to say that the mood of the subject has been conveyed to the finished photograph. However, sometimes the final photo just doesn't look as you had imagined it, and the sad fact is that it is impossible for the photographer to know with certainty if the subject he is photographing will fit with the data of the thousands of photographs programmed into the camera. Simply put, these advanced metering systems work perfectly well most of the time, but the photographer simply can not know for sure when they will not work.

For this reason the experienced photographer, one who has lived for years with a camera with center weighted averaging metering, and learned well its advantages and disadvantages, may simply not feel comfortable in trusting the camera to do his work for him. The experienced photographer knows that the center weighted metering makes an integral measurement of the entire image area with stronger emphasis on the middle of the image.

Such a photographer knows that this system can produce perfectly exposed images when used with average subjects, and that it also performs quite well on high contrast subjects. After many years of experience, he knows which subjects the meter will work correctly with and those which it can not handle. He knows how to make a quick substitute reading when the intended subject is not suitable for metering. For this person the EOS A2E/A2/5 offers center weighted averaging metering, set up so that more emphasis is given to the center and less emphasis is given to the edges of the image. In this metering mode, neither the location of the point of focus nor the size and brightness of the subject are

A subject without high contrast is no problem for a center-weighted averaging type of meter.

given any special significance in the meter reading. The center weighted averaging metering is turned on by pressing the third button on the camera back and turning the main control wheel until the little rectangle in the lower left of the LCD panel is blank. The other indications which appear in that rectangle are a small black dot, indicating spot metering, and the same dot with semi-circular bars above and below it, which indicates the multi area integrated metering.

Once the button has been pressed, the balance of the LCD panel will blank out, leaving only this metering rectangle active, for six seconds. If you wish to operate the camera sooner, simply press the shutter release button partway down and the balance of the LCD panel will become active again and display the rest of its usual data.

If you know that you need to enter an exposure compensation to compensate for reflectance of the subject or for any other

reason, you can do so by turning the secondary control wheel on the camera back and setting the compensation on the bar graph which will be shown on the LCD panel in the lower right. Sometimes it is easier to simply make a substitute meter reading, that is to take the reading not from the actual subject but from some convenient alternate subject of average reflectance which is in the same light as the actual subject. When using the camera in the automatic modes, you can store this exposure reading by pressing in on the button with the asterisk with your right thumb. You must maintain pressure on the button to hold the reading, but you may take any number of photos at the same meter reading so long as you maintain pressure on this button. Also you should know that this system memorizes not the shutter speed and lens aperture, but instead memorizes the EV value. This means that you can change shutter speed or aperture in automatic modes and the corresponding value will also be changed to maintain the same exposure value. As an example, in the Tv mode you can press the asterisk button and memorize a meter reading. You can then use the main control wheel to change the shutter speed and the camera will automatically change the lens aperture to maintain the same exposure. In the program (P) mode, you can change both values simultaneously with the main control wheel and still keep the same exposure. If you intend to take a long sequence of photos at a memorized exposure value, it is usually more convenient (and easier on your tired thumb!) to switch the camera to manual and set the desired shutter speed and aperture manually.

Spot Metering

The most precise type of exposure measurement is spot metering. But it also demands the most concentration on the part of the photographer, or the results will not be what the photographer envisioned.

The spot meter makes its measurement of only a small, narrowly limited part of the subject or scene. Therefore the knowledgeable photographer is able to exclude everything from the reading which is not important or which would disturb the overall desired exposure. The main concern for the new user of a spot metering system is simply the question "what do I measure?"

The answer one often hears is that the light measurement should be made from the most important part of the subject or scene, so that this is exposed correctly, leaving the rest of the image to possibly be a bit under or over-exposed. This is generally not correct, and the photographer who follows this advice blindly will be certain to come away with many incorrectly exposed images. The reason for this is simple – the spot meter in the EOS A2E/A2/5

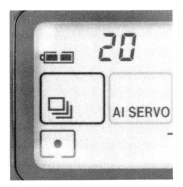

A dot in the LCD panel's lower left corner indicates that the spot meter is in use.

The spot meter was used for this photo of roses. The background was very dark and an averaging meter of any type would have overexposed the roses and made them too light in the photo.

is calibrated for a subject of average reflectance. The famous 18% gray again! All light meters are adjusted to assume a subject reflectance of 18%, and when measuring large areas of varied reflectance, they generally average out close to this 18% gray. However, when reading a tiny subject area which is not subject to averaging in with other areas, the reading will only be absolutely correct if that tiny subject area in fact reflects precisely 18%. Thus if you take a spot reading of a really bright area, the spot meter will provide you with the correct exposure values to render that area as a medium gray in the final photo, which means that the image will be seriously underexposed. Similarly, if you take a spot reading of a very dark area, the camera will provide an exposure reading designed to render that area as medium gray, and this time the overall image will be greatly over-exposed. When using the spot meter you must seek out a part of your subject which approximates a medium gray in reflectance, or use an alternate subject of medium reflectance in the same light.

One reason for taking light readings with a spot meter of both bright and dark areas in your proposed subject is that this will allow you to determine the contrast range of your subject. If you then know the contrast range of the film you are using, you can tell if the film is capable of recording that subject. As an example, at a fixed shutter speed you take two spot readings , one each of the lightest and darkest areas of your subject. The darkest area yields a lens aperture of f/1.4 while the brightest area yields a lens aperture of f/8. That means that there are five stops difference between the two, or five EV levels, and since you are doubling the light each tim you increase one EV level, this means your contrast ratio in this case is 1:32. This is within the range of most films. On the other hand if you did a similar test using a fixed aperture and found that your darkest area gave you a shutter speed of 8 seconds, and your brightest area gave you a shutter speed of 1/2000 second, you would be dealing with a rather impossible contrast range of 1:256.

Turning on the spot meter is done by pressing the third button on the camera back and turning the main control wheel until the rectangle in the lower left of the LCD panel shows just a central dot.

Normally, the spot meter reads the area around the central auto-focus indicator, about 3.5% of the image field. If you wish you

can couple the spot metering function to the manual selection of the autofocus frame, and thus take spot meter readings from any of the five autofocus sensor areas. Remember that this only works when manually selecting the autofocus sensor, it does not work with either eye controlled or automatically controlled selection. This coupling is done by activating Custom Function #15.

There is no indication of the exact area of the spot metering on any of the focusing screens available for the EOS A2E/A2/5. This is somewhat unfortunate, because it leaves the photographer guessing as to precisely what is included in the meter reading and what is not.

In automatic modes it is best to take the spot meter reading using the asterisk button on the camera back, pressing and holding this button with the right thumb while recomposing and taking the photo. Once the exposure reading has been stored, shutter speed and aperture can be changed by means of the main control wheel to best suit the photographic situation.

Special Operating Modes - Conditions

Exposure Corrections

No matter how good a light meter may be, it is still sometimes necessary to correct the exposure value. The EOS A2E/A2/5 offers several possibilities for influencing the exposure so that the photographer can always achieve the desired photograph.

There are four situations in which exposure compensation would be required. The first one is when the subject or scene is very light, reflecting far more than 18% overall. Two typical examples would be a snow scene and a bride dressed all in white in front of a white wall. Because the camera will look at these scenes and assume a reflectance of 18%, it will provide an exposure designed to render them as 18% on the film, which is to say that they will be far too dark in the photograph. The remedy for this is to add a plus correction. Consider this very carefully. In my teaching of photography classes, this is always one of the most confusing points. When photographing subjects which are brighter than 18% reflectance you must add light to make them record properly, and to many people this sounds backwards. It is simply because the camera is programmed to make everything medium gray, and it does this to a white subject by under-exposing it to make it gray. To make it white again, you must add light, which you do by increasing the exposure. That is the reason for using a plus compensation in this case.

The second situation in which exposure compensation will be necessary is that of a subject in which some parts are very bright and reflect far more light than the important part of the subject. An example of this is a boat on the water, in which the moving water glitters in the sunlight, or a landscape of a brilliant sunset over a mountain range. The bright areas in both of these cases influence the light meter so that the camera renders them too dark, in extreme cases even black wihout any detail in the main subject. Again, this calls for a plus correction to lighten up the main subjects and delineate some detail.

In the upper photo, taken without exposure compensation, the brightness of the sky has caused the entire image to be rendered too dark, losing all detail in the building facade. The lower photo shows the result of applying a + correction to the exposure.

The third situation which calls for exposure compensation is a subject or scene which is overall very dark and does not reflect much light. A good example would be a detail study of the side of a black limousine or a close-up portrait of a very dark African face. The light meter in these cases will produce an exposure value to bring these dark subjects up to a medium gray, and will over-expose them in the process, producing "washed out" photographs. In this case you must use a minus exposure compensation because you want to make these subjects darker by removing some of the light. Again, this may be confusing at first, but some little thought on the matter should make it clear.

A fourth situation is one in which a large part of the subject or scene reflects much less light than the main subject. An example might be a table-top in which some small objects are set out on a black background. The meter reading will respond to the black of the background and over-expose it to make it gray, thus losing all detail in the main subjects, and rendering them far too light. Again, a minus correction is what is needed to set things right.

As long as some detail in the subject or scene has about an 18% gray reflectance, whether it be actually gray or a robust green or blue, a saturated red or brown, the spot meter can be used to make an accurate exposure measurement. You need only one small such area and you can confidently meter the scene. So long as the contrast range of the film is not exceeded, you should produce a perfectly exposed photograph.

If there is no suitable area on your subject, you can take a meter reading from a substitute subject in the same light. You can also use the palm of your hand as a substitute subject. Most caucasians. have a palm which reflects exactly one stop more light than 18%, so you need only compensate by increasing the exposure by one stop. For more precise work, you can purchase a photographer's gray card (sold by Kodak and others) and take your substitute meter readings from it.

Because it is not always convenient to hold the asterisk button on the camera with your thumb for prolonged sequences, it probably makes more sense to switch over to manual exposure control and set the shutter speed and aperture manually based on the spot meter reading. If, instead, you use the spot meter to make a measurement and then revert back to one of the other metering modes, you can remember the spot meter reading and use it to set

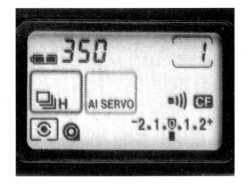

The bar graph at the bottom right of the LCD panel displays exposure compensation, which can be set from +2 to -2 in 1/2 step increments.

an exposure compensation for the balance of the photos of the same subject or scene. In most exposure modes you can use the secondary control wheel on the camera back to set the exposure compensation on the scale on the lower right of the LCD panel. This scale allows you to set up to + or - two full stops of compensation, in 1/2 stop increments. If you require something finer than 1/2 stop increments, you can also use the ISO manual input, by means of the bottom button on the camera back and the main control wheel, as the ISO scale is graduated in increments corresponding to 1/3 stop intervals. Increasing film speed corresponds to a minus correction, decreasing film speed corresponds to a plus correction. Of course, if the + or - two stops of compensation on the exposure compensation scale are not enough, you can revert to the ISO scale for greater compensation, or even combine the two. Whenever the ISO value has been set differently from the DX coded value, the ISO indicator on the LCD panel will continually flash as a reminder that this has been done.

Film Sensitivity

In addition to shutter speed and lens aperture, film sensitivity is, as I have said earlier, the third determining factor in achieving proper exposure. There is no way of knowing, but there must have been many thousands of photos which have been ruined over the years because of incorrect film speeds set on cameras by photographers. With the EOS A2E/A2/5 this possibility is as good as

Winter pictures often require exposure compensation because of the highly reflective nature of snow and ice.

banished. The system is known as DX coding, and this system conveys the correct film speed directly to the camera's light meter when the film cassette is inserted. In a strip on the film cassette is a series of conductive and non-conductive patches made up of bare metal and insulating paint. Inside the camera there is a series of six spring-loaded electrical contacts which press up against this area on the cassette, and by means of a weak electrical current advise the camera of the correct ISO speed of the film, its sensitivity range, and the number of exposures on the film. Not all cameras use all this information, but it is there for the decoding. The DX system is capable of conveying ISO speeds within the range of ISO 25 to ISO 5000. In some special cases, photographers may wish to use films with speeds beyond this range at either extreme, and so the camera is also provided with a manual ISO input. By pressing the bottom button on the camera back until the legend ISO appears on the LCD panel, the photographer may then use

the main control wheel to enter ISO speeds from ISO 6 to ISO 6400 in 1/3 stop increments. Most films are identified by their ISO speed in the film names: e.g. Kodachrome 25, Agfachrome CT 100i, Fuji Super G 200, T-Max 400, Ilford 100 Delta, etc. In those few cases where ISO speed is not part of the film name, it is always on the film box or in the film instructions.

All standard 35mm films can be used in the EOS A2E/A2/5, but there are a few exceptions which should be noted. Because the EOS A2E/A2/5 uses an infrared emitter/detector system to monitor film advance instead of a sprocket wheel as in older cameras, the camera can not be used with infrared films. The infrared light from the film metering system will fog these films. Most photographers never even think of using infrared films, but just in case you get an urge to try some you will have to expose it in a different camera. Because so few photographers use infrared film these days, Canon did not consider this an important disadvantage.

Not long ago I was working on a film test report for a photography magazine and was testing a variety of odd films. One of the films involved in the test was Svema brand black and white film made in the Ukrainian Republic. After exposing the first roll of this film, I heard the camera rewind motor running as usual and assumed that the film had been rewound as usual. Imagine my surprise and displeasure when I popped open the camera back and there sat the film, all on the right side of the camera, and not rewound at all. I had to take the camera into the darkroom and manually remove the film and rewind it into the cassette. Then I discovered the reason for this strange problem. The Svema film is loaded into very nice plastic cassettes with screw-on tops, the type

Pictures Page 87:
If you plan to take pictures of children you had better be fast. For this type of photography the EOS Portrait mode is ideal. On the other hand, it is unlikely that this fellow in the statue will move, so you can take your time photographing him and select exactly the right aperture for the effect you want.

Pictures Page 88:
For small still life images such as these you may wish to use the mirror pre-release as well as a sturdy tripod or other support so that you can use a long exposure and small aperture for great depth of field.

Automatic Exposure Bracketing

Even if you have taken considerable time to determine and set exposure compensation, you could be wrong. Everyone makes mistakes. One possible remedy is to use the automatic exposure bracketing (AEB) of the EOS A2E/A2/5. When this feature is active, the camera will take three photos in succession and vary them both above and below the set exposure. The first exposure is made at the camera settings, while the second is given less exposure and the third more exposure. You activate the AEB mode by pressing the bottom button on the camera back until AEB appears on the LCD panel. You then rotate the main control wheel until the desired deviation is set on the bar graph on the lower right of the LCD panel, in 1/2 stop increments.

If you have the camera set for single exposure, you will have to press the shutter release three times to get the bracketed sequence. More convenient is to set the camera for continuous advance by pressing the top button on the camera back and turning the main control wheel until the icon of the multiple rectangles appears on the LCD panel. When this has been done, the camera will take

Water bubbling from a spring can be stopped and frozen with a very fast shutter speed for unusual pictorial effects.

three photos in rapid succession each time the shutter release button is pressed, bracketing as above in the process.

The manner in which the AEB mode brackets the exposure varies with the exposure mode. In the P mode, both shutter speed and lens aperture are varied. In the Tv mode only the aperture is varied, while in the Av mode only the shutter speed is varied. In the M mode only the shutter speed is varied. In the DEP mode both shutter speed and aperture are varied. And, finally, in the X mode only the aperture is varied. The AEB does not function in the Green Zone or in the pictorial icon modes.

In any mode, used with the AEB, if there are insufficient apertures or shutter speeds to accomplish the bracket, for example if you started the bracket in Tv with the lens wide open, the camera will still complete the bracket sequence of three photos, but the final photo will be exposed identically to the first one.

You may not always want a symmetrical bracket about the camera-determined exposure, and in such cases you can combine the AEB mode with exposure compensation to move the starting point of the sequence toward either plus or minus. You can clearly see what you will be getting in this case by observing the three marker arrows on the bar graph on the LCD panel.

As an example, by setting the exposure compensation to -1 with the secondary control wheel, and then using the AEB mode you can set exposures of -2, -1, and normal. These will be taken in the sequence -1, -2, normal, since the one in the middle is always exposed first, followed by the one to the left and then the one to the right. You can tell which photo in a sequence will be taken next by pressing part way on the shutter release button at which time all but the arrow indicating the next photo will disappear from the LCD panel. After the first photo in a sequence, subsequent exposures will be indicated by flashing arrows as an indication that these are the bracketed exposures. Don't forget to switch off the AEB mode when it is not needed. This is easy to forget, and I once accidentally bracketed a whole roll of film unknowingly.

The shutter of the EOS 5/A2E/A2 is made of very light metal and plastic ⇨
blades, and moves very fast. It provides a maximum shutter speed of
1/8000 second and a very fast 1/200 second flash synch speed.

The Shutter

The EOS A2E/A2/5 camera uses a metal and plastic bladed shutter in which two vertically travelling laminar curtains control exposure duration. They are still called curtains even today, although blades would be a more accurate description, because older shutters used horizontally moving cloth roller blinds in their shutters. So today we have metal curtains.

The shutter is one of the two regulators of exposure on the camera, the other being the iris diaphragm (aperture) in the lens. The shutter controls how long light is allowed to strike the film. The EOS A2E/A2/5 is fitted with an electronically timed shutter, made up of the two laminar blades. Between exposures one set of these blades covers the film aperture and blocks all light from the film. When you press the shutter release button to take a picture several things happen very quickly. First the reflex mirror is released and is driven by springs up out of the way of the light coming from the lens. At the top of its travel it also blocks off any light which might come in through the viewfinder window and reach the film from above. As the mirror moves up to the top of its travel, the electrical stepping motor in the lens closes the diaphragm to the selected aperture value. Once all of this happens, the shutter curtain which was blocking the film flips quickly down and into a slot to fully expose the film to the light coming through the lens. At the end of the exposure time, as

determined by the camera's computer, the second set of shutter blades flips quickly down to cover the film again and end the exposure. At this time the mirror is pulled back into its lower position by a set of gears, the stepper motor re-opens the lens diaphragm fully, and the camera's coreless motors advance the film and re-cock the shutter by raising both sets of shutter curtains into their original position, one covering the film again and the other hidden in the upper slot.

The thin metal and plastic blades of the camera shutter must move very fast to be able to accomplish the fast shutter speeds expected in modern cameras. This means they must have as little mass as possible, so that the drive springs will be reasonable in size, and so that their movement will not shake the camera. To make them light enough, they must be extremely thin. Canon uses a special system they developed to plate metal onto a very thin plastic sheet which produces a laminar composite blade stronger than plastic alone and lighter than metal alone. However, this special material is subject to easy damage from abrasion or crimping and it is very important to keep your fingers away from the camera shutter at all times. Be very careful about this when loading film, as a broken shutter is an expensive thing to have repaired!

Because there are practical limits to how fast such shutters can be made to travel, operation as described above is only totally accurate at speeds of 1/200 second and slower. At all faster speeds the first curtain does not completely open before the second curtain starts to close, which produced a slit between the two curtains which scans across the film from top to bottom. The faster the set speed, the narrower the slit. Thus at 1/8000 second speed, the shutter actually moves no faster than at 1/200 second, but a narrow slit moves across the film during that 1/200 second interval and gives each square millimeter of the film surface an exposure equivalent to 1/8000 second.

Because electronic flash units produce a very short burst of very intense light, they can only be used with such a shutter at the fastest speed at which the shutter fully opens before beginning to close again. That is the reason that the flash synch speed of this camera is 1/200 second, that is the fastest speed at which the entire surface of the film is exposed simultaneously. If you could fire the flash at higher speeds, you would find that only a strip of the film was

exposed, a strip which would be narrower as the shutter speed increased.

In all of the automatic modes except for Tv, the EOS A2E/A2/5 shutter operates steplessly. That means that shutter speeds in between marked values will be produced by the camera to produce very precise exposures. The LCD displays will show the closest full or half shutter speed. For example, even though the LCD indicates 1/200 second, the actual speed chosen by the computer might be 1/178 second. On the M and Tv and X modes, however, the speed will be as close to that set by the photographer as modern design and manufacturing tolerances allow.

The marked shutter speeds follow the same doubling and halving progression as lens apertures and film speeds. Moving from 1/125 to 1/60 (the speeds are somewhat rounded off) will exactly double the amount of like reaching the film, while moving from 1/125 to 1/250 will cut the amount of light in half. Thus it is possible to change the lens aperture to a desired value and then adjust the shutter speed to keep the exposure value constant. Similarly it is possible to pick the shutter speed based on the subject being photographed, whether static or moving, and if moving, whether moving slowly or quickly, and keep the exposure value constant by changing the lens aperture.

To capture something like a balloon exploding without a flash you would need at least 1/8000 second shutter speed (as well as a light beam trigger for the camera). With speeds between 1/8000 and 1/4000 second you can easily stop racing cars and motorcycles, if you are not standing too close to the track. To freeze water droplets in a fountain or waterfall, 1/2000 or even 1/1000 second will suffice. 1/1000 and 1/500 second are useful in taking general photos of cars driving on the street or on race tracks, the closer the car to the photographer the shorter the exposure time required. To freeze the movements of a pedestrian, 1/125 or 1/60 will be plenty, depending on whether he or she is coming toward the camera or passing by the photographer and how far the pedestrian is from the photographer. The same 1/60 second will already begin to show the blur of motion in a rapidly flowing mountain brook. And, of course, if one wants to emphasize the flowing nature of such water even more, slower speeds even so slow as 1/2 second or longer can produce interesting (though over used these days) effects.

It is important to remember that subject movement is not the only movement to be concerned with. Another very important movement is right in your own hands! Just how steady are you, and how still can you hold the camera? Only personal testing will tell. A general rule has always been that you should use a shutter speed that is at least the reciprocal of the focal length of the lens, so for a 250mm lens you would use at least 1/250 second. I have found from personal experience that this is nowhere near right for me, and I would recommend that you do some self testing to determine your own limits. On the wall of my house is a photograph of a young kitten which I took some years ago with a 150mm lens at 1/15 second—hand held! No one has ever accused this kitten of not being sharp. However, as I have gotten older, I have gotten less steady, as most people do. Today I could not take that same photo without at least a monopod, but I can still beat the old reciprocal of focal length rule. Generally, it is a good idea to use the fastest shutter speed possible consistant with the other requirements of the picture.

Also it is important that we not slavishly worship sharpness. Sometimes very effective photos need not be absolutely sharp. Some of the most effective sports and wildlife photos I have ever seen had a considerable amount of blur.

The Lens Diaphragm

The lens diaphragm, in combination with the shutter, determines the quantity of light which reaches the film. Basically, the diaphragm, or iris diaphragm as it is often called, is an opening within the lens of variable size. In the early days of photography lenses were fitted with a slot and the amount of light passing through the lens was controlled by inserting metal plates with various sizes of holes into the slot. These metal plates with holes were called "stops", because they stopped part of the light from passing. Today this terminology still carries on, and you will often hear lens apertures referred to as stops or f-stops (short for focal stops), abbreviated as f/.

In the Canon EOS A2E/A2/5, as in all modern cameras, the diaphragm which controls the amount of light passing through the lens is mounted within each lens. It is made of a series of thin

A small aperture makes the entire castle grounds sharp in this photo.

metal blades which move in eccentric slots to form a more or less round opening of varying size. In all EOS lenses, these diaphragm blades are moved very precisely by stepper motors, a much more precise method than earlier systems using cams or levers to transfer physical movement from a mechanism in the camera body. Canon, in fact, was the first maker of 35mm cameras to use a lens mount which has no mechanical linkages whatsoever, totally eliminating protruding pins and levers on the back of the lens, which often in the past were easily bent or damaged. The Canon EOS lens mount has only a series of electrical contacts.

In addition to controlling the amount of light which can pass through the lens by regulating the diameter of the opening, the diaphragm has another very important function. The size of the lens opening also directly determines the amount of depth of field in an image. Depth of field is simply the portion of the image both in front of and in back of the plane of focus which also appears to be in sharp focus. The amount of depth of field increases as the lens opening is made smaller, and decreases as it is made larger, always with the distribution that 1/3 of it is in front of the plane of focus and 2/3 of it is in back of the plane of focus. Depth of field

exists at and around the subject plane and is not to be confused with depth of focus, which is entirely another phenomenon, and exists at the film plane.

I have already explained earlier in this book about the sequence of f-stops, but it is important enough to repeat here. Although lens apertures are usually written in the form f/2.8, f/4, etc., these numbers are actually part of a ratio. So f/2.8 is more properly written as 1:2.8, where 1 is the focal length of the lens and 2.8 is the relative size of the aperture.

It is important to understand that a lens opening of f/2.0 in a 50mm lens would mean that the diaphragm opening measures 25mm, while f/2.0 in a 100mm lens means that the opening would measure 50mm and so on. Regardless of the physical size of the opening, any lens will pass the same amount of light when set to the same aperture, within limits of physical mechanical and optical tolerances. So if you determine that the proper exposure is, for example, 1/250 second at f/2 with a 50mm lens, that exposure will not change if you switch to a lens of a different focal length. The measurement of the diaphragm opening size is not a physical measurement of the opening, but a measure of the apparent size of the opening presented to the light, and this is measured while looking through the front of the lens with a special measuring instrument. You need not concern yourself with these minute details to make use of your lenses, since the marked apertures provided by Canon are quite accurate.

The reason for the odd-seeming sequence of numbers—1, 1.4, 2, 2.8, 4, 5.6, 8, 11, 16, 22, 32, 45, 64 etc.—is that they are measures of diameter, and the relation of diameter to area produces a geometric progression rather than an arithmatic progression. As you move the lens from f/2 to f/2.8 you are increasing the diameter of the diaphragm opening by a factor of 1.4, but increasing the area of the diaphragm opening by a factor of 2. To determine each succeeding number in the series you multiply the present number by 1.4 (actually 1.42, but everything is rounded off for convenience). To determine each preceeding number you can divide by 1.4. Or, more simply for those who do not relate well to math, every second number in the sequence is halved or doubled.

Moving from any one aperture to the next number in the sequence, e.g. from f/2 to f/2.8 or from f/5.6 to f/8, cuts the amount

of light passing through exactly in half, and going the other way doubles the amount of light passed by the lens. Again, as with film speeds and shutter speeds, we have this concept of exposure control by halving or doubling light. Thus it is possible to keep a constant exposure by halving the shutter speed and doubling the aperture, or vice versa. All exposures in the following sequence will deliver exactly the same amount of light to the film: 1/2 second at f/32, 1/4 second at f/22, 1/8 second at f/16, 1/15 second at f/11, 1/30 second at f/8, 1/60 second at f/5.6, 1/125 second at f/4, 1/250 second at f/2.8, 1/500 second at f/2, 1/1000 second at f/1.4 and 1/2000 second at f/1.0.

Determining the best lens aperture for a particular photo does not totally depend on just matching it arbitrarily with the shutter speed, since, as mentioned above, the lens aperture also determines depth of field. For many photographs, particularly those with lots of subjects at varying distances, you will want to use a relatively small aperture (larger f- number) so that you will have the maximum possible depth of field. For landscapes in which you want foreground detail to be very sharp but also want to maintain sharpness at a distance, you would need to use an aperture of f/11 or smaller. In some cases this will force you to use a relatively long shutter speed, such as 1/30 or even 1/15 second, and you will have to support the camera on a sturdy tripod for a successful photograph.

There are also many occasions in which you will want to narrow the depth of field so that you can throw a distracting background, foreground, or both, out of focus. In such a case you will want to use the largest possible aperture (f/1.4 or even f/1.0) to keep the depth of field as narrow as possible. This will at the same time require you to use a fast shutter speed when the light is bright, and it is very useful in such cases that the EOS A2E/A2/5 offers such a wide range of shutter speeds, all the way up to 1/8000 second. I have taken a number of portrait photographs with the Canon 85mm f/1.2 lens with the lens set for its widest aperture of f/1.2. On very bright days, having these high shutter speeds has proved to be essential. One important tip for such narrow depth portraits, always focus on the subject's eyes. You will find that the overall effect is pleasing if the eyes are sharp, even if the nose and ears begin to be soft. If the eyes are soft, the whole photo is ruined. With the EOS A2E/A2/5 this sort of photograph is very easy to take

by simply placing one of the five autofocus sensors on the subject's eye and letting the camera set the precise focus.

Often when photographing fast action you will be stuck with a fairly wide aperture as a consequence of the fast shutter speed, and you must live with the narrow depth of field this creates. There are several ways to handle this. The most obvious one is to switch to a faster film, which will allow you to stop down some and increase the depth of field, but a less obvious one is to switch to a longer focal length lens and move farther from the subject, as the depth of field at a given aperture increases as the distance to the subject increases, regardless of the focal length of the lens.

In the rare situation in which you want to use the widest possible aperture and at the same time want to maintain a slower shutter speed, special filters called neutral density filters may be fitted to the lens. These are neutral gray filters available in different values which simply reduce the amount of light passing through the lens without having any effect on the depth of field.

Exposure—Manual or Automatic?

As I have said repeatedly in this text, at a given ISO speed of film only two elements determine correct exposure: the shutter speed and the lens aperture. The EOS A2E/A2/5 offers many possibilities, however, for determining these.

Photographic purists will insist that the only proper way to take a photograph is to set both values manually—no real photographer would trust camera automation, they assert. They argue that only in this way can they keep control of the picture. Today this is nonsense. Certainly if they know the lens aperture they want, based on the depth of field they want to have in the photo, there will be only one shutter speed which produces the correct exposure, regardless of whether that shutter speed is determined and set manually or automatically. Similarly, if the experienced photographer selects a specific shutter speed for its action-stopping ability, there will again be only one lens aperture which produces the correct exposure, and it matters not at all if this aperture is determined by manual metering or automatic function of the camera. There is only very rarely a good reason to set both values by hand.

If the photographer has selected a desired shutter speed and

For many photos such as this detail shot of an old church, it is difficult to decide between automatic and manual exposure control. In this case the photographer used automatic.

then turns the aperture control until the light meter pointer comes to the null position, this photographer has done nothing that the camera would not do in the Tv mode. Similarly, if the photographer pre-selects the lens aperture and dials through shutter speeds to null the meter, nothing has been accomplished that the camera could not do, and faster at that. In fact, the use of the automatic modes Tv and Av modes frees the photographer from concentration on metering and allows him or her to pay more attention to the photograph.

If the effect of a photograph does not really depend on a particular depth of field or a particular shutter speed, then there is no reason at all not to use either the P or Green Zone modes for that photograph. Most professional photographers will deny quite hotly that they ever use P modes on their cameras, but I have caught them at work and quietly looked at their cameras and often see the tell-tale P on display! For some reason it is not considered professional to admit that you use the tools of your profession as they were designed to be used. The fact is that many pictures used to be lost in the old days while the photographers frantically

worked to set the shutter speed and lens aperture manually. Often, by the time the camera was set the photo was long gone. I remember those days well, and do not miss them at all.

The P or program mode has done more to aid fast action photography than any other recent addition to the SLR camera. Since introduced in the Canon A-1 and carried through to the Canon T90, all top cameras have been expected to offer one or more program modes. In the P mode, the camera uses a pre-programmed sequence of shutter speed and aperture combinations which change with the light level. In the earlier program modes used in the Canon A-1 and T90 the program could only be made to respond to the light level seen by the camera meter, since there was no transmission of other data to the camera body. When the EOS cameras were introduced, each lens was outfitted with a microchip in which a variety of information is stored. EOS lenses thus communicate with the camera body, informing the body of the focal length of the lens (which changes as zoom lenses are moved from one focal length to another), the maximum aperture of the lens, and the distance at which the lens has been focused. This additional information, most importantly focal length, is used by the camera in determining the proper program. For example, when you mount a telephoto lens on the camera, the program is biased to set faster shutter speeds to compensate for the fact that the photographer can not hold long lenses steady at slower speeds. When a wide angle lens is fitted the program is biased in the other direction. However this does not relieve the photographer of the need to pay attention to the exposure data, and support the lens if the shutter speed drops too low. It is also possible to use what is called program shift to select either a faster shutter speed or a smaller diaphragm opening. This is done by simply turning the main control wheel. Turning it toward the right increases the shutter speed and opens the diaphragm, while maintaining the correct overall exposure, and turning it toward the left selects a smaller aperture and slower shutter speed. This means that you can leave the camera set to P

and still select a small aperture quickly if you encounter an image which requires a large depth of field, and also shift it just as quickly if you encounter a fast moving subject. I will admit to no shame in using the P mode for many of my outdoor photographs, particulary when I am in a hurry and working with a professional model who can change like a chamelion in an instant. Using the P mode allows me to place my full concentration on the composition and lighting of the photograph, and only secondarily on the LCD strip in the viewfinder to confirm that I will get what I want.

In my opinion the second most important operational mode is the Av or aperture value mode. For a very large amount of my photography, the depth of field is the most vitally important single photographic element, and I must have full control of it. Add to this that for many years, after switching to electronically controlled cameras, I used cameras in which this was the only automatic mode available. In other words, I got very used to working in this way, and still gravitate toward it naturally.

Simply put, in the Av mode the photographer picks the lens aperture (f-stop) and the camera picks the correct shutter speed based on the light value and the film speed. To use this mode you simply set the main control dial to the Av position and use the main control wheel to pick the lens aperture you want. In earlier cameras it was usual to have the lens aperture control as a ring at the rear of the lens itself, which in many cases was quite inconvenient to get to when balancing the camera. Canon has moved the control of the lens aperture to the camera body, making it very simple to control the aperture either through the main control wheel or through the secondary control wheel, depending on the

exposure mode. There is an additional advantage to this system which may not be apparent at first. On many zoom lenses the aperture value varies with the focal length, as an example on the Canon EF 28 - 105 mm lens. Note that the maximum aperture of this lens is stated as f/3.5 - 4.5. This means that this lens offers an aperture of f/3.5 at 28 mm and f/4.5 at 105 mm and apertures in between at focal lengths in

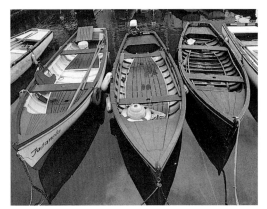

For a subject such as these boats in which depth of field is important, the aperture priority or Av mode allows you to set the diaphragm opening you want and allow the camera to set the shutter speed.

between. On lenses in which the aperture control is on the lens, you never know exactly what f-stop you have set when the lens is in between the two extremes of its focal lengths. When you are photographing with the camera's built in meter, this is of no concern, since the meter automatically compensates for the deviation. But, when you want to use an external meter such as a hand-held incident meter or a flash meter in the studio, you can be in trouble, and wind up with incorrectly exposed photos.

Canon has corrected this problem with a beautifully simple but difficult to design system. On any EOS lens, the lens aperture you set is always the aperture you get. The lens' internal microchip informs the camera body of the focal length you have set, and the camera body corrects the signal it sends to the stepper motor. So if you set f/8, you will get f/8, regardless of the focal length you use. The only time in which the lens aperture varies with focal length is when the lens is used wide open, and if you set the lens wide open and then zoom it through its range of focal lengths while maintaining light pressure on the shutter release button you can watch the maximum aperture change on the LCD panel.

However that is an aside, which has little to do with the Av mode we are discussing. It is just information you should have. The main uses of the Av mode are two extremes, when you want to have as much depth of field as possible and when you want to have the narrowest possible depth of field. I generally use this

mode when I know in advance approximately how much depth of field I want to have in an image. If I know much more precisely how much depth of field I want, I will use instead the DEP mode, which will be described shortly.

The Tv mode, standing for time value mode, is the opposite of the Av mode. In this mode the photographer manually selects the desired shutter speed and the camera picks the correct lens aperture based on the light value and the film speed.

Canon's first automatic exposure camera, the Canon EF, offered this mode of exposure automation which had earlier been developed by Konica in their Autoreflex (Autorex) line. However, the Canon EF was a remarkably innovative camera which offered both mechanical and electronic control of the shutter speeds, and the electronically controlled speeds were far more accurate than previous mechanical systems.

This mode allows the photographer to have movement blur in a photograph or to eliminate it completely as desired. The shutter can be set anywhere between 1/8000 second and 30 seconds in half stop increments, and the camera will pick the matching aperture so long as the range of available apertures on the lens is not exceeded.

For example on a bright summer day with Ektachrome 100X, the camera can not function if set to 1 second, since this light level, corresponding to EV 13 or 14, would require an aperture of f/128, which no SLR camera lens offers. In such a situation the smallest available aperture on the lens in use will flash on the LCD panels as a warning. You will not be prevented by the camera from making the exposure, but your result will be grossly over-exposed.

Conversely it would make no sense to dial in 1/8000 second on a cloudy, rainy spring afternoon. This would be equivalent to an EV of 9 or 10, and would call for a faster lens aperture than any Canon lens can offer. Even f/1.0 would not be fast enough! In this case the largest available lens aperture will flash on the LCD panels, and if you persist and take the photo anyway, under-exposure

will result. The fastest speed you could possibly use in this situation would be 1/250 second, and then only if you use the Canon 50 mm f/1.0 lens!

Short shutter speeds stop movements, regardless of whether it is the subject or the photographer which moves. Therefore short shutter speed are important to avoid subject blur. Closeup and macro photographs fall particularly into this category, as subject and photographer movement are magnified as the distance to the subject is shortened. For macro photography a tripod or some sort of special macro support is essential to solve this problem, unless you resort to flash. Tripods and supports are also essential for long telephoto lenses which also tend to magnify the effects of camera motion. The shortest possible shutter speeds will be a great help in these situations to help minimize adverse effects of camera and subject motion.

Sometimes the shortest possible speed is just not right for the effect however. The effect produced depends on subject movement. For example, at a dogtrack you may photograph a greyhound at 1/250 second or faster if you want to freeze the dog's motion, but you may prefer a more fluid, impressionistic mood, and in this case even 1/4 second may not be too long. Naturally, a substantial tripod is essential for such photography, because it is the subject's motion you are wanting to emphasize, not the movement of the photographer.

The Tv mode is also the most appropriate one to use with fast motor drive operation, and remember that the EOS A2E/A2/5 is capable of a full five frames per second speed. Of course you can only achieve such fast drive speeds at fast shutter speeds, in this case 1/125 second or faster.

Manual Metering

As with all modern high tech cameras, despite the extensive automation offered by the EOS A2E/A2/5, the camera also offers fully manual exposure metering. Is this anything more than a throwback, a return to those thrilling days of yesteryear when photographers were photographers, and set things for themselves?

If you turn the main control dial to the M position you have activated the manual metering mode. That is to say that you are

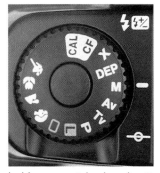

now responsible for setting both the shutter speed and the lens aperture. In the M mode, the main control wheel controls the shutter speed while the secondary control wheel becomes the aperture control. This gives you a true one-handed control of the camera with shutter speed under the control of your right forefinger, while aperture is controlled by your right thumb. Both shutter speed and aperture values are displayed on the LCD strip inside the viewfinder as well as on the LCD on the camera top.

On the right side of the viewfinder LCD strip is a bar graph with an arrow pointer beneath it. This same bar graph with arrow is also displayed on the lower right of the outer LCD panel. It is important to pause here for a moment and help out the North American owner of these cameras. For reasons of licensing problems, the EOS A2E and A2 do not have this bar graph either inside the viewfinder or on the upper LCD panel. Instead they use a simple -/+ display. Othewise the operation of the cameras is identical. On the EOS 5 you move the arrow pointer on the bar graph scale by changing either the shutter speed or lens aperture, or both, until the arrow pointer comes to the central null position. That indicates correct exposure. On the EOS A2E and A2, you similarly change shutter speed or aperture, or both, until both the - and + are displayed. Both systems are equally accurate, but the EOS 5 does let you see within two stops just how far off you are from correct exposure, while the EOS A2E and A2 only let you know that you are off in a plus or minus direction.

At any rate, through this process you have arrived at the same exposure which the camera would have arrived at automatically, and again the camera would have done it so much more quickly. Also, when the camera is set for manual exposure it is a real nuisance when the light suddenly changes and you have to manually correct, and then the light changes again, and again.... It is my opinion that manually determined exposure makes the most sense for pictures which are taken in a leisurely manner, contempletive landscapes and the like, where you can take a number of spot

meter readings and mentally calculate the desired exposure. Devotees of the Zone System will insist that the only way to take a photograph is in this manner, with each element of the image metered separately and placed on the appropriate zone. Since proper use of the Zone System really requires that each negative be developed separately, I generally consider it unsuitable for 35 mm photography.

At the slowest shutter speed available on the M mode, the LCD panel will display the word BULB. This goes back to the early days of photography when the photographer would trip the camera shutter by squeezing a rubber bulb at the end of a long hose. Because the shutter remained open as long as the bulb was squeezed, the word bulb has become a synonym for very long exposure. When the EOS A2E/A2/5 is set to this BULB indication the shutter will remain open as long as pressure is maintained on the shutter release button. Since the camera will automatically time exposures as long as 30 seconds, you should find that you seldom require the use of the BULB setting.

In determining proper exposure for very long time exposures it is important to read the data sheet for the film you are using. Due to something called the Schwartzschild effect, or more commonly referred to in English as reciprocity effect or reciprocity failure, beyond a certain point doubling of the exposure duration will cease to produce double the effect on the film. With some films this limit is reached as soon as one second, with others not until 30 seconds or longer, but in any case once you have passed this limit, film exposure is no longer linear and you will have to apply the correction factors in the film data sheet to produce a correctly exposed photo. Exposures which take into account the reciprocity effect will always be longer than the direct determination from a light meter. In addition to the change in sensitivity which occurs at very long exposures and affects all films, color films also tend to show color shifts because the different emulsion layers change in sensitivity at different rates. Therefore the film data sheet may recommend the use of specific CC (color correction) filters in addition to the change in exposure.

With a super-wide angle lens parallel lines will appear to converge when **you view the subject at an oblique angle. A telephoto lens from the same position will show a much less pronounced convergence of lines.**

Particular uses for the BULB setting are a variety of night photographs. City scapes illuminated by the natural city lights can be spectacular. Night time photos of roadways in which the lights of the automobiles make colored streaks are quite common, as are night time photos of fireworks. For such photos you will have to use a tripod and will have to determine the best exposure by the use of a separate hand-held light meter or from exposure suggestions packaged with the film or from books and photo magazine articles. I have found color negative and black and white films more satisfactory for these experimental subjects because they are less sensitive to precise exposure, and with color negative films corrections can be made for odd color shifts during the printing process.

Automatic Depth of Field Control

With the introduction of Automatic Depth of Field Control, Canon came out with a variant of automatic control not offered by any other manufacturer, and this is not just a gimmick but a very useful form of automation.

While it is possible to look through the eyepiece of the EOS A2E/A2/5 and visually preview the depth of field either with the eye controlled lens stopdown or with manual control of stopdown through Custom Function #11, many photographers find it very difficult to distinguish the actual depth of field on the darkened viewing screen. Experienced photographers know how to do this while adjusting the aperture until precisely the depth of field they require is in focus. But it is not such an easy knack to learn for some people, and many never do quite make it work for them.

The idea of depth of field is somewhat complex to understand from a technical point of view. Simply put, the lens can only focus at one plane, and at only that one plane is everything actually sharply in focus. Subjects before and behind that plane are always just a bit out of focus, and become more so the greater their distance from the plane of focus. At the plane of focus, points in the subject will be rendered as points on the film plane. At

◁ **For detail shots such as these, in which a small part of the overall scene is isolated to form the picture, a short telephoeo lens is ideal.**

distance shorter or greater than the plane of focus, points in the subject are rendered as fuzzy circles on the film plane. These are known as circles of least confusion, often simply called circles of confusion, although that is an incorrect term. When these circles are very small, caused by subjects closer to the plane of focus, we do not see them as circles in the final image but as points, and so the parts of the subject they make up will appear sharp. As the distance from the plane of focus increases, the size of these circles increases likewise, until a point is reached at which the eye begins to distinguish them as fuzzy circles instead of points. The distances at which this change takes place are the front and rear limits of the depth of field. As the diaphragm opening is made smaller, the size of the circles of least confusion becomes smaller in proportion, since these circles are micro mirrors of the diaphragm shape (in fact, if the diaphragm is not round, these "circles" will not be round either, but will have whatever form the diaphragm opening has.)

Since a smaller diaphragm produces smaller circles, the planes at which the circles become too large is moved farther from the plane of focus, both in front of and behind the plane of focus. This increases the area of relative sharpness, which increases the depth of field that we see. Depth of field is not an absolute, it is also based on image enlargement. The depth of field scales on 35 mm lenses and the published depth of field tables for 35 mm lenses assume a specific final print size. This is because the circles of least confusion are enlarged as the size of the image is enlarged, and this had the effect of making the depth of field appear shallower. If your final prints will be 8 x 12 inches or smaller, the published depth of field tables will be perfectly adequate, but if you habitually make 16 x 20 inch prints and larger, you will need to use your own modified values, using a smaller f-stop than the tables indicate.

At any rate, for general photography the automated depth of field mode on the EOS cameras is perfectly adequate. To operate this mode simply turn the main control dial to the DEP position.

 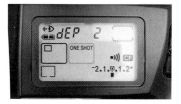

The indications dEP1 and dEP2 shown on the LCD panel let you know that you have successfully locked in the two limits of the depth of field you want in the photo.

Once you have done this, place the central autofocus sensor onto a part of your subject or scene which is at the closest distance you wish to have in sharp focus and press the shutter release button once. DEP-1 will appear in the LCD strip in the viewfinder and on the LCD panel on top of the camera. Then move the central autofocus sensor to a part of your subject or scene which is at the greatest distance you wish to have in sharp focus and press the shutter release again. DEP-2 will now be displayed and you are ready to take the photograph. Compose the image exactly as you want it, and press the shutter release button once more. At this time the LCD displays will show you the shutter speed and aperture selected, and the lens will automatically focus at the correct distance to provide the desired depth of field. You may then press the shutter release all the way down to take the photo. Sometimes, however, you will see that the only way to get the depth of field you want is with a shutter speed which is far too slow to hand hold. You will then have to either put a support under the camera or settle for less depth of field. If you want to cancel a depth of field calculation without taking a photo, you can either wait six seconds and it will self-cancel or you can turn the main control dial from the DEP setting to any other setting and then back again.

The obvious use of the DEP mode is to obtain great depth of field when desired, for landscapes and such, but a much less obvious use is to narrowly limit the depth of field. I have often used this in portraits to set a depth which just extends from the tip of the model's nose to her ears. This narrow limit depth of field only works with lenses with relatively large maximum apertures of f/2.8 and larger. It does not work with f/3.5 and f/4.5 zoom

This photo was taken with the DEP mode by setting the close limit of the depth of field at the bottom of the sign and the distant limit at the top of the sign, thus insuring that the whole sign is in sharp focus in the photo.

lenses because the depth of field is too great even when the lens is used wide open. Unfortunately, the DEP mode can not be used with flash.

Other Automatic Modes

Besides the Green Zone fully automatic mode, the EOS A2E/A2/5 also offers four additional specialty automatic modes. These are all counter-clockwise on the main control dial from the L position, and are identified by pictorial icons.

These specialty modes are particularly suitable for beginners since they remove the necessity of thinking about and setting several different controls to match a particular situation. They are also a great help to the advanced photographer who need a particular combination of control settings in a hurry. It takes but an instant to turn the dial to one of these modes.

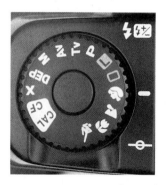

In the Green Zone mode, everything is taken care of automatically. Exposure is calculated and both shutter speed and aperture set automatically with no manual bias or shift override possible. In the Green Zone the autofocus switches from One Shot to AI Servo automatically if subject motion is detected. Eye control of the autofocus sensor selection is turned off, as is manual selection of the sensor. You must rely on the camera to perform this selection. The film advance is set to the single picture mode. The built-in flash on the EOS 5 (but not on EOS A2E or A2) automatically self-erects if the camera senses insufficient light for good exposure.

Portrait Automatic Mode
The next position on the main control dial is marked with a small drawing of a woman's head. This is the portrait mode, and has been set to favor large apertures for limited depth of field. This mode will try to use a lens aperture of f/2 if available on the lens, and will alter the shutter speed accordingly. If the camera reaches

The Green Zone allows even the non-photographer to take good photos. Combined with a zoom lens, the program will set an appropriate shutter speed to prevent camera shake at each focal length.

1/8000 second in bright light it will then begin to stop the lens down to avoid over-exposure. If the shutter speeds become too slow, the EOS 5 (but not the EOS A2E or A2) will automatically erect the built-in flash. However it will still try to maintain a wide aperture if possible to keep the depth of field shallow. Really this mode is only suitable for use with fast lenses, and I prefer to use it with the 85 mm f/1.8 which is my favorite portrait lens (being so much smaller, lighter and less expensive than the big 85 mm f/1.2). I recommend that if you have to use flash with this mode that you make sure that the anti red-eye light is switched on. The bottom button on the camera back, in connection with the main control wheel is used to set this. When it is turned on a small drawing of an eye will appear on the far right of the LCD panel at all times.

In the portrait mode the eye controlled focus is not deactivated, but since most portraits are taken in the vertical format, it is not very useful. Unfortunately, the manual autofocus sensor selector is disabled, and the camera does not invariably pick the sensor I would have chosen. In addition to portraits, this mode is useful whenever the photographer wants the narrowest possible depth of field.

Portrait of a stone lady. This photograph was taken with the portrait automatic mode to provide the best combination of shutter speed and aperture.

Because you may wish to use this mode for such things as fashion photography with moving models, the motor is set for continuous low speed film advance.

Landscape Automatic Mode

The next mode past portrait is the landscape mode, indicated by a small drawing of a mountain range and cloud. In contrast to the portrait automatic mode, in this mode depth of field is made as large as possible, the assumption being that a landscape photographer wants the entire image as sharp as possible. The focal length of the lens is included in the computation of exposure in this mode. This mode is particularly useful with medium to ultra-wide angle lenses which will provide the great depth of field required. The camera's built-in flash is disabled in this mode, so if you want to use fill flash on the foreground you will have to use a different mode. Most of the time flash is of minimal use in landscape photography, so that is the reason this design decision was made.

The motor drive is set for single frame advance since no one is likely to need high speed motor photos of landscapes. Autofocus

is likewise set to one shot, which fits well with landscape photography.

Closeup Automatic Mode

The next mode is a special closeup mode, indicated by a tulip icon. How do you know just what constitutes a closeup? If you think in terms of image size compared to subject size, it would begin at around 1:10 (subject ten times the size of its image on the film. Or, something which extends from top edge to bottom edge of film frame, a distance of one inch, would be ten inches tall in reality.). The other limit is not so well defined and might even extend down to something like 10:1, or a 10X magnification of the subject on the film. Most readers of this book are unlikely to have to worry much about going beyond 1:1, the limits of readily available macro lenses. In this mode the camera attempts to keep a moderate depth of field, since depth of field decreases as the film to subject distance decreases. The built-in flash of the EOS 5 is automatically self-erected when needed in this mode (but not in the EOS A2E or A2). If the red-eye reduction light is turned on it is automatically switched off when this mode is used. The autofocus is automatically switched to one shot, eye controlled or camera selected autofocus frame selection is active, and the drive motor is set for single frame film advance. In most cases this mode will be used on a tripod or some other sort of support. I have experimented with this mode with the Canon 105 mm f/2.8 Macro lens and have been very pleased with the results.

Action Automatic Mode

This mode is obviously for sports or other fast action types of subjects, and the icon emblem is a sprinter. This mode is set to favor shorter shutter speeds for action stopping, even at the expense of depth of field. It is not the intent of this mode to produce shallow depth of field, that is just a side effect of the emphasis on fast shutter speeds. The autofocus is automatically set to AI Servo, which limits the motor speed to three frames per second but still allows the camera to follow focus on action. The eye controlled autofocus is active, or the automatic autofocus sensor selection can be used at the photographer's discretion. The built-in flash is shut off.

Short shutter speeds and open apertures are the order of the day when photographing action, and the sports action mode is perfect for this sort of photography.

Custom Functions

No matter how well designed a camera may be, experienced photographers always complain that there are things they would change. One of the real revolutions in the Canon EOS cameras is the offering of custom functions, features of the camera which the photographer can change to meet his or her needs without the need for any external gadgets. On the EOS A2E/A2/5 there are sixteen custom functions which will enable you to customize the

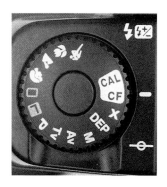

camera to exactly suit your needs on a number of points. To access the custom functions, turn the main control dial to the CF position. You will then see a C on the main LCD panel followed by a number and followed more toward the right by either a 1 or a 0. In every case the 1 indicates that the custom function is engaged while the 0 indicates that it is not. You use the main control wheel to

change the custom function numbers, and use the asterisk-CF button on the upper right back of the camera to switch from 1 to 0 or vice versa.

If yours is a brand new camera, the first time you turn the main control dial to CF you will see C 01 0 on the LCD display. This indicates that you are at custom function number one and that it is currently switched off. If you press the asterisk-CF button, you will see the 0 change to a 1 and back again if you press it again. The following is a list of the custom functions of the Canon EOS A2E/A2/5 cameras along with some personal comments based on using them:

CF 01— Changes the speed of film rewind. The EOS A2E/A2/5 automatically rewinds the film at the end of the roll. The normal rewind is a "soft" or quiet rewind, to cut down on camera noise. If you turn on CF 01 the film rewind speed will be doubled, and the film rewind will be louder. When I first began using the EOS A2E, I found that I could not hear the film rewind. This may not sound like much of a problem, but in the studio with background music playing, I count on hearing the rewind to let me know that I have reached the end of a roll of film. With the EOS 5 I would suddenly find myself pressing the shutter release and nothing happening! Also, professional models learn the sounds of cameras, and know from the whir-whir of rewind that they can relax for a moment while the photographer reloads or changes cameras. The models could not hear the rewind on the EOS A2E either—it was simply too quiet. Switching on CF 01 solved the problem. The EOS A2E is still very quiet, even in this setting, but at least now I can hear it and my studio models can hear it also.

CF 02— Leaves the film tongue protruding from the cassette after rewind. Very useful when shooting Polaroid instant process 35 mm film, since it saves having to fish around in the cassette mouth for the end of the film. Convenient also if you do your own film processing, since you can just pull the film out and don't have to open the cassette. Also useful if you have exposed only part of a roll of film and wish to use the balance later. Just remember if you do this to be very careful about dirt and grit, which can scratch film and ruin photos. If you do plan to re-use a partially exposed film, I recommend using a special pen, available from photo dealers, with which you can mark the film tongue to remind you how many photos have been taken. Then, when you reload the

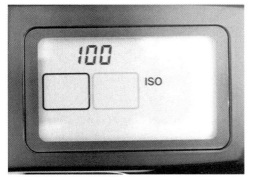

The LCD panel indicates an ISO 100 film has been loaded. This information is read from the DX code on the film cassette. If you manually change this to a different speed, the ISO indication will flash as a reminder ...

... In this case the camera is actually loaded with ISO 50 speed film, and the photographer has manually changed the ISO setting to produce darker transparencies.

film, set the camera to M and turn off the AF switch on the lens so that the camera will fire. Then reload the film and with the lens cap on or in a very dark place advance the camera the number of frame noted and then one extra, since the film does not always start in exactly the same place. You may also want to warn your processing lab of possible irregular frame spaces, so that they will not put your film onto an automatic cutter and cut one of your photos in half! That can easily happen with high-speed automatic film cutter; I know from bitter experience.

CF 03— Shuts off DX code sensor system. Useful if you load your own bulk film or habitually use non-DX-coded film. Also useful if you normally use your own EI instead of the manufacturer's ISO speed. Just remember that if you engage this custom function you must not forget to set the film speed each time you change to a different film speed.

By means of Custom Functions 04 and 06 aspects of autofocus operation are controlled with the CF button.

CF 04— Switches autofocus start to the asterisk-CF button. This is merely a personal preference of some photographers. You may wish to try it and see if you like it.

CF 05— Changes single frame exposure so that pressure must be fully relaxed on the shutter release button before another photo can be taken. This insures a fresh meter reading for each exposure. This is useful in rapidly changing light to prevent accidentally missed photos.

CF 06— Changes function of the asterisk-CF button to stop autofocus in the AI Servo autofocus mode. Again something which may be a personal preference of some photographers. It has never appealed to me but may be just right for you. Give it a try and see if you like it.

CF 07— Shuts off autofocus auxiliary light. Particularly when photographing wildlife or in intelligence work you would not want this bright red beam suddenly shooting out at your subject.

CF 08— Allow sequences of multiple exposures without having to reset the multiple exposure control after each sequence. This one should be self explanatory.

CF 09— Locks shutter speed at 1/200 second whenever built-in or dedicated flash is used. Prevents slow speeds which can create ghost images. Useful in dim light when you want the flash exposure to predominate with little influence from ambient light.

CF 10— Shuts off red illuminited autofocus sensor indicators inside viewfinder. These may be disturbing to some photographers, or under certain circumstances. Personally, I would not want to turn them off because I would not know where the camera was focusing.

CF 11— Adds lens stopdown to asterisk-CF button for depth of field preview. Another photographer's personal preference.

CF 12— Mirror pre-release. When the shutter release button is pressed in the self timer mode, the mirror flips up immediately and the shutter is fired two seconds later to allow for vibration

damping. Particularly useful when using very long telephoto lenses or for very precise macro work where mirror vibration may cause some degradation of the image.

CF 13— Shuts off meter curcuit display timer. Allows LCD readout only when shutter release button is partially depressed to conserve battery power. I always use this, and it seems to give me more battery life with no inconvenience.

CF 14— Changes built-in flash from standard to second curtain synch for creative special effects with flash. In normal flash operation, the flash is fired the instant the shutter is fully open, regardless of shutter speed. When set this way the flash is instead fired just before the shutter closes at the end of the exposure. Allows you to mix ambient light streaking with a sharply rendered flash exposure and have the streaks seem to trail from the subject. In normal flash synch the trails will seem to preceed the subject.

CF 15— Links spot metering to the manually selected autofocus sensor area. Allow spot meter readings to be taken from the area of any of the five autofocus sensors. Operates only when sensor is manually selected.

CF 16— Cancels automatic flash reduction in backlighted situations. Prevents underexposure of main subject when strongly backlighted, as by bright sun.

Only **CF 01**, **CF 02** and **CF 03** remain active in all camera modes, the others are de-activated in both the Green Zone and in the pictorial icon modes. You may wish to make up a small card listing the custom functions and what they do to carry with you at all times, since it is very difficult to memorize this sort of thing and call it back later when you need it. This has happened to me so often that I made a photocopy of the two pages from the instruction manual listing the custom functions, and put it into my camera bag. That way I always have a quick reference to look at if I become confused. Not exactly a custom function, but the focus confirmation beeper on the EOS 5 (not present on EOS A2E or A2) can be switched off with the bottom button on the camera back and the main control wheel. However, in the Green Zone and pictorial modes which use one shot autofocus it can not be shut off. The beeper also produces a continuous beeping to warn of camera shake in low light in the Green Zone and pictorial modes.

The Built-in Flash

For many people the built-in flash only means that they can take pictures even when the sun it not out. However, this is only a scratch on the surface of what the knowledgeable photographer can accomplish with the built-in flash.

It is nice to always have a small flash nearby, and with the EOS 5 and with the North American A2E and A2 models you need reach no farther than the camera itself. The difference between the EOS 5 and the North American models is simply that the EOS 5 offers what Canon calls "flash on demand" in some modes, in which the flash automatically pops itself up and turns itself on when the camera senses that there is insufficient light. On the North American models the photographer must press a small button to the left of the built-in flash head to cause it to come up into firing position. The flash is built into the top of the viewfinder hump and its presence is betrayed only by a small line where it unfolds. The flash is very sophisticated for a built-in unit, with a zoom flash head and its own red-eye reduction light as well. This little flash is surprisingly powerful, with a guide number at ISO 100 of 43 in feet (13 in meters) at the 28 mm position and 56 in feet (17 in meters) at the 80 mm position. With this much power,

The built-in flash of the EOS 5/A2E/A2 pops up automatically in certain modes on the EOS 5, and may be manually erected by pressing the small button to its right. This is a zoom flash which changes its angle of coverage to match that of the lens in use. On the right side of the flash, you can see the small redeye reduction light which shoots out a beam of light before the picture is taken.

this little flash can provide the main exposure light up to about 15 feet with ISO 100 film, or about 35 feet with ISO 400 film.

Since the zoom flash head adjusts automatically to cover the angle of view of the lens, you will always have the maximum light output possible for each lens you use. It is not recommended to use lenses wider than 28mm with this little flash because the light will not reach the corners of the image, leaving dark corners in your photos. At the other extreme, you can use lenses longer than 80 mm with no problem so long as your subject is not so far away as to exceed the range of the flash. However, it is important to realize that certain Canon lenses with extremely large diameters will interfere with the light from the flash and throw shadows on your subject. Large diameter lenses such as the EF 20 - 35mm f/2.8 L , EF 28 - 80mm f/2.8 - 4 L, and super telephoto lenses such as the EF 300mm f/2.8 L and EF 600mm f/4 L will block some of the light as will the lens hoods for many lenses. Always remove the lens hood before using the built-in flash to prevent this problem.

Small subjects in a dark place, the perfect place for using the small built-in flash.

As with most modern camera/flash systems, the built-in flash on the EOS A2E/A2/5 cameras uses TTL OTF flash control. These letters refer to through the lens (TTL) and off the film (OTF). The way this works is that during the exposure light from the flash strikes the surface of the film and some is reflected to a sensor inside the camera which points back toward the film. This sensor measures the reflected flash light and shuts off the flash tube when sufficient light has reached the film. Just as with light meters for responding to ambient light, this flash sensing system is programmed to assume an 18% reflectance of the subject and an average reflectance of the film surface. Just as with the normal meter, a very light or very dark subject can cause the flash to produce incorrect exposure. To deal with this possibility the flash is equipped with an exposure bias control. This is operated by pressing the button to the left of the flash after the flash is erected. At this point a bar graph and pointer will appear on the LCD display, and you can use the main control wheel to move the pointer on the graph in 1/2 stop increments as much as + or - two stops.

In addition to its usefulness as a main light source, the built-in flash is particularly useful for outdoor fill flash. This is all I ever use it for. In bright direct sun you may think it strange that I almost always use a flash, but this is really when it is most needed. The flash throws light into the shadows and reduces the contrast of the subject so that the photos are not too contrasty. This is especially important and useful with slide films which are contrasty by nature and can handle a relatively limited subject contrast. My rule here is to expose for the highlights and use the fill flash to fill in the shadows. Generally, I find that setting the built-in flash for -1/2 to -1 stop gives me the effect I want in which contrast is cut but the use of flash is not obvious. The anti red-eye light is not generally needed in outdoor fill flash photography.

If you become serious about the use of flash from your experience with the built-in flash, then I would suggest that you consider purchasing one of the Canon accessory flash units for your camera. You can not use the built-in flash and one of the Canon flash guns at the same time, putting a dedicated flash into the hotshoe disables the built-in flash. My own personal favorite for general use is the Canon 430 EZ flash, a fully capable unit which has proved to be both entirely reliable and quite rugged in my travels.

Multiple Exposures

A sunset over a mountain range which lies in the north, multiple full moons over a landscape, the same person lighting his own cigarette, and other such trick effects are simply the result of double or multiple exposures. In the earlier days of photography most multiple exposures were unwanted accidents, and camera designers were asked to incorporate double exposure prevention mechanisms on their cameras to prevent this accident. Other photographers, however, saw unique possiblities in multiple ex-posures and often worked out creative ways to bypass the double exposure prevention mechanisms. So camera designers were then asked to devise cameras which normally prevented double exposures but would allow them on demand. Today most top cameras offer a way to make multiple exposures, and the EOS A2E/A2/5 is no exception.

Making multiple exposures with the EOS A2E/A2/5 is quite simple. You press the bottom button on the camera back until the multiple exposure emblem appears on the LCD panel. This looks like two rectangles on top of one another, one black and one white. At the same time that this appears a number 1 will appear in the upper right of the LCD panel. This is the normal setting and indicates only one exposure will be made for each film frame. If you now turn the camera's main control wheel, you can advance this number up to nine, setting from two to nine exposures to be made on a single frame of film. Once you have done this and let the camera revert back to its operating mode, the double rectangle symbol for multiple exposure will remain on display on the LCD panel as a reminder that the double exposure mode is engaged.

Remember that unless the subject you are using for your multiple exposure sequence is on an absolutely black background and does not overlap significantly in the exposures, you will have to compensate for the added exposure. For example,if you want to double expose a sky onto a landscape, you will generally need to underexpose both by one stop to provide a normal looking exposure in the final product. If you are adding together four photographs, you would have to underexpose each by about two stops. I have found it best to use black and white or color negative films for multiple exposure photos, since they are less critical in their overall exposure. There may be situations in which you will

want to make more than 9 exposures in a sequence, as I have often done when combining elements against a black background, and this is quite easily done by setting the camera for nine exposures, and then taking only eight photos. At this point the lower button on the camera back may be pressed again and the control dial used to increase the number again to as many as nine. In principle, any number of photos can be taken on one frame in this manner. Once you have set the camera for a number of exposures on a frame, that number remains displayed on the LCD panel until you take the first one, and then counts down as you make the exposures. If you have set for nine and take three and decide to take no more, you can again simply press the button and dial the number back to one, at which time you will need to cover the lens (and switch to manual focus) to fire the camera and advance it to the next free frame.

If you plan to make several different photos with multiple exposure, you will have to reset the multiple exposure mode after each sequence of exposures as it automatically cancels when the counter comes back to one. You can change lenses on the EOS A2E/A2/5 in the middle of a sequence without cancelling the sequence.

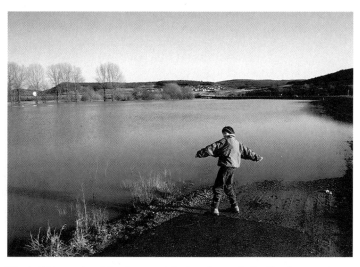

The built-in motor drive is convenient and very fast, allowing you to ...

Photographers often want to use multiple exposure to add a moon to an image. For this to have the most effect the moon must be exposed into a part of the image which is black on other images in the sequence. This will make it stand out sharply. How do you determine proper exposure for the moon? Very simple, just remember that it is always a bright sunny day on the moon! Therefore the base exposure for a bright sunny day on earth will suffice, and that is f/16 with the shutter speed the same as the ISO speed of the film, or for example with ISO 100 film, the exposure would be 1/125 second at f/16. The moon's albedo (the term for reflectance of a celestial opject) is a little higher than 18%, but we want it brighter than medium gray in the photo anyway, so this basic daylight exposure is correct.

For a photo of the same person twice against a normal background you can not simply have the person pose on the left and then take a second exposure with him standing on the right. If you do, the background will show through him and he will become a ghost. If that is the effect you want, fine, but usually you want something less spectral and more normal looking. To make this work you must mask off the right side of the frame while he is on he left and mask off the left side when he is on the right.

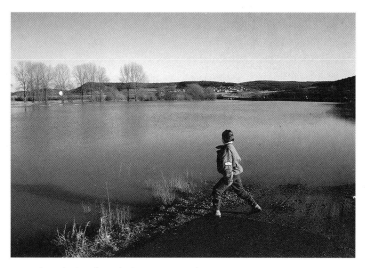

... capture fast action photos.

You can use black paper to do this, if you like, but ready made masking sets are available from Cokin and several other suppliers for making a professional job of it. When you mask part of the frame like this, you do not need to compensate exposure because your images are not overlapping. There is much to learn about multiple exposure and, indeed, whole books exist on the subject.

The Film Advance Motor

It used to be that film advance motor drives were only for the professional photographers. They were large, complicated to use, very expensive and required large numbers of heavy batteries for power. The first company to offer a small, low cost, add-on motor winder for their camera was Topcon, with their winder for the Super-D camera. Later other companies began to introduce motors for their non-professional cameras, such as the motor winder Canon introduced for the AE-1. These external motors quickly became a badge of prestige among amateur photographers, in many cases becoming little more than film eating machines.

The idea that the motor should be integrated into the camera body and not a separate component was pioneered by Rollei and Konica, who introduced the first cameras with motorized film advance as an integral part of the camera. Canon first introduced integrated motorized camera bodies with their T series and carried this on into the EOS cameras.

Today, motor integrated cameras are the norm. Canon EOS cameras have two motors in the camera body, one of which is inside the film takeup drum and advances the film, and the other of which cocks the mirror and shutter mechanisms when turning in one direction, and rewinds the film by reversing direction. There are also two motors in each lens, one which focuses the lens and one which operates the diaphragm. Thus, every time

These work tools were found in a flea market and photographed with a ⇨ **"portrait lens", a medium telephoto. The fruit was arranged in the bowl and photographed with a wide angle lens.**

you take a photo with your EOS A2E/A2/5 you are operating four separate electric motors. The two motors used in the camera body are coreless motors which are very efficient and produce little noise. To reduce noise even more, special rubber-like mounting blocks have been used to isolate the vibration of the shutter and mirror chamber from the rest of the camera, and the usually great number of small gears have largely been replaced with belts. Canon first used these belts in the EOS 100/Elan camera, and many people were concerned that their camera was operating on "rubber bands", which they thought would not stand up to much use.

Actually, these belts have no resemblence to rubber bands. They are aramid-fiber-reinforced neoprene toothed belts, and are an exact miniature version of the same type of belts used in modern automobile engines as timing belts. If they will withstand the rigors of automotive use, they will certainly hold up well in cameras. Canon sent me one of these belts some time back, and I have handed it around to many visitors to my office and asked them to try to stretch or break it by pulling it with their hands. After many such encounters the belt is just like when I first received it, not stretched and certainly not broken.

These belts have been used to replace most of the conventional gears in Canon's newest cameras because they make possible the unique new "Whisper Drive," which is absolutely the quietest operation of any SLR camera.

Another innovation is to be seen inside the camera back. On the righthand side, there is no take-up toothed sprocket mechanism as on older cameras. This sprocket used to always be necessary to measure the amount of film advanced to keep the frames correctly spaced. Now there is only a little rectangular block with two square "windows". Behind these "windows" is an infrared emitter and detector. What this does is bounce an infrared beam off the film and actually count the sprocket holes in the edge of the film as they pass, triggering the advance spool to stop moving

⟵ **These two church towers were made to look much closer together than they are in reality by using a long telephoto lens. By photographing them from a high location, converging lines have been avoided.**

when the proper count has been registered. This simple mechanism is extremely accurate, all of my film from the EOS 5 and EOS A2 has had absolutely regular frame spacing. Unfortunately, this high technology comes at a small price. Because this system works by bouncing infrared beams off the film, it will fog infrared film, and infrared film simply can not be used in the EOS A2E/A2/5 camera.

The low friction produced by the lack of sprocket wheels and rows of gears has allowed Canon to achieve a speed of five frames per second with the EOS A2E/A2/5 drive system. This is a bit faster than the AI Servo autofocus can handle, however, so when you combine the high speed drive setting with AI Servo autofocus you are cut back to three frames per second. In practice I have found that three frames per seconds is fast enough for most moving subjects, but if it isn't for a particular subject you are probably best off to focus manually.

The drive mode indicators on the LCD panel are first an individual rectangle, then three rectangles, then those same three rectangles followed by an H. In the first setting, single frame advance, the film is automatically advanced after each photo but only one photo is taken even if pressure is maintained on the shutter release button. In the second setting, continuous low speed, the camera will take photos and advance the film rapidly so long as the shutter release is held down. Maximum speed is determined by the shutter speed, but will not exceed three frames per second. In the third setting, everything is exactly like the second setting, except that the camera will run at its top speed, up to five frames per second. If this setting is engaged and the camera is switched to AI Servo autofocus, the camera automatically reverts to the slower advance speed.

It is also possible to change the speed of the film rewind motor in two speeds by means of Custom Function #1. The normal setting is best when quietest operation is required, and the second setting is best where rewind speed matters or when noise is not a consideration (or is actually preferred! See comments in Custom Function section).

Lenses

The Canon EF Lenses

Although still technically not discontinued, the era of the Canon FD lenses ended with the introduction of the first EOS 650 in 1987. There were things that the Canon lens designers wanted to do which simply could not be done within the constraints imposed by the FD mount, primarily due to the relatively narrow diameter of the FD mount itself. Certain high speed lenses would require rear glass elements which were too large in diameter to fit into FD mounts. Also, Canon had come to the realization that mechanical lens linkages were simply not accurate enough for the lenses of the future, and such systems had always had durability problems.

The result of all of this was that Canon's engineers decided to make a complete break with FD mount tradition and introduce a totally new lens mount, the Canon EF mount, which is much larger in diameter, a simple bayonet in design, and utilizes no mechanical linkages at all between the camera and the lens. Not only do these gold-plated contacts convey information between the camera and the lens, they also carry the electrical power for the autofocus motor and the diaphragm motor, eliminating the need for a separate battery compartment in the lens. Canon concluded early in their research that the autofocus motors belonged in the lenses, where the motors could be placed as closely as possible to what they actually moved, and each lens could be fitted with a motor best suited to its needs and specifications. This has resulted so far in four different types of motors used in EF lenses. That Canon was right in this decision is shown by the fact that their competition now has to back-pedal and re-design some of their lenses with motors in them to achieve fast enough auto-focus operation, and has had to redesign camera bodies with electrical contacts to power these lenses. Canon got it right the first time.

The first type of motor Canon designed for EOS lenses was the Arc Form Drive (AFD). This is a very traditional small electrical motor but with its components arranged in an arc shape so that it

The large bayonet mount of the EOS cameras makes very fast lenses possible. In this photo you can see the reflex mirror, in which the viewing screen with its five autofocus points is reflected. At the bottom you can see the eight electrical contacts for the lens.

EF-lenses—a complex combination of optical, mechanical and electrical components into an integrated whole. Picture courtesy of Canon.

will easily fit into lens barrels. While the AFD worked very well, it wasn't quite fast enough for Canon and has largely been replaced now with a new generation of the next type of motor.

The second type of motor is hardly a motor at all in the normal sense of that word. It is simply two metal rings with special surfaces on their mating sides. These rings are held in contact by springs and one is fixed to the lens barrel while the other is free to turn. An electrically excited piezo-electric crystal acts as an oscillator at ultrasonic frequencies to vibrate the rings. Because of the nature of their surfaces, the standing wave generated in the rings causes them to rotate against one another. Since one ring is fixed in place, the other one turns and its direction of rotation and speed are controlled by the frequency and intensity of the wave generated. This unusual device is referred to by Canon as an Ultra-Sonic Motor (USM).

The first generation of USMs were large and expensive, and were reserved for L series lenses of large diameter. Continued research on USM technology has resulted in a second generation of USM which is much less expensive to make and much smaller in diameter, and these are now replacing the original AFD motors as new lenses are designed and old lenses redesigned. Ultimately Canon intends to have all EOS lenses powered by USM drives.

The fourth type of motor is a traditional small electrical motor with a long drive shaft. Because of the long extension necessary, this was the only sort of motor Canon could fit to the 100mm f/2.8 macro lens. This is the only EF lens which does not use the AFD or one of the two types of USM.

Although the electrical contacts on the back of EF lenses are much less subject to damage than pins and levers, they still should be protected from environmental dust and dirt and particularly from fingerprints when the lenses are not on the cameras. That is the purpose of rear lens caps. Always put one on each lens the minute it is taken off the camera, and keep it there until just before that lens is again mounted onto the camera. The same goes for the rear glass of the lens, which is easily scratched. Similarly, front caps should be left on all lenses when they are not actually in use.

Everyone makes mistakes, and if you do get dirt or dust onto the front or rear glass of your lens you can easily and safely remove it. First simply see if it will blow off. Camera dealers sell small squeeze bulb blowers for this purpose or you can buy an ear

syringe from a drugstore. Gentle puffs of air will usually get rid of most dust and grit. If you encounter stubborn material, then you may resort to the brush, which should always be a soft "camel's hair" (actually made from squirrel's tail hair) brush. Use this in a sweeping circular pattern starting at the center and working to the edges. Hold the lens either sideways or with the glass surface to be cleaned pointing down so that gravity will carry away the offending matter. Then try the blower again. This should work.

If you still don't have success, resort to lens cleaning tissue or a special lens chamois and wipe gently, again in a circular motion from the center. If even this does not work, moisten the tissue with a drop or two of lens cleaning fluid and try again, exerting only very gentle pressure. If none of these work, carry the lens to a professional.

Don't be a fanatic about dust, however. A few specks of dust on the front of your lens, a few on the rear, or even a few on the inside glass elements will not have a noticeable effect on your photos. Reasonable cleanliness is important, not rigidly clinging to the idea that a single dust speck is ruination.

Three Lenses for the Beginner

The beginner is faced with a very difficult choice. With so many lenses to pick from, so many of them seemingly similar, how do you decide which lenses to buy? As a first point, I will recommend taking care to shop with a reputable photo dealer, and to make absolutely certain that you are actually getting Canon lenses. Often you will see bargain priced camera outfits which are advertised something like..." Canon EOS 5 with three lenses....only..." and at a ridiculously low price. How is this possible? Notice that the advertisement only says "with three lenses". It does not say that they are Canon lenses. They could be anything! Know what you are buying, particulary if buying by mailorder.

It used to be that most 35mm cameras were sold with a 50mm lens as a standard package. This was so much the case that the 50mm came to be known as the "normal lens" and is still often referred to that way. Canon does indeed offer three different "normal" lenses for the EOS cameras, 50mm f/1.0, 50mm f/1.4 and 50mm f/1.8, and for some photographers they are the right

choice. More often today photographers are finding that they are happier with a "normal zoom". My personal "normal" lens is the 28 - 80 f/2.8 - 4 L, which I have used for several years. It is an expensive lens, admittedly, but it is incredibly sharp and replaces three fixed lenses at minimum: 28mm, 50mm, 80mm. More recently I have been using the new 28 - 105mm f/3.5 - 4.5 with very good results and may just switch over to it as my "normal".

My three lens location kit would ideally consist of 20 - 35mm L, 28 - 80mm L, and 100 - 300mm L series lenses. What is this L? Canon makes two separate series of EF lenses which might be thought of as standard and super. The L series, which stands for Luxury, are their absolute top of the line professional lenses. All of them have superlative performance characteristics, and all of them are expensive. But if your goal is absolutely the best possible photographs, nothing else can touch them.

A more realistic three lens kit would consist of the lower priced 20 - 35mm, the 28 - 105mm, and the standard 100 - 300mm. These lenses are all very good, and many professionals do use them. In the case of the first two, the economy of price is achieved by making them slower, but this also makes them smaller and lighter which is often an advantage. In the case of the 100 - 300mm, the difference is that the L uses very exotic glass types and has a higher degree of color correction. Whether you would notice a difference or not depends on your own personal critical standards.

Whether the slower and less expensive wide angle and normal zooms will meet your needs depends entirely on the type of photography you do. If you habitually work outdoors in bright light, they would certainly be adequate. If your forte is low light photos by available light, then you would want the faster lenses and might bypass zooms altogether in favor of the very fast fixed focal length lenses. If you do a lot of closeup work, one of the two macro lenses may make more sense to you. The important thing is to know in advance what it is that you want to do photographically and then to match the lenses you buy to the tasks. It makes no sense to buy a particular lens just because it will impress people if they see you carrying it if you have no earthly use for such a lens!

Zoom Lenses

There are many photographers who simply refuse to use zoom lenses at all because they cling to the old prejudice that zoom lenses simply are not sharp. Zoom lenses got this reputation in their early days, and the first zoom lenses such as the Voigtlander Zoomar were pretty bad by anyone's standards. But that was many years ago, and much technological progress has been made during those years, and today we have high class zoom lenses which give very little away to fixed focal length lenses.

Zoom lenses have their advantages and so do non-zooms, and most well equipped photographers will have some of both types for use in different circumstances. For example, even though I usually use the 28 - 80mm L zoom, I also have the 85mm f/1.8. Why? Because at the 80mm end of its zoom range, the 28 - 80

Looking into the amazing EF 50mm f/1.0 lens from the front. Lenses of such large aperture were difficult or impossible prior to Canon's switch to the very large diameter EF lens mount. The front lens is actually quite a bit larger than the visible opening in this photo.

becomes f/4, and that is not fast enough for some purposes. Also it does not allow me to set a really shallow depth of field, as I can easily do with the 85mm by simply setting it to f/1.8 or so. For a similar reason I also have a 50mm f/1.8, although I do not use it very much. When I have to have it, nothing else will do.

And for some special jobs I have used the 300mm f/2.8 because at the 300mm setting the maximum opening of the 100 - 300mm zoom is f/5.6.

Another consideration is that even the very best wide angle to telephoto zoom lenses have some optical distortion. It is impossible with current technology to totally eliminate it. At the wide angle end there is always some barrel distortion, which means that straight lines across the image but not passing through the center will bow outward somewhat. At the telephoto end of things, such lenses always have some pincushion distortion, in which similar straight lines bow inward. For many subjects this does not matter at all, and is not noticed. But for critical subjects such as architecture and document copying it may not be acceptable. Fixed focal length lenses, particularly the macro lenses, are generally very well corrected and do not show visible amounts of such distortion.

Fisheye Lenses

The days when an image taken with a fisheye lens brought gasps of astonishment to an audience are long gone. Everyone has seen the fisheye effect, in fact far too much in my opinion. This is not to say that we should renounce all use of fisheye lenses, just that we should use them judiciously. Canon's 15mm f/2.8 fisheye for EOS is one of the best of these special lenses.

Fisheye lenses are examples of barrel distortion gone mad, and totally uncorrected. The only straight lines which will be rendered straight are those passing through the exact center of the image.

Canon has chosen to give us a full-frame fisheye, not one of the sort which produces a small circular image in the center of the film. This one fills up the frame and provides approximately a 180 degree view diagonally from corner to corner. This can be used to produce very exaggerated perspectives in views of interiors, and can also be used for sweeping panoramas of landscapes

**The Canon Fisheye Lens
EF 15mm f/2.8**

in which the distortion will not be so obvious unless the lens is tilted up or down. My friend George Lepp, the well known nature photographer, tells me he uses the fisheye for very close flower photos, sometimes getting all the way down on the ground and looking at the flower from below. Don't be afraid to try unusual things like this, the photos may be spectacular and certainly will get you to thinking about ways to use unusual perspectives.

Ultra-Wide-Angle Lenses

Perhaps not as spectacular as photos taken with fisheye lenses, photos taken with ultra-wide-angle lenses can still be remarkably striking. These lenses lend themselves to providing unusual perspectives and opening up spaces indoors as well as outdoors. In the area of ultra-wide-angle lenses Canon has two lenses of fixed focal length and two zoom lenses. These are the EF 14mm f/2.8 L, EF 20mm f/2.8 , EF 20 - 35mm f/2.8 L and EF 20 - 35mm f/3.5 - 4.5.

The main characteristic of fisheye lenses, uncorrected barrel distortion **which makes straight lines bow and converge.**

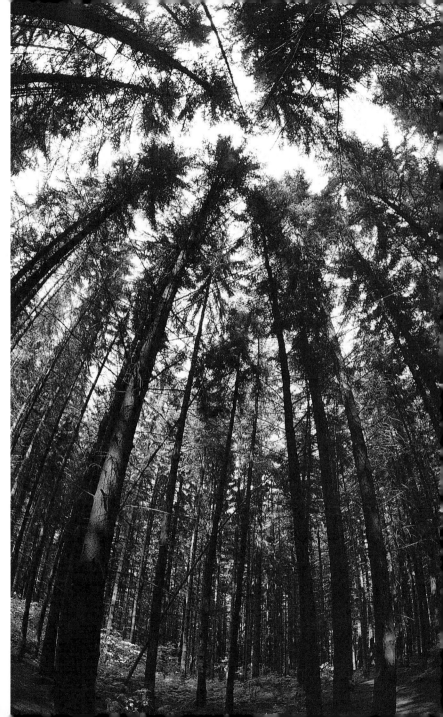

The Canon Super-Wide Angle EF 14mm f/2.8 – shorter than the fisheye, but without the distortion.

 You may well wonder what distinguishes the 14mm from the fisheye, but the answer is quite simple. While the fisheye design allows barrel distortion to go uncorrected, distorting straight lines into arcs as they become more distant from the image center, the 14mm is a rectilinear design with maximum correction for distortion. In other words, if aligned carefully this lens will provide images without barrel distortion. Any wide angle lens will produce distortion if tilted up or down, but rectilinear ones will have no distortion if aligned carefully. For this purpose an accessory bubble level which attaches to the camera hot shoe is a useful accessory, and readily available from better photo shops.

 One of the most important advantages of ultra-wide-angle lenses is that with them you can take in large areas from very short distances, and this is particularly an advantage indoors in cramped surroundings. These lenses open up such surroundings and make them appear more spacious. Advertising photos of auto interiors are generally taken with wide angle lenses for this reason; viewed through a 20mm the cramped cockpit of a Lamborghini Diablo looks like the spacious interior of a Mercedes limousine! Don't think that these lenses are just for indoors, however, they are also very useful out and about in the city. I encountered a very

The Canon Zoom Lens EF 20 - 35mm f/2,8 L is a super-wide angle to moderate wide angle zoom. It has just been joined in the EOS lens range by a much less expensive 20 - 35mm lens with variable aperture f/3.5 - 4.5.

interesting doorway of a shop on a busy street one day. I could only get the image I wanted with a normal lens if I could stand in the middle of the street, not a healthy proposition. However, I just happened to have the 20mm f/2.8 lens with me since I was testing it at the time for a magazine article. With the 20mm I was able to get just the photo I wanted of the shop doorway, and from the middle of the sidewalk which was relatively much safer. I have also used the 20mm to include the balance of a city block from a vantage point across the street. Just don't tip the lens up to get the tops of the buildings in, the exaggerated perspective of an ultra-wide-angle makes the buildings really tip over like they are falling down.

Wide Angle Lenses

There is really no clear definition of when a lens stops being an ultra-wide-angle lens and becomes just an ordinary wide angle. When I was first getting started in photography over twenty-five years ago, a 28mm was an exotic ultra-wide-angle for most of us. Now a 28mm is a very pedestrian focal length, not regarded as

A highly corrected super-wide angle lens will not show barrel distortion if carefully aligned with the horizon.

ultra-anything. I suppose it makes sense today to call anything wider than about 24-25mm an ultra-wide-angle, and we will leave it at that in this book.

The more usual wide angle lenses such as 24mm, 28mm and 35mm are much easier to use than the wider ones because their alignment is far less critical. The 24mm can do practically anything that the 20mm can do, you just have to move back a bit more, and so for the 28mm and 35mm. The perspective is still exaggerated in these lenses, but nowhere as much as in the 20mm and 14mm, so care must still be exercised to avoid tipping over buildings and the like. I find them also to be excellent landscape lenses.

With the 28mm and 35mm you can easily take more normal photos. You can even use them for portraiture so long as you do not move in too close to your subject which will distort his or her features in an unattractive manner. One major photojournalist that I know is famous for his environmental portraits for magazines, and he nearly always takes these photos with a 35mm lens.

Many fashion photographers use the exaggerated perspective of the 28mm or 35mm to photograph models from low angles which makes their already long slender legs appear to be endless. These lenses are also excellent for group portraits when four or more people must be included in a single image.

The EF 35mm f/2 is a particularly striking lens, combining exceptional optical quality with a fast aperture and convenient size. Many will find that it becomes their "normal" lens. Then there is the 28mm f/2.8 lens, an excellent "all around" wide angle and also some zooms with 28mm at their short end. Also very interesting is the new zoom 35 - 350 f/3.5 - 5.6, with a really amazing 10 to 1 zoom range. Unfortunately this new super zoom is not small, not light and fast to use, and certainly not cheap.

The wide angle zoom EF 28 - 105mm f/3.5 - 4.5. It was introduced with the EOS A2E/A2/5 and has become very popular with photographers already.

The wide angle Canon EF 24mm f/2.8 is an essential lens for those who love wide angle photography.

Normal Lenses

It used to be that the rule of thumb for cameras was that the "normal" lens was said to be a lens with a focal length of about the same as the diagonal of the image. By this rule the normal lens for a 35mm camera should be the diagonal of the frame which measures 24 x 36mm. A 24 x 36mm rectangle has a diagonal of about 43mm, so we should all rush down to our camera dealer and demand a 43mm lens for our EOS! In actual practice, most photographers prefer a lens a little bit longer than the precise measure of the diagonal, so the standardized normal lens for 35mm has become something in the 50 - 55mm range.

Canon offers three different 50mm lenses with maximum apertures of f/1, f/1.4 and f/1.8. Add to this the 50mm f/2.5 Macro and the 45mm f/2.8 Tilt-Shift, and we have five different lenses of "normal" focal length. Then there are the zooms which include 50mm in their range! Suddenly the choice of any one normal lens

The superfast normal lens, the Canon EF 50mm f/1.0 L.

With the 50mm lens almost anything is possible, from landscapes to these dolls in a flea market.

becomes a real headache. As always my advice is to pick the lens to do the job you need doing. If your forte is macro photography, then buy the macro lens. If architecture is your specialty, buy the Tilt-Shift lens. If you use flash a lot and need maximum flash distance, you will have to have one of the fast normal lenses. If you don't require a fast aperture, forget a normal altogether and just use one of the zoom lenses.

Short Telephoto Lenses

Short telephoto lenses, those in the general range from 70mm up to about 150mm, are often called portrait lenses. Compartmentalizing them so is an injustice, since they are useful for a large number of things other than just for portraits. The EOS line boasts six lenses which fit into this range, and sixteen zoom lenses! You certainly have plenty to choose from here.

Lenses are really well suited to portraits only from the range of about 70mm up to about 150mm, because they force the photographer to think in terms of head and shoulders portraits, and they provide a very undistorted and flattering perspective for the portrait subject. Ideal working distance is maintained ranging from about four feet at one extreme to about twelve feet at the other. Typically,

The portrait lens, Canon's EF 85mm f/1.8 is the ideal lens for people pictures and portraiture in general.

The portrait lens is not just for portraits, as this detail shot and nature shot show clearly.

lenses are used for portraiture at wide apertures to throw backgrounds and foregrounds out of focus and place all emphasis on the subject. However you should never let this naming of medium telephotos as portrait lenses persuade you not to use other lenses for portraits. I have often taken portrait photos with lenses in the 180mm - 200mm range and I know a professional glamour photographer in New York who normally takes head and shoulders portraits with 300mm and 400mm lenses because he likes the perspective better. Since his photos grace the covers or major magazines around the world, others must agree. I have been in his studio during a session, and he is so far away from the model that he has to shout directions to her!

The point I am really trying to make here is that there are really no rules on which lens to use, only general guides. If a particular lens works for you for a particular picture, then it is the correct lens. What really matters behind all of this technical information about cameras and lenses is the final image—ultimately that is all that the viewer sees or cares about.

One unique lens in the EOS range is the 135mm f/2.8 Variable Soft Focus. Some photographers like the effect produced by soft focus lenses, and this is one of the best. When the soft focus control is set to 0 this lens becomes just an ordinary, but very good, 135mm lens. The photographer then has the choice of two different degrees of soft focus, set by turning the ring, to match the mood desired in the photo. This is an excellent case of two lenses in one, and the soft focus effect is very nice.

The built-in flash was used in this photo of lupin to add an extra ⇨
lightness and sparkle to the photo.
The rose was photographed with flash and a softening filter.

Telephoto Lenses

Most photographers first think about buying telephoto lenses with the thought of bringing distant subjects closer without having to try to approach them. Telephoto lenses do work for this purpose, but that is only one of many things for which telephoto lenses are useful.

So how do you know which is the right telephoto for your photography? To decide this you need to know something about what telephoto lenses are and also precisely what they do. Strictly speaking a telephoto lens is a particular optical design in which the actual lens is shorter than its focal length would imply. For example, not many of us would want to carry 300, 400, 500 and 600mm lenses around if they were actually 200, 400, 500 and 600mm in length. By means of multi-element optical designs it is possible to shorten these lenses down to manageable size, although they are admittedly still rather large.

When a telephoto lens design is combined with a very wide aperture, as in the EF 200mm f/1.8 L, the possibility of working with extremely shallow depth of field allows the creation of very interesting images. I have used this lens for outdoor portraits and have been very pleased with the results it has allowed me to create.

In the case of 300mm lenses, I have used the 300mm f/2.8 a number of times, but it is a very heavy lens and not well suited to hand-held shooting which is my preferred working method. When the new 300mm f/4 was introduced last year I got one of the first ones Canon USA had, and have found that it is an exceptional lens for my use when I need a telephoto in this range. It is perfect for wildlife and nature photography, since it is fast enough for most applications and it does not put a permanent groove in your shoulder if you hike with it for a day.

◁ **Daylight film was used for this photo to accurately record the color of the neon sign and the blue of twilight, the tungsten lamps inside the building have produced a warm yellow glow.**

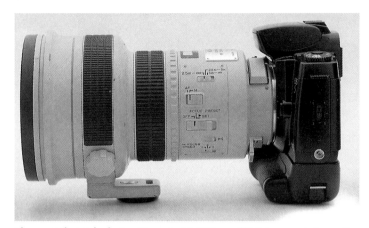

The superfast telephoto, Canon's EF 200mm f/1.8 L mounted on the EOS 5. In this case we do not mount the lens on the camera, we mount the camera on the lens.

The "all around" lens, Canon's EF 35 - 350mm f/3.5 - 5.6, shown at its 350mm position. When set for 35 mm it is considerably shorter as it is a push-pull zoom design.

158

The long focal length of a zoom has allowed the photographer to make the cat quite large in the photo without getting too close.

You may wonder why the 300mm lenses are both painted in a light gray color instead of the traditional black. Actually, it makes little functional difference what color a lens is, and they used to all be shiny chrome in the old days. However, for unknown reasons in recent years the color black has taken on professional connotations, and we now see most camera equipment and now audio equipment and even computers turning black. The stated reason for painting these lenses in a light color is that their physical length makes them sensitive to changes in focal length caused by the metal of the barrels heating up from the sun and expanding. That is probably a real consideration in certain circumstances, although it has never been a problem for me and I would be just as happy if the lens came in black. Because the lighter color is more likely to frighten animals than black, some nature photographers cover their light colored telephoto lenses with camouflage pattern tape.

One important use for telephoto lenses is that they compress perspective. You have seen this effect often in the movies when a long distance view of a crowded street makes it look like all of the people are right up against each other, when in fact they are

separated by several feet. The same effect is often seen in city scapes taken from the tops of buildings in which all of the buildings seem stacked up against each other. Telephoto lenses also alter perspective by making background objects larger in proportion to the main subject, an effect which is often used in fashion photography.

Super Telephoto Lenses

At any sporting event you see them, rows of white super telephoto lenses from the press corps who use Canon EOS. Whether it is football, baseball, soccer, tennis, swimming, auto-racing, or any other sport which requires magazine and newspaper coverage, they are there. For the average photo hobbyist these are dream lenses, but for the professional photojournalists they are the tools of the trade.

Canon offers four super telephotos, all of them finished in light gray paint which looks white at a distance. The smallest of these giants is the new EF 400mm f/5.6 L, which is actually quite reasonable in size and not all that much larger than the 300mm f/4 which it strongly resembles. However it is a real baby compared to its brother the EF 400mm f/2.8 L. Canon has gone all out on their big lenses, making them as good as possible optically. The 400mm lenses as well as the 500 which follows are true apochromats, which means that they focus all colors of light at precisely the same plane. This eliminated chromatic aberration which causes color fringing in telephotos which are less well designed.

The EF 500mm f/4.5 L and the EF 600mm f/4 L round out Canon's big guns. These lenses should be powerful enough for almost anything on their own, but just in case the photographer needs more reach Canon also offers both a 1.4X and a 2X tele converters which increase the focal lengths of the lenses by those factors. I have used both of these converters with the 300mm f/2.8 and 300mm f/4 and can confirm that they do not degrade image quality in any visible way.

The super telephotos are useful for the same types of effects as the telephotos, only with them the effect will be even more pronounced. Compresssion is greater, depth of field is shallower

The super telephoto, Canon's EF 600mm f/5.6 L with a very large tripod collar which can also double as a handgrip or carrying handle.

at a given aperture, and it is possible to isolate a smaller subject from distracting surroundings. I number among my friends many nature photographers who use Canon lenses. Most of them own one or more of these big lenses and carry them into the field for spectacular photos of animals and birds. All of these photographers curse the weight and size of the lenses, but use them because nothing else will produce the quality of photos on which their reputation depends.

Macro Lenses

At present Canon offers two macro lenses, a 50mm f/2.5 and a 100mm f/2.8. Both are extremely well-corrected flat field designs which can be used for the most critical work. A flat field lens is a lens which has a field of focus which is very close to a flat plane, meaning it can focus sharply on a flat subject such as a document to be copied and provide sharp focus in the center and at all four corners. Because they are not used for such critical purposes, most lenses are not designed as flat field lenses and actually have a concave plane of focus. In general photography this matters little, and we do not normally even notice it, but it is disastrous for critical copying work. That is why if you intend to do a lot of macro work of this sort you should break down and buy a good

true macro lens and not try to make do with a normal or zoom lens fitted with screw-on closup lenses or extension tubes.

In addition to being computed as flat field lenses these macro lenses are also designed to focus very close. In the case of the 50mm macro lens it will focus as close as 9 1/2 inches (230mm) for a magnification of 1:2 (half life size). For greater magnification the companion Life Size Converter EF25 is required. This makes it possible to focus all the way to a scale of 1:1 for precisely life sized copies. The EF25 converter transfers all informtion from the lens to the camera, so all automatic function is maintained, including autofocus. However, at very close focusing distances, the space between the front of the lens and the subject becomes very short, making lighting of the subject difficult.

For those types of subjects such as live insects when you require more space for lighting or simply not to frighten the subject, the 100mm macro is more useful. Besides it will focus all the way to 1:1 without the need for an accessory converter. Precise focus is very important in macro photography because the depth of field is quite shallow at high magnification and subject or camera move-

ment is magnified. Use of the depth of field preview is important in this sort of photography to insure that the depth of field is sufficient. Also, if you have the time to work with it, the DEP mode does work with the macro lenses at very close distances to compute the needed aperture for a specific range of sharpness.

The Canon EF 100mm f/2.8 Macro, which focuses all the way to a 1:1 reproduction ratio without any accessories.

For macro photographs such as this, a copy stand is very useful to support the camera and lens.

A strong and stable support is absolutely essential for much macro photography. Outdoors, a very good tripod with a ball head is generally the most useful accessory. Many nature photographers have found for years that the odd looking Benbo tripods are just about the most versatile for outdoor use. The Benbo's completely freewheeling legs can be twisted into practically any configuration without limits and locked securely. The central column also can be put at any angle to the legs and locked. Benbo tripods come in a variety of sizes depending on your needs, and Benbo also offers an excellent assortment of different sizes of ball heads to accompany them. Screwing a camera and lens on and off a tripod is a waste of time, and everyone I know is now using one quick release system or another. Personally, I have adopted the Stroboframe Quick Release™ system (QRC) which is the fastest I know of, and abolutely secure when locked. Their system lets me quickly put a camera onto a tripod, take it off again just as

quickly, and mount it again onto a Stroboframe® flash bracket without having to remove the mounting plate from the camera body. This system works well with the EOS A2E/A2/5 either with or without the vertical grip VG-10.

Tilt-Shift Lenses

It used to be that shift lenses were called PC lenses for perspective control, and that is about all they were used for. Everyone has noticed that when you point your camera up at a building to get it all in the picture, the lines of the building converge, like a railroad track extending into the distance, and the building appears to be falling down. Every view camera photographer knows that you never tilt a camera up to get a building in, you raise the front of the camera. Even cheap cameras in earlier times had rising lens panels to take advantage of this. But no production 35mm camera has a body which allows the lens to be raised and lowered, or moved in any other way parallel to the film.

To our rescue Canon has given us not one, but three lenses which can all be used as PC lenses since they incorporate shift.

These are the TS E 24mm f/3.5 L, TS E 45mm f/2.8 L, and TS E 90mm f/2.8 L. This is the first time shift lenses have been offered in 35mm which are not wide angles, and for good reason. They have many other uses than just architecture, as photographers are starting to learn.

One important use for a shift lens occurs when you are photographing an interior in which there is a large mirror on the wall opposite your position. With any usual lens, you can take this photo, but your own reflection will be in the mirror. If you move to one side or the other until your reflection vanishes, you may not have the viewpoint you want. With a shift lens you can position yourself on either side of the mirror to remove your reflection and then shift the lens sideways to bring back the point of view that you wanted to have. Similarly, such a lens can be used to remove the photographer's reflection in any shiny surface, such as the side of an automobile, a polished silver plate, a glass window, a bottle, etc. This is a very important use for shift lenses which is often ignored. Since Canon gives us three separate focal lengths to work with, we now have greater versatility than ever before in the use of shift lenses.

However, we must not fall into the trap of regarding Canon's

The first photo in this series shows the view with the camera held level. As you can see only the base of the building is in the photograph. The photographer can tilt the camera up, as in the second photo, to include the building, but at the cost of converging vertical lines which make the building appear to be tipping over backwards. In the third photo, the lens has been shifted vertically, including the whole building, but keeping the vertical lines parallel.

lenses merely as shift lenses. To do so misses completely their most important and unique feature. These are tilt lenses as well as shift lenses. Photographers who have used view cameras will immediately recognize the significance of this, but most others will not.

There is an important rule of optics, known as the Scheimpflug rule, which says that imaginary planes projected through the film plane, center plane of the lens, and plane of focus will meet along a common line. This means that as you can tilt the plane of the lens with respect to the plane of the film, you tilt the plane of focus at the same time. There is not room in this book to go into this in great detail, and this is somewhat of an oversimplification, but it is enough to know to start working with a tilt lens.

What this means is that you can tilt the lens slightly downward while keeping the film plane precisely vertical and get a landscape in sharp focus from the closest foreground all the way out to infinity, with the lens wide open. This does not in any way violate the rules of depth of field; the depth of field is still quite shallow, but the plane of focus has been made to coincide with the plane of the subject. Depth of field still extends in front of and behind this tilted plane, and stopping the lens down still extends it in both directions.

Another good example would be a photograph of a bridge taken from the side of the road at one end. The bridge railing crosses the image at an oblique angle, and with the lens in normal position you would have to stop down quite a bit to get both ends of the bridge rail in focus. By rotating the lens through 90 degrees and then tilting it sideways (properly referred to as a swing movement) you can align the plane of focus with the bridge rail so that it is in sharp focus from end to end, and still keep the lens close to wide open, allowing a higher shutter speed or a slower film to be used.

Equally, this sort of movement can be used for special effects. Imagine a row of four wine bottles in an advertisement. Three bottles are competing brands while one is the sponsor's brand. If you arrange the four in a row with all of them at the same distance from the camera, your normal lens position will make all four equally sharp. However if you put the lens on its side and use a sideways tilt (or, properly, swing), you can put the plane of focus in a position so that it passes through the sponsor's bottle, rendering it absolutely sharp, but misses the other three bottles

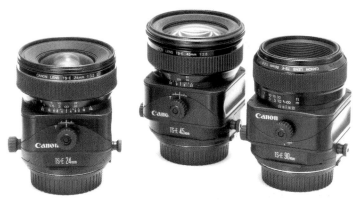

The Canon Tilt-Shift lens family, consisting of 24mm, 45mm and 90mm lenses. All allow the lens to be shifted in its barrel, and tilted as well, a feature offered by no other 35mm camera system.

completely, throwing them out of focus. There are many other applications in creative and commercial photography to which these special lenses lend themselves.

Canon has actually worked in cooperation with a computer software firm to develop a computer program which allows you to very precisely set the plane of focus to exactly achieve the effect you want in tabletop photography. I expect these lenses to become the staple of commercial photographers who specialize in product photography.

But these are not lenses for use in the studio alone. My friend George Lepp has told me that he now uses the 90mm Tilt-Shift lens for much of his closeup nature photography. He uses the lens alone, and with both the 1.4X and 2X converters, and with a 25mm extension tube. For light he uses a 430 EZ Canon flash mounted on one of his Lepp Macro Brackets. This flash overcomes camera and subject motion and allows him to shoot macro photographs hand-held. The tilt function of the lens allows him to precisely align the plane of focus to the main plane of his subject, which can somewhat overcome the very shallow depth of field which is always a problem in macro photography.

Tele Converters

Tele converters, also called tele extenders and sometimes doublers, used to have a terrible reputation. This was because the early designs, often with only a single optical element, degraded the image to an unacceptable level in the process of increasing the magnification of the lens. Nowadays many makers produce very high-class tele converters, having from five to seven separate lens elements inside and manufactured to the same quality standards as first class lenses.

Canon currently offers two tele extenders of their own, which match the quality and characteristics of the EOS lenses. The first one, the EF 2X E, multiplies the focal length of the lens mounted on it by two times. The second one, the EF 1.4X E, multiplies the focal length of the lens by 1.4 times.

Since the image emerging from the lens is acted upon and spread out to be larger, the amount of light falling on any given part of the film is cut down. There is no way around this, and any tele converter will have this effect. In the case of a 2X converter the light loss is two stops. The light is reduced by a factor of four because the area of the image has been magnified 2 times in a linear measure, which converts to four times in surface area. This means that a lens with a maximum opening of f/2.8 is turned into a lens of f/5.6 when used with a 2X converter. The loss it less with a 1.4X converter since the magnification is less. Light is only reduced by a factor of two, or by one f-stop. So a lens with a maximum opening of f/2.8 becomes a lens of f/4 when used with a 1.4X converter.

You need not worry about this computation when using the EOS camera's built-in meter, since it automatically compensates for the light loss. You need only remember this light loss when you use an external meter and transfer the readings to the camera.

I almost always carry a 2X tele converter with me in my camera bag because it effectively doubles the number of lenses I am carrying. However, there is a price for every convenience, and Canon's tele converters are not cheap. Also, because of the light loss encountered, you will have to revert to manual focus when you use the 2X converter with a lens slower than f/4, because the f/4 lens becomes f/8 with such a converter and does not pass enough light for the autofocus system to function.

Perspective

Perspective is defined as the apparent change of size in objects at varying distances from the viewer. If you take ten yard sticks and set them up vertically at a distance of ten feet from each other, and then stand at one end of the row, you will see that as the distance from you increases the apparent size of the yard sticks decreases, even though you know that the size has not changed. If the distance doubles, the apparent size is cut in half.

You can use another yard stick and hold it up and measure the apparent size of each yard stick as they recede into the distance, and each one will appear to be smaller than the one before.

Another way to visualize perspective is to consider a railroad track which goes straight off into the distance. From your viewpoint the space between the rails grows smaller and smaller until at the horizon the rails will appear to meet. This point is called the vanishing point. At all distances up to the vanishing point, doubling the distance from the observer makes the space between the rails seem to cut in half.

People had little understanding of perspective, as evidenced by drawings and paintings, until the Renaissance, when the rules were codified by artists and a common concensus was reached about how to render perspective. Paintings after that time appear natural and realistic to us, while those from earlier times look artificial.

Similarly, camera lenses render the scenes they transmit with a perspective which looks natural to us most of the time. The size of an object is always cut in half if the distance is doubled.

Perspective of a particular part of a scene is not altered by the focal length of the lens. If you question this based on the difference in look of photos from wide angle and telephoto lenses, you can easily prove to yourself that what I say is correct. You must set up your camera on a tripod and take two photos, one with a wide angle and one with a telephoto. Then if you take the section of the wide angle photo which exactly matches the view from the telephoto and enlarge it to the same size, you will see that the perspective is in each case identical. Why is it then that wide angle lenses create the impression of expanded perspective while telephotos give the impression of compressed perspective?

One reason is that the larger picture angle of the wide angle lens typically includes lines very close to the camera, which will

This sort of compression of perspective, in which distant objects seem nearly on the same plane as closer ones, is typical of long telephoto lenses.

appear to be widely spaced, along with lines at a distance, which will appear to be close together. With the telephoto, only lines which are already distant will be recorded and the range of distance, corresponding with how close together they will appear to come, is much less.

However, if you move to a much greater distance with the telephoto so that you include exactly the same image area as you see through the wide angle, will you get the same perspective? No you will not, because it is the distance from the camera which determines the perspective, and once you move the camera to a greater distance you have altered the perspective accordingly.

As a photographer you need to be aware of the difference between the exaggerated perspective effect of wide angle lenses and the compressed effect of telephoto lenses. When confronted by a

◁ **In this photo of railroad tracks a telephoto lens has been used and you will note that the tracks do not converge at a steep angle.**

scene, there are many different perspectives which can be used and they all depend strictly on the focal length of the lens. With a wide angle to telephoto zoom, the range of perspective effects is infinite. Therefore, don't just think of changing focal length to change what is included in a photo, think also of the perspective effect which will be most appropriate to the image you want to produce.

Another aspect of long distance perspective is the air between the photographer and subject. We have all seen in movies or on television the waving effect when images are seen through very powerful telephoto lenses, particularly on hot days. The air between the photographer and his or her subject is never still, and in many cases will act as a distortion or diffusion filter. Because particles and water droplets in the air act to bounce light around, contrast is always reduced at great distances and color saturation is decreased.

Flash

Electronic Flash

In earlier times, most night time exposures were made with flash bulbs which were used once and then thrown away. Today we are blessed with a variety of electronic flash units which are not only more economical and less wasteful, but more powerful and more compact as well. Technology has made it possible now to offer compact flash units which mount directly on the camera, and which couple to the camera through a series of electrical contacts in the hot shoe to provide completely automatic flash operation.

Today we have cameras like the EOS A2E/A2/5 with a very capable built-in flash, and with the capability to accept a variety of accessory flash units from Canon and other flash makers. In talking about proper flash in my photography classes and in my workshops, a number of questions come up repeatedly and it makes sense to deal with some of the most common ones here.

What is a Guide Number and how is it used? Every flash unit has a Guide Number, and this is a simple expression of its light output. Generally Guide Numbers are expressed at ISO 100, and can be easily compared to determine which flash unit is more powerful. But be careful, some advertisers have started to slip in Guide Numbers computed at ISO 400, which produces larger numbers and makes their flash units appear to be more powerful than they are. Basically, the guide number of a flash is determined by the formula:

GN (Guide Number) = lens aperture X subject distance.

For example, a flash which produced proper exposure at ten feet with an aperture of f/4 would have a GN of 40. This is a guide number in feet. There are also metric Guide Numbers computed the same way but using distance in meters instead. When comparing guide numbers, make sure that they are all expressed

in the same units. To convert a metric Guide Number to a Guide Number in feet, multiply by 3.3, or to convert one in feet to one in meters divide by 3.3.

If you know the GN of a flash unit and want to know the aperture to use, you must first measure the distance from the flash (not the camera!) to the subject. You then divide this distance into the GN, and that gives you the f-stop to set. As an example, let's consider a flash unit with a GN in feet of 56. If we photograph a subject at ten feet, we have 56/10 or f/5.6. If the same flash is used to photograph a subject at 14 feet, we would have 56/14 or f4. Sometimes you will get odd numbers, as for example at 15 feet you end up with f/3.7333—-. You would simply round this off to f/3.5, the closest half-stop.

How about converting a Guide Number at ISO 100 to an equivalent one at a different ISO? Let's use our GN of 56 again as an example. To convert this to an equivalent GN at ISO 200 we would simply multiply by 1.43, giving us a new GN of 80.08, which we would round off to GN 80. If we want to get one for ISO 400, we would again multiply by 1.43, and this gives us GN 114.4, which we can round off to GN 110. You will note that the progression here is the same one used in lens apertures.

You can go from one GN to another by seeing how many doublings of the original ISO are involved. In the case of going from ISO 100 to ISO 800, you are doubling three times. You then add together 1.43 once for every doubling except the first, in this case giving you 1.43 + 1.43 or 2.86. Multiplying our example GN of 56 by 2.86 gives us 160.06, which we round off to 160. The same thing works in the opposite direction if you want to move from one ISO to a lower one.

However, you need not concern yourself overly much with learning about Guide Numbers today. Any dedicated flash you will use with your Canon EOS camera will do this work for your automatically. If you just understand the basic concept you will be able to compare one flash unit to another intelligently.

Just what is this dedicated flash you keep talking about? A dedicated flash is one made to work specifically with one type of camera. It is fitted with the proper number of electrical contacts in its hot shoe to couple with those on the camera for fully auto-

mated operation. Canon offers a full line of dedicated flash units made specifically to match the specifications of the EOS cameras. There are also flash units from other makers which are advertised as dedicated for Canon, but this is not always an honest statement. If you are considering one of these, make certain that it has all five of the electrical contacts in the proper place on its flash shoe for correct connection and operation. While I can not claim to have tested all brands and types of flash units, I have found that the Metz flash units which use the SCA system module to adapt to Canon EOS do perform quite well on Canon EOS cameras.

Remember that you must not look for just any old dedicated flash unit, it must be Canon EOS dedicated. A dedicated flash unit set up for Nikon, Olympus, Pentax or whatever will not work correctly and could even damage your camera.

Why do my photos taken with direct on-camera flash look so darned flat? What can I do to fix that? Electronic flash is harsh, undiffused light. Texture in a subject is enhanced by light striking from an angle to the camera and de-emphasized by light coming from the camera position. Also light coming from the camera often leaves a very ugly black outline shadow on the wall behind your subject.

One way to help this problem is to take the flash and get it to a higher position with respect to the camera. This is easily accomplished with the Stroboframe System 2000™ Rotary Link flash bracket, which I have been using for some time. With this system the flash is moved up a few inches above the camera, and remains in an elevated position even when the camera is turned on its side for vertical photos. Getting the flash up high puts texture back into your subjects, and throws shadows down behind them, producing a more natural look. It also cuts down on the possibility of red-eye, which is reduced as the axis of the flash is placed at a greater distance from the axis of the lens.

I've tried putting the flash up high like this, but the light is too harsh for portraits. How can I soften it? The answer to this question has to do with a little understood point about light. How hard (harsh) or soft light is depends almost totally on one thing, the apparent size of the light source from the sujbect's position. Flash is harsh because the apparent size of the light source, the flash tube, is tiny from the subject's position. There are two easy

ways to make it larger. If you are working indoors you can turn the flash head (never buy a flash with a head which will not turn!) up and bounce the light from the ceiling. If the ceiling is at moderate height and white in color, this works very well, and the apparent size of the light source becomes large, the portion of the ceiling illuminated by the flash when it fires. If the ceiling is too high, you can bounce the flash sideways at a convenient wall, and achieve a nice effect also. Just remember that whatever you bounce the light from must be white, or at least only lightly tinted with a warm color. A blue or green ceiling will throw that color onto your subject!

The other way to increase the apparent size of the light source is to use some sort of a bounce reflector or large diffuser on the flash. I have had good success with the bounce light attachments on the Canon 430 EZ flash. They produce a softer effect than direct flash, but not quite so diffused as when bounced from a large surface. Some manufacturers offer bounce reflectors with holes in them so that some light will pass through and bounce off the ceiling, and these work well to provide a light with a combination of characteristics in between the two.

Why do the people in my photographs have red eyes? Are all of my family secretly vampires? Stop worrying about protecting your neck at night! The retina of the human eye is covered with a network of tiny blood vessels which carry oxygen and nutrients to the light sensitive cells. This makes your retina blood red in color. When the light from your flash comes straight into your subject's eyes and bounces straight back to the camera lens, you see the red retina where the flash has illuminated it. Canon has tried to address this problem withe red-eye reduction light on the built-in flash, and it works fairly well. However, nothing really cures red-eye except getting the flash head as far as possible from the lens axis. That's another reason for using a flash bracket to support the flash and get it up where it belongs. You will often see a similar green eye or silvery eye effect in many animals, particularly night animals which have a silvery or greeninsh reflective layer behind their retina. Remember that you can also make intentional use of this effect if you want to produce a spooky photo for your Halloween card!

Why can you only synchronize flash at certain shutter speeds? What is the advantage of having a fast flash synch speed? This is explained in the chapter about the shutter, but briefly put the shutter of the EOS A2E/A2/5 is a vertically scanning bladed shutter. Such a shutter creates fast shutter speeds by forming a slit between the upper and lower set of blades and scanning that slit across the film. The fastest speed at which you can use flash is therefore the fastest speed at which the shutter fully opens before beginning to close, rather than slit scanning. In the EOS A2E/A2/5 this speed is 1/200 second. In other cameras it varies widely from as low as 1/30 second in some older designs to 1/250 in a few top cameras. Of course this is simply the fastest speed you can use with flash, you can certainly use any slower speed if you wish.

The advantage of having a fast synchronization speed is that it allows you to expose by flash in relatively brightly lighted areas without concern that the ambient light will interfere with the exposure. A very fast flash synch speed will allow you to isolate subjects, such as flowers, against a totally black appearing background even when the ambient light is relatively bright by using a small lens aperture. A fast flash synch speed also gives you greater flexibility when shooting outdoor fill flash, since you can't do this at faster than the flash synch speed.

The Canon Speedlites

While most older Canon flash units will work properly with the EOS cameras, several flash units have been designed by Canon specifically for use with EOS and I would recommend sticking with them for best results. The two which are best matched to the EOS A2E/A2/5 are the Speedlite 430 EZ and the Speedlite 300 EZ.

The current top flash model from Canon is the 430 EZ. It is one of the most versatile on-camera flash units ever made. This flash has a zoom head, which is automatically coupled to the lens in use and adjusts the light coverage accordingly. Focal lengths from 24mm up to 80mm are sensed from the resident ROM chip in the lens, and the flash head zooms by means of a small motor to the correct position. The flash head also can be tilted up and swung either left or right.

Flash control in the 430 EZ can be either TTL, A-TTL, plain auto-

The Canon Speedlite 430 EZ

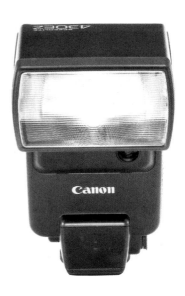

matic or full manual. The flash also has its own built-in near infra-
red autofocus assist light which is triggered in dim light. This flash
uses an unusual two-tone ready light on the back to indicate the
state of its charge. If the ready light glows yellow-green, you can
take a photo but the flash has not fully charged and will not pro-
duce its maximum distance. At maximum distance underexposure
may result, but at normal distances exposure will be correct. Since
this flash uses a thyristor circuit, unused energy in each flash cycle
is stored in the flash for use on the following cycle, making recycle
times very short for most distances. After the ready light glows
yellow-green it will shift to red if you wait a little longer, and then
is fully charged and can be used at maximum distance, or at full
power on manual control. Power output of the flash can be
manually controlled in proportional power all the way from 1/1
or full power down to 1/32 power, and the flash also offers a stro-
boscopic effect. Second curtain synch is also offered for special
effect shooting. The 430 EZ has its own built-in exposure com-
pensation control; if the one on the camera has been set for the
built-in flash, this will not influence the 430 EZ when it is mounted
on the camera. The Guide Number for the 430 EZ is 140 at the
80mm position (ISO 100 in feet).

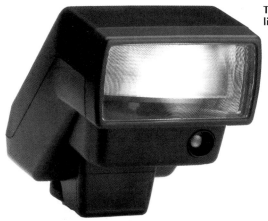

**The Canon Speed-
lite 300 EZ**

The Speedlite 300 EZ is a somewhat simpler flash with a not tilting, non-rotating flash head. It does, however have the automatic zoom feature, but extends only from 28mm to 70mm lenses. Manual control of the zoom head is not possible. The flash couples to the camera for TTL and A-TTL modes only, it has no manual control. It is also provided with a thyristor circuit as on the 430 EZ to make it faster in recycling and prolong battery life. The Guide Number for the 300 EZ is 100 at the 70mm position. The only special feature of this flash is that it does offer second curtain synch.

Although figuring out exposure using the Guide Number system is not all that difficult, many amateurs had problems with it and it does take time. For this reason fully automatic flash units have taken over most of the field for on-camera use. Canon first offered automatic flash exposure in the 1970s with special flash equipment for their TL and FT series cameras. Then in 1986 they offered their first fully automatic TTL flash, on the T90 camera.

TTL stands for Through The Lens and means that the determination of flash exposure is made through the camera lens just as the ordinary light measuring is done. A separate metering cell is located in the bottom of the mirror box and is mounted to point back at the film. During exposure this metering cell responds to flash light reflected from the film surface, and shuts off the flash when sufficient light has been delivered. This is a true TTL OTF system, with OTF meaning Off The Film.

Since the metering cell reads the light coming through from the flash after the lens diaphragm has closed down for the exposure, it can read the light accurately at any lens aperture and with any sort of lens. Nothing matters except that the right amount of light reaches the film. This system can also work correctly with any shutter speed from 1/200 on down to 30 seconds and even on BULB. The Canon speedlites also have an added enhancement to simple TTL flash operation, and in the P, Av, Tv, as well as with the Green Zone and pictorial modes, these flash units offer A-TTL operation.

As I have already explained, TTL flash control is an excellent system. The flash is metered and controlled during the exposure the provide accurate and very fast operation. With A-TTL control (Advanced TTL) the ambient light exposure is measured as well and is fully integrated with the TTL flash exposure for the ideal mix of the two.

By setting the flash for a reduced exposure, from 1/3 to 2/3 reduction, it is possible to use A-TTL operation for full automated fill flash outdoors in bright sun. So long as the flash is turned on the camera will not set a shutter speed faster than 1/200 second and will use the lens diaphragm to reduce light if a faster speed would be required. With the Canon Off Camera Shoe Cord the 430 EZ or 300 EZ flash can be used off camera, with all operations retained. I normally use the 430 EZ flash for my outdoor fill flash photography, and mount the flash on the top bar of the Stroboframe System 2000 bracket. I mount a flash diffuser on the front of the flash and operate the flash through the Off Camera Shoe Cord in the A-TTL mode with the camera set for P or Av modes. This has always produced exceptional results for me with a variety of different EOS models in recent years.

If you do not want ambient light entered into the exposure but wish to maintain flash as the primarly light source, you should activate Custom Function #9, and the camera will then provide you with 1/200 second shutter speed whenever the flash is activated (but not in the Green Zone or pictorial modes).

When you are using the 430 EZ flash with the head tilted or swung for bounce flash, the flash unit will emit a small dosed flash when you first press the shutter release button partway down. This is a test flash to determine if there will be sufficient flash light for a good exposure. If the light is sufficient, both shutter speed and

aperture will remain constant in the viewfinder. If there is insufficient light one or both numbers will flash as a warning. Remember that the intensity of the flash is determined by the total distance the light has to travel, not the distance from the camera to the subject, so if you attempt to bounce off a too distant surface there will not be enough light to properly expose your subject.

In direct flash use, every time you let the camera come to focus the distance range which the flash can cover will be displayed on the LCD panel on the back of the flash. By looking at the focusing scale on the camera lens and checking this scale, you can be sure not to exceed the range of the flash.

Although rarely required in these automatic days, the 430 EZ flash can be switched over to manual control. In the manual flash mode it can deliver full flash power, or can be set to produce a fractional value between 1/1 and 1/32 power. The chosen level is shown on the LCD panel of the flash. This manual flash control can only be used in the P, Tv, Av, M, and X modes. If you switch the camera to the Green Zone or pictorial modes the flash is automatically switched back to A-TTL automatic operation. When you use the manual flash control, after you have allowed the camera to focus, the focusing distance and proper lens aperture for correct exposure will be displayed on the LCD panel on the flash.

One use of this manual control is in the taking of fast sequence photos with high speed film. For example, with a film with a speed of ISO 800 (Ektachrome 800/1600 P) with an 80mm lens, lens aperture of f/4, and flash set to 1/16 you can photograph at about 25 feet. If the batteries are fresh, you can fire off ten or twelve frames at five frames per second and the flash will keep up with you. Pause a few moments, and you can do it again. However, with ISO 100 film the distance range for the same shrinks down to about eight feet.

The EOS A2E/A2/5 with Studio Lights and other Flash Features

With the EOS A2E/A2/5 we see for the first time Canon's unique X mode. In this mode the camera will not set a shutter speed which will not synchronize with flash, and will not set a speed below

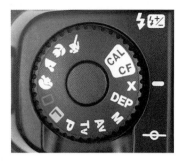

1/60 second, so this mode is obviously intended for use with flash as the main light source. Since I do a lot of studio photography, I was delighted to find this mode on the new camera. It lets me use the main control wheel to quickly set my lens aperture and not have to worry that I might accidentally change the shutter speed to one which will not work with my flash equipment.

The EOS A2E/A2/5 is the only EOS other than the EOS-1 which also has a standard PC connection socket. This is under a threaded cap on the left end of the camera, and will accept any standard PC type cord. Some will use this to connect the camera to their studio flash equipment, but I have learned by long bad experience never to do this. It is far too easy to pull a light stand over, pull a camera off a counter onto the floor, or have someone trip over these damnable dangling cords. They should be banished from your studio. Instead, for years now I have used the infrared triggering systems made by Wein in my studios. This system consists of a small transmitter which fits into the hot shoe of your camera, and a small receiver which attaches to your flash. The transmitter is actually a very small electronic flash unit which emits infrared instead of visible light. The receiver is sensitive to this frequency of infrared, and fires your flash when it senses the pulse from the transmitter. Transmitters are available with multiple channels, so you can turn some flash equipment on and off from the camera. After using these for a while, I can't imagine going back to old fashioned synch cords. As another bonus, these units protect your camera. If the flash trigger voltage is too high it can damage sensitive switches in your camera's triggering system, and a malfunctioning flash can short circuit through the synch cord and destroy a camera or even deliver a nasty shock to the photographer. With the Wein transmitter/receiver system, a malfunctioning flash can damage only the inexpensive receiver.

An excellent example of the proper use of fill flash. ⇨

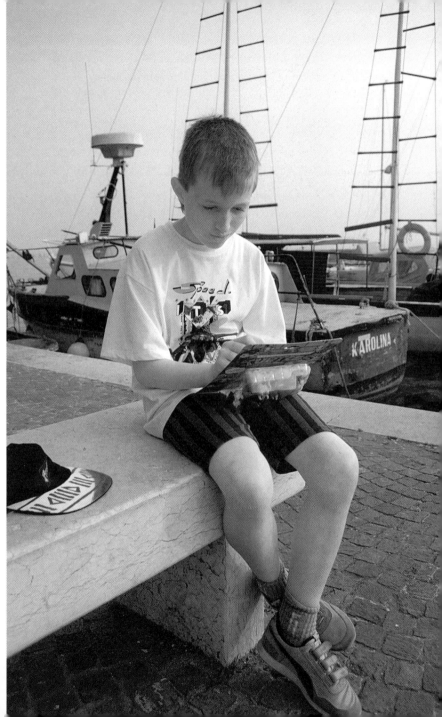

Second Curtain Synch

Both the 300 EZ and 430 EZ Speedlites as well as the built-in flash of the EOS A2E/A2/5 can be set for second curtain synch. This means that the flash will fire not when the shutter first comes fully open, but instead just an instant before it closes. This means that you can use a long exposure at a relatively high ambient light level and have your subject move around and then freeze a sharp flash image of the same subject at the end of the exposure. Any moving subject is a possible subject for this sort of image, which has been much seen in advertising in recent years. By having the flash fire at the end of the exposure you produce images in which the streaks seem to follow the subject, not preceed it as with normal flash synch.

The key to making this sort of image successful is experimentation, shooting many images to get a few which work. Since the best effects are often achieved when the flash is off camera, the Canon Off Camera Shoe Cord may be used to put the flash at a different angle to the camera. Also, because the built-in flash offers second curtain synch, it is possible to use the camera with studio flash equipment for second curtain synch by using easily available slave triggers to activate the studio flash units from the light pulse of the built-in flash. To prevent the built-in flash from having too much influence on the overall exposure, you can use its compensation control to dial it down to minimum intensity.

Manual Control of Flash Coverage

On the 300 EZ and 430 EZ flash units, the flash head automatically zooms so that the light coverage it produces matches the image area of the lens in use. On the 430 EZ it is also possible to manually control this, and either increase or decrease the flash coverage on demand. To achieve particularly soft light inside large rooms you may want to set the flash head for its 24mm position even though you are using a 50mm or longer lens, since the broad light from the 24mm coverage will bounce from walls and other surfaces and throw extra softened light back on your subject. It is also possible to set the flash head for 80mm when using a wide angle lens to emphasize a central subject in a shaft of light and let everything else fade to dark.

Strobe Effect

I very often hear all electronic flash units referred to by the generic term "strobe". This is very incorrect. Ordinary units should be called electronic flash or electronic flash units. Properly "strobe" is a short form of stroboscope, and refers only to a rapidly repeating type of electronic flash, such as the ones which used to be so popular in discos.

Now the Canon 300 EZ and 430 EZ have a special mode in which they are truly strobes. On the 430 EZ you can set the rate of flashes up to ten flashes per second. The flash will then display the proper distance for the film speed and aperture in use. Regardless of the duration of the exposure the maximum number of flashes in each strobe sequence is limited to twenty.

The Macro Ring Lite ML-3

The Macro Ring Lite ML-3 is intended for use with any of the EOS cameras with the 50mm f/2.5 Macro lens. It may also be used on the 100mm f.2.8 Macro and some other EOS lenses with an adapter (available for 52mm and 58mm threads). A very unusual feature for any ring flash is the built-in focusing light on the ML-3. This light provides extra light for autofocus or manual focusing and automaticaly switches off when the shutter is fired or after twenty seconds if no photo is taken to conserve battery power. The focusing lamp may be switchd off entirely when not needed.

While Canon calls this a Ring Lite, it really isn't in the traditional sense. Most ring lites use a circular flash tube for even, shadowless illumination. The ML-3 instead has two small flash tubes mounted on either side of the support ring which attaches to the lens. These two flash tubes may be fired together or independently. Using both tubes provides a very flat illumination resembling that of true ring lites, while firing only one tube provides subject modeling.

The ML-3 consists of two sections, the ring with flash tubes which attaches to the lens, and the power pack which attaches to the camera's hot shoe. A connecting cable runs between the two parts.

The ML-3 operates with any EOS camera for automatic TTL (but not A-TTL) flash in all exposure modes which support flash. It has a Guide Number of 11 in meters and 36 in feet at ISO 100, making

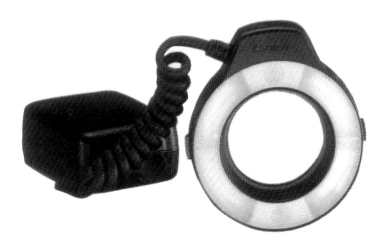

The Canon Macro Ring Lite ML-3 which is specially designed for closeup photography. Photo courtesy of Canon.

it powerful enough for use as a special effects flash at moderate distances as well as a macro flash.

The ML-3 is powered by four AA cells, either alkaline or NiCd. Alkaline cells will provide about 100 flashes with recycle times between 0.2 and 13 seconds depending on subject distance. NiCd cells provide only about 45 flashes but speed up recycle times to 0.2 to 6 seconds. The ML-3 weighs about a pound without batteries (470 g).

Flash Accessories

Flash accessories are often the little things which make the difference of whether a photo can be taken or not. For those times when on-camera flash is just not right, Canon offers two different ways of getting the flash away from the camera. The first is rather complex (and expensive) and consists of three parts, the Flash Shoe Adapter, a connecting cable, and the Flash Foot Adapter.

The Flash Shoe Adapter fits into the hot shoe on the camera, the connecting cable plugs into it, and the Flash Foot Adapter attaches to the other end of the cable. The Flash Foot Adapter has its own hot shoe into which the flash fits, and has a 1/4"-20 threaded socket on its bottom for attachment to a support. If one flash is not enough, a multiple flash adapter plate on the Flash Shoe Adapter has sockets for three cables which each with their own added Flash Foot Adapter can accept a flash. Cables to work with this system come in 600mm (about two feet) and 3000mm (about ten feet) lengths. Up to three of the long cables can be connected together for a maximum distance from camera to flash of nine meters (about 30 feet). When used with this system, the flash loses its A-TTL, auto zoom head, second curtain synch, and preflash features.

There is also a second system for getting the flash off the camera, and this is the one I use. It is called Off Camera Shoe Cord and has a camera fitting, flash fitting and cable all in one. The cable is coiled and will stretch to about three feet. This complete unit is far less expensive than the system described above and maintains all flash functions as well. Several of these cords can be linked together for greater flash distance. The only limitation of this system is that you can use only one flash with it.

If you often make many flash photographs with the 430 EZ, it may make sense to add the Transistor Pack E, which attaches to a socket on the front of the 430 EZ with a coiled cable. The pack itself is carried on your belt and is powered by either 6 C size cells or by a NiCd rechargeable pack. This device greatly increases the number of flashes and speeds up recycling. I have used one with great success for several years now. Just recently Canon introduced a much smaller version of the same product, this one accepting AA cells instead and being pocket sized. It should be a nice break from the larger one and I am anxious to have a chance to try it out.

Appendix

Other Accessories

Interchangeable Viewfinder Screens

Although autofocus is right for most photography, there are some situations in which manual focus is preferred. For those occasions you may find that the standard viewing screen supplied with the EOS A2E/A2/5 is just not right. For this reason Canon offers four alternate screens which are easily changed through the lens mount with the special tweezer-tool supplied with the screens.

The Screen with Focusing Sensor Marks has precise markings of the position and shape of the autofocus sensors marked on it. Some may prefer it for general shooting.

The Matte Screen with Grid has horizontal and vertical scribed lines forming a grid. Essential for architectural photography and particularly useful with the Tilt-Shift lenses. Also useful in copying work with macro lenses.

The Matte Screen with Scale is primarily intended for use when the camera is mounted on a microscope or other instrument. The horizontal and vertical scale lines make it possible to determine precise magnification factors for high precision work.

The All Matte Screen is a simple, plain screen with no marks on it at all. Preferred by some photographers who find screen markings to be distracting. Usable for all general photography.

Electronic Release

On the right end of the camera is a small round cap which screws off to reveal a socket with three pins. This is for attachment of the Canon Remote Switch 60T3. The Remote Switch 60T3 is the modern replacement for the old mechanical cable release we all used to use, and can be used to fire the camera without vibration and also to fire the camera from a distance if connected to the Extension Cord 1000T3 which is 10 meters (about 33 feet) in length.

Data Back

The camera back on the EOS A2E/A2/5 can not be removed, so no accessory data back is possible. However, in some parts of the world the EOS 5 is also available in a second model, the EOS 5 QD, with a permanently attached quartz data back.

This has a built-in quartz clock and calendar set up to carry you through the year 2029. When that year comes you must throw the camera away, for it will declare itself obsolete by refusing to date your images any longer!

This quartz back will imprint as you wish: year/month/day, day/hour/minute, month/day/year or day/month/year. Of course you can switch it off and imprint nothing. The desired imprint appears in the lower right corner of your image in orange.

Tips on Film Choices

It is at the same time a blessing and somewhat of a curse that we have so many different film types available today. Choices were much easier in earlier times when there were only a few different types of film on the market. Today there is very much confusion about which film to use, and my students at photo workshops are always asking my opinion on which is the best film. I also get many calls and letters every month from magazine readers wanting advice on this subject.

First of all, the choice of film type depends primarily on the sort of image you wish to produce. You must have that firmly in mind before committing to a film type, or you will certainly be disappointed much of the time.

The first choice to make is whether you want a black and white or a color image. I have had many students say that since we see in color, why even bother with black and white? In fact, black and white photographs have a subtle quality of their own which can not be duplicated by color. Saying that we should only photograph in color makes as much sense as telling an artist that he must not work in pencil, charcoa,l or pen and ink. Certain images simply lend themselves better to a black and white rendition.

Today's black and white films are of a quality which could not have been imagined just a few years ago. Advancements in crystal

growth technology have enabled manufacturers to produce films today with a full ISO speed of 400, but which are finer in grain than the ISO 100 films of the past. Examples of these new generation black and white films are Fuji Neopan 400, Ilford 400 Delta and Kodak T-Max 400. Kodak and Fuji also offer even faster films which use the new technology, Kodak's T-Max P3200 and Fuji's Neopan 1600. Many photographers have simply standardized on one of the new 400 speed films and use it for everything.

Not only have 400 speed films profited from new technology, but there are also some new films rated at ISO 100 which have grain so fine that is actually is better than ISO 25 films from the past. Ilford has a 100 Delta and Kodak has a T-Max 100 which are truly spectacular films. I have used both extensively, and now consider Ilford's 100 Delta my standard film for all general black and white photography.

There is also one special category of black and white films, the chromogenic black and white films, which is at the moment represented only by Ilford's XP-2. XP-2 has a nominal speed of ISO 400, but unlike all other black and white films it is processed in C-41 color chemicals. This produces a negative in which the image is formed from clouds of colored dye, just as in color films, rather than grains of silver as in all other black and white films. The result is extremely fine grain with a very long tonal scale. This film can also be exposed at a variety of different EI speeds, ranging from about 100 to 1600, with no change in processing.

I use this remarkable film whenever I need to make black and white photos of very contrasty scenes, since it will accept such scenes without losing highlight or shadow detail, impossible with other films. I do not like to use it, however, with low contrast subjects since the resulting negatives can be very flat and hard to print. In the studio with electronic flash I rate it at EI 200, which actually makes the grain smaller and boosts the contrast a little.

However, let me say that you will never be happy with black and white photography unless you set up your own darkroom and do your own printing. Having someone else make your prints simply loses too much of the creative control which can be exercised in the darkroom.

Now, that being said about black and white, you may decide to use color film anyway. If you do, you have two main choices you must make and then a whole assortment of secondary choices.

Color films come in two basic types, color negative (for making color prints) and color transparency (or slide). Color slides are necessary if you wish to project the images with a slide projector, and are generally preferred by printers for publication. It used to be that printers would only work from color slides, but that is no longer the case and most will now work with high quality color prints. If the printed page size is not very large, reproduction from color prints can be excellent, but for larger printed size such as glossy magazines and posters, slides are still preferred.

Color print films are readily available in speeds ranging from ISO 25 up to ISO 3200. The same rules apply as with any other film: the lower the ISO number the finer the grain and the greater the resolving power to render fine detail. Also, generally speaking, the lower the ISO the higher the contrast. Color print films also come in two versions, amateur and professional. Do not be confused by this, the professional film does not necessarily provide better colors. It is simply more carefully matched to the needs of the professional, and is usually refrigerated or frozen to hold it at its peak color balance prior to exposure. Professional color films are issued on the assumption that the film will be exposed within a short time of removal from refrigeration, and then processed promptly. If you are the type who leaves film in the camera for months at a time, you probably should not use professional films.

There are other variations in color negative films. For example, Fuji makes a film called Reala which uses extra dye layers to mimic the way in which the human eye sees colors, and Reala is an exceptional film for use in mixed lighting. It has an ISO speed of 100. Agfa has their Triade films, with a 50 speed Ultra, for very intense colors, a 125 and 200 speed Optima for general use and a 160 speed Portrait film, specially made for best skin colors. Kodak has, of course, a broad range of color negative films in both amateur and professional versions. Konica has films ranging from an ISO 50 called Impressa, with very rich colors and fine grain, up to a 3200 speed film for very dim light.

Again, I think the fullest realization from color negative films comes when you have your own darkroom and make your own prints. In my own darkroom I can work with my color prints to make the skin tones exactly as rosy as I want, make a rose as red as I like, make a sky as blue as I like, and so on. With modern equipment, color printing is not nearly as difficult as it used to be,

and with the newest RA type papers, it is even faster than black and white.

There are only two types of color slide films today that you are likely to encounter. The first and oldest is Kodak's Kodachrome films, available in several ISO speeds. Kodachrome films are actually fine grained black and white films which have the colors added by dye infusion during processing. Kodachrome processing is very complicated and only done by a few labs. It used to be that Kodachrome was the standard for all professional color slide photography, but the difficulty of processing has brought changes in this. Unless you live in a very big city, it is unlikely that you can get Kodachrome processed the same day or overnight.

All of the other current color slide films use the process called E-6, a relatively simple process using six chemical steps. You can even buy chemical kits and process your own E-6, and there are shortened versions which use only three chemicals. In all E-6 films the dye precursers are added to the film during manufacture and are converted to visible dyes during processing. This makes processing less difficult than that for Kodachrome. it still requires care in following directions and monitoring temperature closely, and you may prefer simply to drop your films off at a good E-6 lab. In most places you can have E-6 done the same day or overnight.

Today everyone is concerned with the longevity of their images. Kodachrome films still have an edge in usable life if stored in the dark, but Ektachrome films will last longer if projected frequently.

The same basic rules apply to color slide films; the slower films are finer in grain and contrastier. As with color negative films, slide films come in amateur and professional versions. In most cases the films are identical, but the professional variants are kept refrigerated or frozen and released at their peak of color balance. Professional films should be exposed promptly and processed promptly. Fuji makes one exceptional film called Velvia which has an ISO of 50 and produces exceptionally saturated colors and extremely fine grain. Fuji professional films are actually different from the amateur versions. In this case the professional versions are coated onto a different plastic base, with a small amount of neutral density. In all normal uses this makes no difference at all, but it helps the printer to reproduce the films with more accurate colors. Most of my work for publication has been done on Fuji

professional films, and I have had several printers and separators tell me that they preferred to work with them.

The rules of the game in color slide film have just been changed at the time of writing. Kodak has produced an entirely new type of color slide film called Panther in Europe and Lumiere in North America. This new type of film has a dramatic improvement in grain and color. Unfortunately, testing samples did not arrive in time for me to include personal comments on these new films in this text.

Color slide films also come in versions balanced for different types of light. The usual ones are balanced for daylight and electronic flash. However, there are special ones which are intended for use with tungsten-filament lights and these are called Tungsten films for that reason. They work best in studios when tungsten photofloods are the light source, and sometimes can provide a very useful color rendition when used with ordinary household lights (not fluorescent!). If used outdoors, they give an overall blue color to everything, and this can sometimes be used for artistic effects. Similarly, daylight films exposed under tungsten light will have an overall yellow-orange color, an this is sometimes used intentionally for effect. Filters are available to correct either type of film for use under the other sorts of light.

Once you have finished with your photos, you must not hide them away in dusty drawers. Pictures are meant to be looked at. If you make color prints, put together an attractive album of your best work to show your family and friends. If you have special color photos which really excite you, have large prints made and put them up on your walls. If you take color slides, put together a slide show.

If you get really excited about slide shows you may want to look into purchasing twin projectors and using a synchronizer to operate them automatically to a musical score or narration on a tape recorder. Devices to make all of this possible are available from many suppliers, and Rollei actually makes a twin projector with built-in programming cards which can memorize and play back the entire program. Only your imagination is the limit here, with a variety of frame masks available for special effects, the capability for dissolves, superimposed images and so forth.

If you have taken your photos as slides and find that you would like to have a print for display, this can be easily done. Many labs

specialize in making high quality color prints from slides and in some cases these are even better than prints from negatives.

The point about this is that photography is a creative process and you should be excited about it. You are creating something unique each time you press the shutter release button. That particular photograph has never existed before and will never exist again, it is uniquely yours!

Acknowledgements

My first thanks must go to Mr. Herbert Kaspar on whose German original this book is based.

I would like to express my sincerest thanks for the assistance and support provided to my by Canon USA in this and many other projects. Particular thanks go to Mr. Dave Metz, National Manager, Professional Markets Group, Camera Division, Canon USA, for his long-standing support and friendship. Special thanks go to Mr. Chuck Westfall, Technical Information Specialist, Camera Division, Canon USA, for reading the pertinent sections of this manuscript and for suggesting corrections and changes which greatly improved the clarity of the text.

Bob Shell

March 1993, Radford, VA, USA

Elle le suivit sans un mot. La patronne, tout en tricotant, regardait obstinément le remorqueur. Il était visible qu'à son gré les choses prenaient un tour déplaisant.

— Là.

Il lui désigna une table. Elle s'assit, et lui en face d'elle.

— Merci, murmura-t-elle.

Dans la salle, il faisait la pénombre fraîche d'un début d'été.

— Je suis revenue, voyez.

Dehors, très près, un enfant siffla. Elle sursauta.

— Je voudrais que vous preniez un autre verre de vin, dit l'homme, les yeux sur la porte.

Il commanda le vin. La patronne s'exécuta sans un mot, déjà lassée sans doute du dérèglement de leurs manières. Anne Desbaresdes s'adossa à sa chaise, s'abandonna au répit que lui laissait sa peur.

— Il y a maintenant trois jours, dit l'homme.

Elle se redressa avec effort et but de nouveau son vin.

— C'est bon, dit-elle, bas.

Les mains ne tremblèrent plus. Elle se redressa encore, s'avança légèrement vers lui qui maintenant la regardait.

— Je voulais vous demander, vous ne travaillez donc pas aujourd'hui ?

— Non, j'ai besoin de temps en ce moment.

Elle eut un sourire d'une hypocrite timidité.

— Du temps pour ne rien faire ?

— Rien, oui.

La patronne était bien à son poste, derrière sa caisse. Anne Desbaresdes parla bas.

29

— La difficulté, c'est de trouver un prétexte, pour une femme, d'aller dans un café, mais je me suis dit que j'étais quand même capable d'en trouver un, par exemple un verre de vin, la soif...

— J'ai essayé de savoir davantage. Je ne sais rien.

Anne Desbaresdes s'exténua encore une fois à se ressouvenir.

— C'était un cri très long, très haut, qui s'est arrêté net alors qu'il était au plus fort de lui-même, dit-elle.

— Elle mourait, dit l'homme. Le cri a dû s'arrêter au moment où elle a cessé de le voir.

Un client arriva, ne les remarqua guère, s'accouda au comptoir.

— Une fois, il me semble bien, oui, une fois j'ai dû crier un peu de cette façon, peut-être, oui, quand j'ai eu cet enfant.

— Ils s'étaient connus par hasard dans un café, peut-être même dans ce café-ci qu'ils fréquentaient tous les deux. Et ils ont commencé à se parler de choses et d'autres. Mais je ne sais rien. Ça vous a fait très mal, cet enfant ?

— J'ai crié, si vous saviez.

Elle sourit, s'en souvenant, se renversa en arrière, libérée tout à coup de toute sa peur. Il se rapprocha de la table, lui dit sèchement :

— Parlez-moi.

Elle fit un effort, trouva quoi dire.

— J'habite la dernière maison du boulevard de la Mer, la dernière quand on quitte la ville. Juste avant les dunes.

— Le magnolia, à l'angle gauche de la grille, est en fleurs.

— Oui, il y en a tellement à cette époque-ci de

l'année qu'on peut en rêver et en être malade tout le jour qui suit. On ferme sa fenêtre, c'est à n'y pas tenir.

— C'est dans cette maison qu'on vous a épousée, il y a maintenant dix ans ?

— C'est là. Ma chambre est au premier étage, à gauche, en regardant la mer. Vous me disiez la dernière fois qu'il l'avait tuée parce qu'elle le lui avait demandé, pour lui plaire, en somme ?

Il s'attarda, sans répondre à sa question, à voir enfin la ligne de ses épaules.

— Si vous fermez votre fenêtre à cette époque-ci de l'année, dit-il, vous devez avoir chaud et mal dormir.

Anne Desbaresdes devint sérieuse plus que le propos, apparemment, ne l'exigeait.

— L'odeur des magnolias est si forte, si vous saviez.

— Je sais.

Il quitta des yeux la ligne droite de ses épaules, la quitta des yeux.

— Au premier étage, n'y a-t-il pas un long couloir, très long, qui est commun à vous et aux autres dans cette maison, et qui fait que vous y êtes ensemble et séparés à la fois ? *le couloir sépare les gens*

— Ce couloir existe, dit Anne Desbaresdes, et comme vous le dites. Dites-moi, je vous en prie, comment elle en est venue à découvrir que c'était justement ça qu'elle voulait de lui, comment elle a su à ce point ce qu'elle désirait de lui ?

Ses yeux revinrent aux siens, d'une fixité devenue un peu hagarde.

— J'imagine qu'un jour, dit-il, un matin à l'aube, elle a su soudainement ce qu'elle désirait de lui. Tout est devenu clair pour elle au point qu'elle lui

31

a dit quel serait son désir. Il n'y a pas d'explication, je crois, à ce genre de découverte-là.

Dehors, les jeux calmes de l'enfant continuaient. Le deuxième remorqueur était arrivé à quai. Dans le répit qui suivit l'arrêt de ses moteurs, la patronne bougea des objets sous le comptoir, avec ostentation, leur rappela le temps qui s'écoulait.

— C'est par ce couloir que vous disiez qu'il faut passer pour aller dans votre chambre ?

— C'est par ce couloir.

L'enfant entra en courant très vite, renversa sa tête sur l'épaule de sa mère. Elle ne prit pas garde à lui.

— Oh, que je m'amuse, dit-il. Il s'enfuit de nouveau.

— J'oubliais de vous dire combien je voudrais qu'il soit déjà grand, dit Anne Desbaresdes.

Il la servit de vin, lui tendit son verre, elle le but aussitôt.

— Vous savez, dit-il, j'imagine aussi qu'il l'aurait fait de lui-même un jour, même sans ses instances à elle. Qu'elle n'était pas seule à avoir découvert ce qu'elle désirait de lui.

Elle revint de loin à ses questions, harcelante, méthodiquement.

— Je voudrais que vous me disiez le commencement même, comment ils ont commencé à se parler. C'est dans un café, disiez-vous...

Les deux enfants jouaient à courir en rond, toujours sur l'avancée du quai.

— Nous avons peu de temps, dit-il. Les usines ferment dans un quart d'heure. Oui, je crois bien que c'est dans un café qu'ils ont commencé à se parler, à moins que ce soit ailleurs. Ils ont peut-être parlé de la situation politique, des risques de guerre, ou

bien d'autre chose encore de bien différent de tout ce qu'on peut imaginer, de tout, de rien. Peut-être pourrait-on boire encore un verre de vin avant que vous ne retourniez boulevard de la Mer.

La patronne les servit, toujours en silence, peut-être un peu vivement. Ils n'y prirent pas garde.

— Au bout de ce long couloir — Anne Desbaresdes parlait posément — il y a une grande baie vitrée, face au boulevard. Le vent la frappe de plein fouet. L'année dernière, pendant un orage, les vitres se sont cassées. C'était la nuit.

Elle se renversa sur sa chaise et rit.

— Que ce soit justement dans cette ville que ce soit arrivé... ah, comment se faire à cette idée !...

— C'est une petite ville, en effet. A peine le contingent de trois usines.

Le mur du fond de la salle s'illumina du soleil couchant. En son milieu, le trou noir de leurs ombres conjuguées se dessina.

— Alors ils ont parlé, dit Anne Desbaresdes, et parlé, beaucoup de temps, beaucoup, avant d'y arriver.

— Je crois qu'ils ont passé beaucoup de temps ensemble pour en arriver là où ils étaient, oui. Parlez-moi.

— Je ne sais plus, avoua-t-elle.

Il lui sourit de façon encourageante.

— Qu'est-ce que ça peut faire ?

De nouveau elle parla, avec application, presque difficulté, très lentement.

— Il me semble que cette maison dont nous parlions a été faite un peu arbitrairement, vous voyez ce que je veux dire, mais quand même en raison d'une commodité dont tout le monde devrait être satisfait.

33

— Au rez-de-chaussée il y a des salons où vers la fin mai, chaque année, on donne des réceptions au personnel des fonderies.

Foudroyante, la sirène retentit. La patronne se leva de sa chaise, rangea son tricot rouge, rinça des verres qui crissèrent sous l'eau froide.

— Vous aviez une robe noire très décolletée. Vous nous regardiez avec amabilité et indifférence. Il faisait chaud.

Elle ne fut pas surprise, frauda.

— Le printemps est exceptionnellement beau, dit Anne Desbaresdes, tout le monde en parlait déjà. Vous croyez quand même que c'est elle qui a commencé à le dire, à oser le dire et qu'ensuite il en a été question entre eux comme d'autre chose ?

— Je ne sais rien d'autre que vous. Peut-être en a-t-il été question une seule fois entre eux, peut-être en a-t-il été question tous les jours ? Comment le saurions-nous ? Mais sans doute sont-ils arrivés très exactement ensemble là où ils étaient il y a trois jours, à ne plus savoir du tout, ensemble, ce qu'ils faisaient.

Il releva la main, la laissa retomber près de la sienne sur la table, il la laissa là. Elle remarqua ces deux mains posées côte à côte pour la première fois.

— Voilà que j'ai encore bu trop de vin, se plaignit-elle.

— Ce grand couloir dont vous parliez reste parfois allumé très tard.

— Il m'arrive de ne pas arriver à m'endormir.

— Pourquoi allumer aussi ce couloir et pas seulement votre chambre ?

— Une habitude que j'ai. Je ne sais pas au juste.

— Rien ne s'y passe, rien, la nuit.

— Si. Derrière une porte, mon enfant dort.

Elle ramena ses bras vers la table, rentra les épaules, frileusement, ajusta sa veste.

— Il faut que je rentre peut-être, maintenant. Voyez comme c'est tard.

Il releva sa main, lui fit signe de rester encore. Elle resta.

— Quand c'est le jour, au petit matin, vous allez regarder à travers la grande baie vitrée.

— L'été, les ouvriers de l'arsenal commencent à passer vers six heures. L'hiver, la plupart prennent le car à cause du vent, du froid. Ça ne dure qu'un quart d'heure.

— La nuit, il ne passe jamais personne, jamais ?

— Quelquefois si, une bicyclette, on se demande d'où ça peut venir. Est-ce de la douleur de l'avoir tuée, qu'elle soit morte, que cet homme est devenu fou, ou autre chose s'est-il ajouté de plus loin à cette douleur, autre chose que les gens ignorent en général ?

— Sans doute qu'autre chose s'est en effet ajouté à sa douleur, autre chose que nous ignorons encore.

Elle se leva, se leva avec lenteur, fut levée, réajusta une nouvelle fois sa veste. Il ne l'aida pas. Elle se tint en face de lui encore assis, ne disant rien. Les premiers hommes entrèrent au café, s'étonnèrent, interrogèrent la patronne du regard. Celle-ci, d'un léger mouvement d'épaules, signifia qu'elle-même n'y comprenait pas grand-chose.

— Peut-être que vous ne reviendrez plus.

Quand à son tour il se releva et se redressa, Anne Desbaresdes dut remarquer qu'il était encore jeune, que le couchant se jouait aussi limpide dans ses yeux que dans ceux d'un enfant. Elle scruta à travers le regard leur matière bleue.

— Je n'avais pas pensé que je pourrais ne plus venir.

Il la retint une dernière fois.

— Souvent, vous regardez ces hommes qui vont à l'arsenal, surtout l'été, et la nuit, lorsque vous dormez mal, le souvenir vous en revient.

— Lorsque je me réveille assez tôt, avoua Anne Desbaresdes, je les regarde. Et parfois aussi, oui, le souvenir de certains d'entre eux, la nuit, m'est revenu.

Au moment où ils se quittèrent, d'autres hommes débouchaient sur le quai. Ceux-là devaient venir des Fonderies de la Côte, qui étaient plus éloignées de la ville que l'arsenal. Il faisait plus clair que trois jours avant. Il y avait des mouettes dans le ciel redevenu bleu.

— J'ai bien joué, annonça l'enfant.

Elle le laissa raconter ses jeux jusqu'à ce qu'ils aient dépassé le premier môle à partir duquel filait, sans une courbe, le boulevard de la Mer, jusqu'aux dunes qui marquaient sa fin. L'enfant s'impatienta.

— Qu'est-ce que tu as ?

Avec le crépuscule, la brise commença à balayer la ville. Elle eut froid.

— Je ne sais pas. J'ai froid.

L'enfant prit la main de sa mère, l'ouvrit, y enfouit la sienne dans une résolution implacable. Elle y fut contenue tout entière. Anne Desbaresdes cria presque.

— Ah, mon amour.

— Tu vas toujours à ce café maintenant.

— Deux fois.

— Mais tu vas y aller encore ?

— Je crois.

36

Ils croisèrent des gens qui rentraient, des pliants à la main. Le vent frappait de front.

— Moi, qu'est-ce que tu vas m'acheter ?

— Un bateau rouge à moteur, tu veux bien ?

L'enfant soupesa cet avenir en silence, soupira d'aise.

— Oui, un gros bateau rouge à moteur. Comment t'as trouvé ?

Elle le prit par les épaules, le retint comme il essayait de se dégager pour courir en avant.

— Tu grandis, toi, ah, comme tu grandis, comme c'est bien.

IV

Le lendemain encore, Anne Desbaresdes entraîna
son enfant jusqu'au port. Le beau temps continuait,
à peine plus frais que la veille. Les éclaircies étaient
moins rares, plus longues. Dans la ville, ce temps,
si précocement beau, faisait parler. Certains expri-
maient la crainte de le voir se terminer dès le len-
demain, en raison de sa durée inhabituelle. Certains
autres se rassuraient, prétendant que le vent frais
qui soufflait sur la ville tenait le ciel en haleine et
qu'il l'empêcherait encore de s'ennuager trop avant.

Anne Desbaresdes traversa ce temps, ce vent, elle
arriva au port après avoir dépassé le premier môle,
le bassin des remorqueurs de sable, à partir duquel
s'ouvrait la ville, vers son large quartier industriel.
Elle s'arrêta encore au comptoir alors que l'homme
était déjà dans la salle à l'attendre, ne pouvant sans
doute échapper encore au cérémonial de leurs pre-
mières rencontres, s'y conformant d'instinct. Elle
commanda du vin, dans l'épouvante encore. La
patronne, qui tricotait sa laine rouge derrière le
comptoir, remarqua qu'ils ne s'abordèrent que long-
temps après qu'elle fut rentrée et que leur apparente
ignorance l'un de l'autre se prolongea plus que la
veille encore. Qu'après même que l'enfant eut rejoint
son nouvel ami, elle dura.

— Je voudrais un autre verre de vin, réclama Anne Desbaresdes.

On le lui servit dans la désapprobation. Cependant, lorsque l'homme se leva, alla vers elle et la ramena dans la pénombre de l'arrière-salle, le tremblement des mains s'était déjà atténué. Le visage était revenu de sa pâleur habituelle.

— Je n'ai pas l'habitude, expliqua-t-elle, d'aller si loin de chez moi. Mais ce n'est pas de la peur. Ce serait plutôt, il me semble, de la surprise, comme de la surprise.

— Ça pourrait être de la peur. On va le savoir, dans la ville, tout se sait de la même façon, ajouta l'homme en riant.

Dehors, l'enfant cria de satisfaction parce que deux remorqueurs arrivaient côte à côte vers le bassin. Anne Desbaresdes sourit.

— Que je bois du vin en votre compagnie, termina-t-elle — elle rit subitement dans un éclat —, mais pourquoi ai-je tant envie de rire aujourd'hui ?

Il s'approcha de son visage assez près, posa ses mains contre les siennes sur la table, cessa de rire avec elle.

— La lune était presque pleine cette nuit. On voyait bien votre jardin, comme il est bien entretenu, lisse comme un miroir. C'était tard. Le grand couloir du premier étage était encore allumé.

— Je vous l'ai dit, parfois je dors mal.

Il joua à faire tourner son verre dans sa main afin de lui faciliter les choses, de lui laisser l'aise, comme il crut comprendre qu'elle le désirait, de le regarder mieux. Elle le regarda mieux.

— Je voudrais boire un peu de vin — elle réclama plaintivement, comme déjà lésée. Je ne

savais pas que l'habitude vous en venait si vite. Voilà que je l'ai presque, déjà.

Il commanda le vin. Ils le burent ensemble avec avidité, mais cette fois rien ne pressa Anne Desbaresdes de boire, que son penchant naissant pour l'ivresse de ce vin. Elle attendit un moment après l'avoir bu et, avec la voix douce et fautive de l'excuse, elle recommença à questionner cet homme.

— Je voudrais que vous me disiez maintenant comment ils en sont arrivés à ne plus même se parler.

L'enfant arriva dans l'encadrement de la porte, s'assura qu'elle était encore là, s'en alla de nouveau.

— Je ne sais rien. Peut-être par de longs silences qui s'installaient entre eux, la nuit, un peu n'importe quand ensuite, et qu'ils étaient de moins en moins capables de surmonter par rien, rien.

Le même trouble que la veille ferma les yeux d'Anne Desbaresdes, lui fit, de même, courber les épaules d'accablement.

— Une certaine nuit, ils tournent et retournent dans la chambre, ils deviennent comme des bêtes enfermées, ils ne savent pas ce qui leur arrive. Ils commencent à s'en douter, ils ont peur.

— Rien ne les satisfait plus.

— Ce qui est en train de se passer, ils en sont débordés, ils ne savent pas le dire tout de suite. Peut-être qu'il leur faudra des mois, pour le savoir.

Il attendit un instant avant de lui parler de nouveau. Il but un verre entier de vin. Pendant qu'il buvait, dans ses yeux levés le couchant passa avec la précision du hasard. Elle le vit.

— Devant une certaine fenêtre du premier étage, dit-il, il y a un hêtre qui est parmi les plus beaux arbres du parc.

40

— Ma chambre. C'est une grande chambre.

Sa bouche à lui fut humide d'avoir bu et elle eut à son tour, dans la douce lumière, une implacable précision.

— Une chambre calme, dit-on, la meilleure.

— En été, ce hêtre me cache la mer. J'ai demandé qu'un jour on l'enlève de là, qu'on l'abatte. Je n'ai pas dû assez insister.

Il chercha à voir l'heure au-dessus du comptoir.

— Dans un quart d'heure, ça sera la fin du travail, et vous rentrerez très vite après. Nous avons vraiment très peu de temps. Je crois, ça n'a pas d'importance, que ce hêtre soit là ou non. A votre place, je le laisserai grandir avec son ombre chaque année un peu plus épaisse sur les murs de cette chambre qu'on appelle la vôtre, m'a-t-il semblé comprendre, par erreur.

Elle s'adossa de tout son buste à la chaise, d'un mouvement entier, presque vulgaire, se détourna de lui.

— Mais, parfois, son ombre est comme de l'encre noire, protesta-t-elle doucement.

— Ça ne fait rien, je crois.

Il lui tendit un verre de vin tout en riant.

— Cette femme était devenue une ivrogne. On la trouvait le soir dans les bars de l'autre côté de l'arsenal, ivre morte. On la blâmait beaucoup.

Anne Desbaresdes feignit un étonnement exagéré.

— Je m'en doutais, mais pas à ce point. Peut-être dans leur cas était-ce nécessaire ?

— Je le sais aussi mal que vous. Parlez-moi.

— Oui — elle chercha, loin. Parfois aussi, le samedi, un ou deux ivrognes passent boulevard de la Mer. Ils chantent très fort ou ils font des discours. Ils vont jusqu'aux dunes, au dernier réverbère, et ils

41

reviennent, toujours en chantant. En général, ils passent tard, lorsque tout le monde déjà dort. Ils s'égarent courageusement dans cette partie de la ville si déserte, si vous saviez.

— Vous êtes couchée dans cette grande chambre très calme, vous les entendez. Il règne dans cette chambre un désordre fortuit qui ne vous est pas particulier. Vous y étiez couchée, vous l'étiez.

Anne Desbaresdes se rétracta et, comme à son habitude parfois, s'alanguit. Sa voix la quitta. Le tremblement des mains recommença un peu.

— Ce boulevard va être prolongé au-delà des dunes, dit-elle, on parle d'un projet prochain.

— Vous y étiez couchée. Personne ne le savait. Dans dix minutes, ça va être la fin du travail.

— Je le savais, dit Anne Desbaresdes, et... ces dernières années, à quelque heure que ce soit, je le savais toujours, toujours...

— Endormie ou réveillée, dans une tenue décente ou non, on passait outre à votre existence.

Anne Desbaresdes se débattit, coupable, et l'acceptant cependant.

— Vous ne devriez pas, dit-elle, je me rappelle, tout peut arriver...

— Oui.

Elle ne cessa plus de regarder sa bouche seule désormais dans la lumière restante du jour.

— De loin, enfermé comme il est, face à la mer, dans le plus beau quartier de la ville, on pourrait se tromper sur ce jardin. Au mois de juin de l'année dernière, il y aura un an dans quelques jours, vous vous teniez face à lui, sur le perron, prête à nous accueillir, nous, le personnel des Fonderies. Au-dessus de vos seins à moitié nus, il y avait une fleur blanche de magnolia. Je m'appelle Chauvin.

42

Elle reprit sa pose coutumière, face à lui, accoudée à la table. Son visage chavirait déjà sous l'effet du vin.

— Je le savais. Et aussi que vous êtes parti des Fonderies sans donner de raisons et que vous ne pourrez manquer d'y revenir bientôt, aucune autre maison de cette ville ne pouvant vous employer.

— Parlez-moi encore. Bientôt, je ne vous demanderai plus rien.

Anne Desbaresdes récita presque scolairement, pour commencer, une leçon qu'elle n'avait jamais apprise.

— Quand je suis arrivée dans cette maison, les troènes y étaient déjà. Il y en a beaucoup. Quand l'orage approche, ils grincent comme l'acier. D'y être habituée, tenez, c'est comme si on entendait son cœur. J'y suis habituée. Ce que vous m'avez dit sur cette femme est faux, qu'on la trouvait ivre morte dans les bars du quartier de l'arsenal.

La sirène retentit, égale et juste, assourdissant la ville entière. La patronne vérifia son heure, rangea son tricot rouge. Chauvin parla aussi calmement que s'il n'avait pas entendu.

— Beaucoup de femmes ont déjà vécu dans cette même maison qui entendaient les troènes, la nuit, à la place de leur cœur. Toujours les troènes y étaient déjà. Elles sont toutes mortes dans leur chambre, derrière ce hêtre qui, contrairement à ce que vous croyez, ne grandit plus.

— C'est aussi faux que ce que vous m'avez dit sur cette femme ivre morte tous les soirs.

— C'est aussi faux. Mais cette maison est énorme. Elle s'étend sur des centaines de mètres carrés. Et elle est tellement ancienne aussi qu'on peut tout supposer. Il doit arriver qu'on y prenne peur.

43

Le même émoi la brisa, lui ferma les yeux. La patronne se leva, remua, rinça des verres.

— Dépêchez-vous de parler. Inventez.

Elle fit un effort, parla presque haut dans le café encore désert.

— Ce qu'il faudrait c'est habiter une ville sans arbres les arbres crient lorsqu'il y a du vent ici il y en a toujours toujours à l'exception de deux jours par an à votre place voyez-vous je m'en irais d'ici je n'y resterais pas tous les oiseaux ou presque sont des oiseaux de mer qu'on trouve crevés après les orages et quand l'orage cesse que les arbres ne crient plus on les entend crier eux sur la plage comme des égorgés ça empêche les enfants de dormir non moi je m'en irais.

Elle s'arrêta, les yeux encore fermés par la peur. Il la regarda avec une grande attention.

— Peut-être, dit-il, que nous nous trompons, peut-être a-t-il eu envie de la tuer très vite, dès les premières fois qu'il l'a vue. Parlez-moi.

Elle n'y arriva pas. Ses mains recommencèrent à trembler, mais pour d'autres raisons que la peur et que l'émoi dans lequel la jetait toute allusion à son existence. Alors, il parla à sa place, d'une voix redevenue tranquille.

— C'est vrai que, lorsque le vent cesse dans cette ville, c'est tellement rare qu'on en est comme étouffé. Je l'ai déjà remarqué.

Anne Desbaresdes n'écoutait pas.

— Morte, dit-elle, elle en souriait encore de joie.

Des cris et des rires d'enfants éclatèrent dehors, qui saluaient le soir comme une aurore. Du côté sud de la ville, d'autres cris, adultes ceux-là, de liberté, s'élevèrent, qui relayèrent le sourd bourdonnement des fonderies.

— La brise revient toujours, continua Anne Desbaresdes, d'une voix fatiguée, toujours et, je ne sais pas si vous l'avez remarqué, différemment suivant les jours, parfois tout d'un coup, surtout au coucher du soleil, parfois, au contraire, très lentement, mais alors seulement quand il fait très chaud, et à la fin de la nuit, vers quatre heures du matin, à l'aube. Les troènes crient, vous comprenez, c'est comme ça que je le sais.

— Vous savez tout sur ce seul jardin qui est à peu de choses près tout à fait pareil aux autres du boulevard de la Mer. Quand les troènes crient, en été, vous fermez votre fenêtre pour ne plus les entendre, vous êtes nue à cause de la chaleur.

— Je voudrais du vin, le pria Anne Desbaresdes, toujours j'en voudrais...

Il commanda le vin.

— Il y a dix minutes que c'est sonné, les avertit la patronne en les servant.

Un premier homme arriva, but au comptoir le même vin.

— A l'angle gauche de la grille, continua Anne Desbaresdes à mi-voix, vers le nord il y a un hêtre pourpre d'Amérique, je ne sais pas pourquoi du tout...

L'homme qui était au bar reconnut Chauvin, lui fit un signe de tête un peu gêné. Chauvin ne le vit pas.

— Dites-moi encore, dit Chauvin, vous pouvez me dire n'importe quoi.

L'enfant surgit, les cheveux en désordre, essoufflé. Les rues qui aboutissaient à cette avancée du quai résonnèrent de pas d'hommes.

— Maman, dit l'enfant.

— Dans deux minutes, dit Chauvin, elle va s'en aller.

L'homme qui était au bar essaya de caresser au passage les cheveux de l'enfant — celui-ci s'enfuit, sauvagement.

— Un jour, dit Anne Desbaresdes, j'ai eu cet enfant-là.

Une dizaine d'ouvriers firent irruption dans le café. Quelques-uns reconnurent Chauvin. Chauvin ne les vit encore pas.

— Quelquefois, continua Anne Desbaresdes, quand cet enfant dort, le soir je descends dans ce jardin, je m'y promène. Je vais aux grilles, je regarde le boulevard. Le soir, c'est très calme, surtout l'hiver. En été, parfois, quelques couples passent et repassent, enlacés, c'est tout. On a choisi cette maison parce qu'elle est calme, la plus calme de la ville. Il faut que je m'en aille.

Chauvin se recula sur sa chaise, prit son temps.

— Vous allez aux grilles, puis vous les quittez, puis vous faites le tour de votre maison, puis vous revenez encore aux grilles. L'enfant, là-haut, dort. Jamais vous n'avez crié. Jamais.

Elle remit sa veste sans répondre. Il l'aida. Elle se leva et, une fois de plus, resta là, debout près de la table, à son côté, à fixer les hommes du comptoir sans les voir. Certains tentèrent de faire à Chauvin un signe de reconnaissance, mais en vain. Il regardait le quai.

Anne Desbaresdes sortit enfin de sa torpeur.

— Je vais revenir, dit-elle.

— Demain.

Il l'accompagna à la porte. Des groupes d'hommes arrivaient, pressés. L'enfant les suivait. Il courut vers sa mère, lui prit la main et l'entraîna résolument. Elle le suivit.

46

Il lui raconta qu'il avait un nouvel ami, ne s'étonna pas qu'elle ne lui répondît pas. Face à la plage désertée — il était plus tard que la veille — il s'arrêta pour voir les vagues qui battaient assez fort ce soir-là. Puis il repartit.

— Viens.

Elle suivit son mouvement, repartit à son tour.

— Tu marches lentement, pleurnicha-t-il, et il fait froid.

— Je ne peux pas aller plus vite.

Elle se pressa autant qu'elle put. La nuit, la fatigue, et l'enfance, firent qu'il se blottit contre elle, sa mère, et qu'ils marchèrent ainsi, ensemble. Mais, comme elle voyait mal au loin, à cause de son ivresse, elle évita de regarder vers la fin du boulevard de la Mer, afin de ne pas se laisser décourager par une aussi longue distance.

To seems like elle a peur
de continuer, Celle
avance son enfant un
rappelle de sa vie
is en teathique mais en
même temps, l'ambivalen
se manleste.
ce besoin qu'elle
continue her reaching
towards him.

V

— Tu t'en souviendras, dit Anne Desbaresdes, ça veut dire modéré et chantant.

— Modéré et chantant, répéta l'enfant.

A mesure que l'escalier montait, des grues s'élevèrent dans le ciel vers le sud de la ville, toutes en des mouvements identiques dont les temps divers s'entrecroisaient.

— Je ne veux plus qu'on te gronde, sans ça j'en meurs.

— Je veux plus, moi aussi. Modéré et chantant.

Une pelle géante, baveuse de sable mouillé, passa devant la dernière fenêtre de l'étage, ses dents de bête affamée fermées sur sa proie.

— La musique, c'est nécessaire, et tu dois l'apprendre, tu comprends ?

— Je comprends.

L'appartement de Mademoiselle Giraud était suffisamment haut, au cinquième étage de l'immeuble, pour que le champ de ses fenêtres donnât de très loin sur la mer. A part le vol des mouettes, rien ne s'y profilait donc aux yeux des enfants.

— Alors, vous avez su ? Un crime, passionnel, oui. Asseyez-vous, Madame Desbaresdes, je vous en prie.

— Qu'est-ce que c'était ? demanda l'enfant.

48

— Vite, la sonatine, dit Mademoiselle Giraud.

L'enfant se mit au piano. Mademoiselle Giraud s'installa auprès de lui, le crayon à la main. Anne Desbaresdes s'assit à l'écart, près de la fenêtre.

— La sonatine. Cette jolie petite sonatine de Diabelli, vas-y. Quelle mesure, cette jolie petite sonatine ? Dis-le.

Au son de cette voix, aussitôt l'enfant se rétracta. Il eut l'air de réfléchir, prit son temps, et peut-être mentit-il.

— Modéré et chantant, dit-il.

Mademoiselle Giraud croisa les bras, le regarda en soupirant.

— Il le fait exprès. Il n'y a pas d'autre explication.

L'enfant ne broncha pas. Ses deux petites mains fermées posées sur ses genoux, il attendait la consommation de son supplice, seulement satisfait de l'inéluctabilité, de son fait à lui, de sa répétition.

— Les journées allongent, dit doucement Anne Desbaresdes, à vue d'œil.

— Effectivement, dit Mademoiselle Giraud.

Le soleil, plus haut que la dernière fois à cette même heure, en témoignait. De plus, la journée avait été assez belle pour qu'une brume recouvrît le ciel, légère, certes, mais précoce cependant.

— J'attends que tu le dises.

— Il n'a peut-être pas entendu.

— Il a parfaitement entendu. Vous ne comprendrez jamais une chose, c'est qu'il le fait exprès, Madame Desbaresdes.

L'enfant tourna un peu la tête vers la fenêtre. Il resta ainsi, de biais, à regarder la moire, sur le mur, du soleil reflété par la mer. Seule, sa mère pouvait voir ses yeux.

— Ma petite honte, mon trésor, dit-elle tout bas.

— Quatre temps, dit l'enfant, sans effort, sans bouger.

Ses yeux étaient à peu près de la couleur du ciel, ce soir-là, à cette chose près qu'il y dansait l'or de ses cheveux.

— Un jour, dit la mère, un jour il le saura, il le dira sans hésiter, c'est inévitable. Même s'il ne le veut pas, il le saura.

Elle rit gaiement, silencieusement.

— Vous devriez avoir honte, Madame Desbaresdes, dit Mademoiselle Giraud.

— On le dit.

Mademoiselle Giraud déplia ses bras, frappa le clavier de son crayon, comme elle faisait d'habitude depuis trente ans d'enseignement, et elle cria.

— Tes gammes. Tes gammes pendant dix minutes. Pour t'apprendre. Do majeur pour commencer.

L'enfant se remit face au piano. Ses mains se levèrent ensemble, se posèrent ensemble avec une docilité triomphante.

Une gamme en do majeur couvrit la rumeur de la mer.

— Encore, encore. C'est la seule façon.

L'enfant recommença encore d'où il était parti la première fois, à la hauteur exacte et mystérieuse du clavier d'où il fallait qu'il le fît. Une deuxième, une troisième gamme en do majeur s'éleva dans la colère de cette dame.

— J'ai dit, dix minutes. Encore.

L'enfant se retourna vers Mademoiselle Giraud, la regarda, tandis que ses mains restaient abandonnées sur le clavier, mollement.

— Pourquoi ? demanda-t-il.

Le visage de Mademoiselle Giraud, de colère, s'enlaidit tant que l'enfant se retourna face au

piano. Il remit ses mains en place et se figea dans une pose scolaire apparemment parfaite, mais sans jouer.

— Ça alors, c'est trop fort.

— Ils n'ont pas demandé à vivre, dit la mère — elle rit encore — et voilà qu'on leur apprend le piano en plus, que voulez-vous.

Mademoiselle Giraud haussa les épaules, ne répondit pas directement à cette femme, ne répondit à personne en particulier, reprit son calme et dit pour elle seule :

— C'est curieux, les enfants finiraient par vous faire devenir méchants.

— Mais un jour il saura ses gammes aussi — Anne Desbaresdes se fit réconfortante —, il les saura aussi parfaitement que sa mesure, c'est inévitable, il en sera même fatigué à force de les savoir.

— L'éducation que vous lui donnez, Madame, est une chose affreuse, cria Mademoiselle Giraud.

D'une main elle prit la tête de l'enfant, lui tourna, lui mania la tête, le força à la voir. L'enfant baissa les yeux.

— Parce que je l'ai décidé. Et insolent par-dessus le marché. Sol majeur trois fois, s'il te plaît. Et avant, do majeur encore une fois.

L'enfant recommença une gamme en do majeur. Il la joua à peine plus négligemment que les fois précédentes. Puis, de nouveau, il attendit.

— Sol majeur j'ai dit, maintenant, sol majeur.

Les mains se retirèrent du clavier. La tête se baissa résolument. Les petits pieds ballants, encore bien loin des pédales, se frottèrent l'un contre l'autre dans la colère.

— Tu n'as peut-être pas entendu ?

— Tu as entendu, dit la mère, j'en suis sûre.

51

L'enfant, à la tendresse de cette voix-là, ne résistait pas encore. Sans répondre, il souleva une fois de plus ses mains, les posa sur le clavier à l'endroit précis où il fallait qu'il le fît. Une, puis deux gammes en sol majeur s'élevèrent dans l'amour de la mère. Du côté de l'arsenal, la sirène annonça la fin du travail. La lumière baissa un peu. Les gammes furent si parfaites que la dame en convint.

— Puis, en plus du caractère, ça lui fait les doigts, dit-elle.

— Il est vrai, dit tristement la mère.

Mais, avant la troisième gamme en sol majeur, l'enfant s'arrêta une nouvelle fois.

— J'ai dit trois fois. Trois.

L'enfant, cette fois, retira ses mains du clavier, les posa sur ses genoux et dit :

— Non.

Le soleil commença à s'incliner de telle façon que la mer, d'un seul coup, obliquement, s'illumina. Un grand calme s'empara de Mademoiselle Giraud.

— Je ne peux rien vous dire d'autre que ceci : je vous plains.

L'enfant, subrepticement, glissa un regard vers cette femme tant à plaindre et qui riait. Puis il resta fixé à son poste, le dos nécessairement tourné à la mer. L'heure fléchit vers le soir, la brise qui se levait traversa la chambre, contradictoire, fit frémir l'herbe des cheveux de cet enfant obstiné. Les petits pieds, sous le piano, se mirent à danser à petits coups, en silence.

— Qu'est-ce que ça peut faire une fois de plus, une seule gamme, dit la mère en riant, une seule fois de plus ?

L'enfant se retourna vers elle seule.

— J'aime pas les gammes.

52

Mademoiselle Giraud les regarda tous les deux, alternativement, sourde à leurs propos, découragée de l'indignation même.

— J'attends, moi.

L'enfant se remit face au piano, mais de biais, le plus loin qu'il pouvait se le permettre de cette dame.

— Mon amour, dit sa mère, une fois encore.

Les cils battirent sous l'appellation. Cependant, il hésita encore.

— Plus les gammes, alors.

— Justement les gammes, tu vois.

Il hésita puis, alors qu'elles en désespéraient tout à fait, il s'y décida. Il joua. Mais l'isolement désespéré de Mademoiselle Giraud resta un instant égal à lui-même.

— Voyez-vous, Madame Desbaresdes, je ne sais pas si je pourrai continuer à m'en occuper.

La gamme en sol majeur fut de nouveau exacte, peut-être plus rapide cette fois que la fois précédente, mais d'un rien.

— C'est une question de mauvaise volonté, dit la mère, j'en conviens.

La gamme se termina. L'enfant, dans le désintérêt parfait du moment qui passait, se releva légèrement de son tabouret et tenta l'impossible, d'apercevoir ce qui se passait en bas, sur le quai.

— Je lui expliquerai qu'il le faut, dit la mère, faussement repentante.

Mademoiselle Giraud se fit déclamatoire et attristée.

— Vous n'avez rien à lui expliquer. Il n'a pas à choisir de faire ou non du piano, Madame Desbaresdes, c'est ce qu'on appelle l'éducation.

Elle frappa sur le piano. L'enfant abandonna sa tentative.

— Ta sonatine maintenant, dit-elle, lassée. Quatre temps.

L'enfant la joua comme les gammes. Il la savait bien. Et malgré sa mauvaise volonté, de la musique fut là, indéniablement.

— Que voulez-vous, continua Mademoiselle Giraud, par-dessus la sonatine, il y a des enfants avec lesquels il faut être très sévère, sans ça on n'en sort pas.

— J'essaierai, dit Anne Desbaresdes.

Elle écoutait la sonatine. Elle venait du tréfonds des âges, portée par son enfant à elle. Elle manquait souvent, à l'entendre, aurait-elle pu croire, s'en évanouir.

— Ce qu'il y a, voyez-vous, c'est qu'il se croit permis de ne pas aimer faire du piano. Mais je sais bien que ce que je vous dis ou rien, c'est la même chose, Madame Desbaresdes.

— J'essaierai.

La sonatine résonna encore, portée comme une plume par ce barbare, qu'il le voulût ou non, et elle s'abattit de nouveau sur sa mère, la condamna de nouveau à la damnation de son amour. Les portes de l'enfer se refermèrent.

— Recommence et bien en mesure, cette fois, plus lentement.

Le jeu se ralentit et se ponctua, l'enfant se laissa prendre à son miel. De la musique sortit, coula de ses doigts sans qu'il parût le vouloir, en décider, et sournoisement elle s'étala dans le monde une fois de plus, submergea le cœur d'inconnu, l'exténua. Sur le quai, en bas, on l'entendit.

— Il y a un mois qu'il est dessus, dit la patronne. Mais c'est joli.

Un premier groupe d'hommes arrivait vers le café.

— Oui, il y a bien un mois, reprit la patronne. Je le sais par cœur.

Chauvin, au bout du comptoir, était encore le seul client. Il regarda l'heure, s'étira d'aise et fredonna la sonatine dans le même temps que l'enfant la jouait. La patronne le dévisagea bien tout en sortant ses verres de dessous le comptoir.

— Vous êtes jeune, dit-elle.

Elle calcula le temps qui lui restait avant que le premier groupe de clients atteigne le café. Elle le prévint vite, mais avec bonté.

— Quelquefois, voyez-vous, quand il fait beau, il me semble bien qu'elle fait le tour de l'autre côté, par le deuxième bassin, qu'elle ne passe pas par ici chaque fois.

— Non, dit l'homme en riant.

Le groupe d'hommes passa la porte.

— Un, deux, trois, quatre, comptait Mademoiselle Giraud. C'est bien.

La sonatine se faisait sous les mains de l'enfant — celui-ci absent — mais elle se faisait et se refaisait, portée par son indifférente maladresse jusqu'aux confins de sa puissance. A mesure qu'elle s'échafaudait, sensiblement la lumière du jour diminua. Une monumentale presqu'île de nuages incendiés surgit à l'horizon dont la splendeur fragile et fugace forçait la pensée vers d'autres voies. Dans dix minutes, en effet, s'évanouirait tout à fait de l'instant toute couleur du jour. L'enfant termina sa tâche pour la troisième fois. Le bruit de la mer mêlé aux voix des hommes qui arrivaient sur le quai monta jusqu'à la chambre.

— Par cœur, dit Mademoiselle Giraud, la prochaine fois, c'est par cœur qu'il faudra que tu la saches, tu entends.

— Par cœur, bon.

— Je vous le promets, dit la mère.

— Il faut que ça change, il se moque de moi, c'est criant.

— Je vous le promets.

Mademoiselle Giraud réfléchit, n'écoutait pas.

— On pourrait essayer, dit-elle, qu'une autre que vous l'accompagne à ses leçons de piano, Madame Desbaresdes. On verrait bien ce que ça donnerait.

— Non, cria l'enfant.

— Je crois que je le supporterais très mal, dit Anne Desbaresdes.

— Je crains fort qu'on soit quand même obligé d'y arriver, dit Mademoiselle Giraud.

Dans l'escalier, une fois la porte refermée, l'enfant s'arrêta.

— Tu as vu, elle est méchante.

— Tu le fais exprès ?

L'enfant contempla tout le peuple de grues maintenant immobilisé en plein ciel. Au loin, les faubourgs de la ville s'illuminèrent.

— Je sais pas, dit l'enfant.

— Mais que je t'aime.

L'enfant descendit lentement tout à coup.

— Je voudrais plus apprendre le piano.

— Les gammes, dit Anne Desbaresdes, je ne les ai jamais sues, comment faire autrement ?

56

VI

Anne Desbaresdes n'entra pas, s'arrêta à la porte du café. Chauvin vint vers elle. Quand il l'eut atteinte, elle se tourna dans la direction du boulevard de la Mer.

— Comme il y a déjà du monde, se plaignit-elle doucement. Ces leçons de piano finissent tard.

— J'ai entendu cette leçon, dit Chauvin.

L'enfant dégagea sa main, s'enfuit sur le trottoir, désireux de courir comme chaque fois, à cette heure-là du vendredi soir. Chauvin leva la tête vers le ciel encore faiblement éclairé, bleu sombre, et il se rapprocha d'elle qui ne recula pas.

— Bientôt l'été, dit-il. Venez.

— Mais dans ces régions-ci on le sent à peine.

— Parfois, si. Vous le savez. Ce soir.

L'enfant sautait par-dessus des cordages en chantant la sonatine de Diabelli. Anne Desbaresdes suivit Chauvin. Le café était plein. Les hommes buvaient leur vin aussitôt servi, un devoir, et ils s'en allaient chez eux, pressés. D'autres les relayaient qui arrivaient d'ateliers plus lointains.

Aussitôt entrée, Anne Desbaresdes se cabra près de la porte. Chauvin se retourna vers elle, l'encouragea d'un sourire. Ils arrivèrent à l'extrémité la moins en vue du long comptoir et elle but très vite

son verre de vin, comme les hommes. Le verre tremblait encore dans sa main.

— Il y a maintenant sept jours, dit Chauvin.

— Sept nuits, dit-elle comme au hasard. Comme c'est bon, le vin.

— Sept nuits, répéta Chauvin.

Ils quittèrent le comptoir, il l'entraîna au fond de la salle, la fit asseoir à l'endroit où il le désirait. Des hommes au bar regardèrent encore cette femme, s'étonnèrent encore, mais de loin. La salle était calme.

— Alors, vous avez entendu ? Toutes ces gammes qu'elle lui fait faire ?

— C'était tôt. Il n'y avait encore aucun client. Les fenêtres devaient être ouvertes sur le quai. J'ai tout entendu, même les gammes.

Elle lui sourit, reconnaissante, but de nouveau. Les mains, sur le verre, ne tremblèrent plus qu'à peine.

— Je me suis mis dans la tête qu'il fallait qu'il sache la musique, vous comprenez, depuis deux ans.

— Mais je comprends. Alors, ce grand piano, à gauche, en entrant dans le salon ?

— Oui. — Anne Desbaresdes serra ses poings, se força au calme. — Mais il est si petit encore, si petit, si vous saviez, quand on y pense, je me demande si je n'ai pas tort.

Chauvin rit. Ils étaient encore seuls à être attablés dans le fond de la salle. Le nombre des clients au comptoir diminuait.

— Vous savez qu'il sait parfaitement ses gammes ?

Anne Desbaresdes rit, elle aussi, cette fois à pleine gorge.

— C'est vrai qu'il les sait. Même cette femme

en convient, voyez-vous... je me fais des idées. Ah...
je pourrais en rire...

Tandis qu'elle riait encore mais que le flot de son
rire commençait à baisser, Chauvin lui parla d'autre
manière.

— Vous étiez accoudée à ce grand piano. Entre
vos seins nus sous votre robe, il y a cette fleur de
magnolia.

Anne Desbaresdes, très attentivement, écouta cette
histoire.

— Oui.

— Quand vous vous penchez, cette fleur frôle le
contour extérieur de vos seins. Vous l'avez négli-
gemment épinglée, trop haut. C'est une fleur énorme,
vous l'avez choisie au hasard, trop grande pour vous.
Ses pétales sont encore durs, elle a justement atteint
la nuit dernière sa pleine floraison.

— Je regarde dehors ?

— Buvez encore un peu de vin. L'enfant joue
dans le jardin. Vous regardez dehors, oui.

Anne Desbaresdes but comme il le lui demandait,
chercha à se souvenir, revint d'un profond étonne-
ment.

— Je ne me souviens pas d'avoir cueilli cette
fleur. Ni de l'avoir portée.

— Je ne vous regardais qu'à peine, mais j'ai eu
le temps de la voir aussi.

Elle s'occupa à tenir le verre très fort, devint
ralentie dans ses gestes et dans sa voix.

— Comme j'aime le vin, je ne savais pas.

— Maintenant, parlez-moi.

— Ah, laissez-moi, supplia Anne Desbaresdes.

— Nous avons sans doute si peu de temps que
je ne peux pas.

Le crépuscule s'était déjà tellement avancé que

seul le plafond du café recevait encore un peu de clarté. Le comptoir était violemment éclairé, la salle était dans son ombre. L'enfant surgit, courant, ne s'étonna pas de l'heure tardive, annonça :

— L'autre petit garçon est arrivé.

Dans l'instant qui suivit son départ, les mains de Chauvin s'approchèrent de celles d'Anne Desbaresdes. Elles furent toutes quatre sur la table, allongées.

— Comme je vous le disais, parfois, je dors mal. Je vais dans sa chambre et je le regarde longtemps.

— Parfois encore ?

— Parfois encore, c'est l'été et il y a quelques promeneurs sur le boulevard. Le samedi soir surtout, parce que sans doute les gens ne savent que faire d'eux-mêmes dans cette ville.

— Sans doute, dit Chauvin. Surtout des hommes. De ce couloir, ou de votre jardin, ou de votre chambre, vous les regardez souvent.

Anne Desbaresdes se pencha et le lui dit enfin.

— Je crois, en effet, que je les ai souvent regardés, soit du couloir, soit de ma chambre, lorsque certains soirs je ne sais quoi faire de moi.

Chauvin proféra un mot à voix basse. Le regard d'Anne Desbaresdes s'évanouit lentement sous l'insulte, s'ensommeilla.

— Continuez.

— En dehors de ces passages, les journées sont à heure fixe. Je ne peux pas continuer.

— Nous avons très peu de temps devant nous, continuez.

— Les repas, toujours, reviennent. Et les soirs. Un jour, j'ai eu l'idée de ces leçons de piano.

Ils finirent leur vin. Chauvin en commanda d'autre. Le nombre des hommes au comptoir diminua

encore. Anne Desbaresdes but de nouveau comme une assoiffée.

— Déjà sept heures, prévint la patronne.

Ils n'entendirent pas. Il fit nuit. Quatre hommes entrèrent dans la salle du fond, ceux-là décidés à perdre leur temps. La radio informa le monde du temps qu'il ferait le lendemain.

— J'ai eu l'idée de ces leçons de piano, je vous disais, à l'autre bout de la ville, pour mon amour, et maintenant je ne peux plus les éviter. Comme c'est difficile. Voyez, sept heures déjà.

— Vous allez arriver plus tard que d'habitude dans cette maison, vous y arriverez plus tard, peut-être trop tard, c'est inévitable. Faites-vous à cette idée.

— On ne peut pas éviter les heures fixes, comment faire autrement ? Je pourrais vous dire que je suis déjà en retard sur l'heure du dîner si je compte tout le chemin que j'ai à faire. Et aussi, j'oubliais, que ce soir il y a dans cette maison une réception à laquelle je suis tenue d'être présente.

— Vous savez que vous ne pourrez faire autrement que d'y arriver en retard, vous le savez ?

— Je ne pourrais pas faire autrement. Je sais.

Il attendit. Elle lui parla sur le ton d'une paisible diversion.

— Je pourrais vous dire que j'ai parlé à mon enfant de toutes ces femmes qui ont vécu derrière ce hêtre et qui sont maintenant mortes, mortes, et qu'il m'a demandé de les voir, mon trésor. Je viens de vous dire ce que je pourrais vous dire, voyez.

— Vous avez immédiatement regretté de lui avoir parlé de ces femmes et vous lui avez raconté quelles seraient ses vacances cette année, dans quelques jours, au bord d'une autre mer que celle-ci ?

61

— Je lui ai promis des vacances dans un pays chaud au bord de la mer. Dans quinze jours. Il était inconsolable de la mort de ces femmes.

Anne Desbaresdes de nouveau but du vin, le trouva fort. Ses yeux en furent embués alors qu'elle souriait.

— Le temps passe, dit Chauvin. Vous êtes de plus en plus en retard.

— Quand le retard devient tellement important, dit Anne Desbaresdes, qu'il atteint le degré où il en est maintenant pour moi, je crois que ça ne doit plus changer rien à ses conséquences que de l'aggraver encore davantage ou pas.

Il ne resta plus qu'un seul client au comptoir. Dans la salle, les quatre autres parlaient par intermittence. Un couple arriva. La patronne le servit et reprit son tricot rouge délaissé jusque-là à cause de l'affluence. Elle baissa la radio. La mer, assez forte ce soir-là, se fit entendre contre les quais, à travers des chansons.

— Du moment qu'il avait compris qu'elle désirait tant qu'il le fasse, je voudrais que vous me disiez pourquoi il ne l'a pas fait, par exemple, un peu plus tard ou... un peu plus tôt.

— Vous savez, je sais très peu de choses. Mais je crois qu'il ne pouvait pas arriver à avoir une préférence, il ne devait pas en sortir, de la vouloir autant vivante que morte. Il a dû réussir très tard seulement à se la préférer morte. Je ne sais rien.

Anne Desbaresdes se replia sur elle-même, le visage hypocritement baissé mais pâli.

— Elle avait beaucoup d'espoir qu'il y arriverait.

— Il me semble que son espoir à lui d'y arriver devait être égal au sien. Je ne sais rien.

— Le même, vraiment ?

— Le même. Taisez-vous.

Les quatre hommes s'en allèrent. Le couple resta là, silencieux. La femme bâilla. Chauvin commanda une nouvelle carafe de vin.

— Si on ne buvait pas tant, ce ne serait pas possible ?

— Je crois que ce ne serait pas possible, murmura Anne Desbaresdes.

Elle but son verre de vin d'un trait. Il la laissa s'empoisonner à son gré. La nuit avait envahi définitivement la ville. Les quais s'éclairèrent de leurs hauts lampadaires. L'enfant jouait toujours. Il n'y eut plus trace dans le ciel de la moindre lueur du couchant.

— Avant que je rentre, pria Anne Desbaresdes, si vous pouviez me dire, j'aimerais savoir encore un peu davantage. Même si vous n'êtes pas sûr de ne pas savoir très bien.

Chauvin raconta lentement, d'une voix neutre, inconnue jusque-là de cette femme.

— Ils habitaient une maison isolée, je crois même au bord de la mer. Il faisait chaud. Ils ne savaient pas, avant d'y aller, qu'ils en viendraient là si vite. Qu'au bout de quelques jours il serait obligé de la chasser si souvent. Très vite, il a été obligé de la chasser, loin de lui, même loin de la maison, très souvent.

— Ce n'était pas la peine.

— Ça doit être difficile d'éviter ces sortes de pensées, on doit en avoir l'habitude, comme de vivre. Mais l'habitude seulement.

— Elle, elle partait ?

— Elle s'en allait quand et comme il le voulait, malgré son désir de rester.

Anne Desbaresdes fixa cet homme inconnu sans le reconnaître, comme dans le guet, une bête.

— Je vous en prie, supplia-t-elle.

— Puis le temps est venu où quand il la regardait, parfois, il ne la voyait plus comme il l'avait jusque-là vue. Elle cessait d'être belle, laide, jeune, vieille, comparable à quiconque, même à elle-même. Il avait peur. C'était aux dernières vacances. L'hiver est venu. Vous allez rentrer boulevard de la Mer. Ça va être la huitième nuit.

L'enfant entra, se blottit contre sa mère un instant. Encore, il fredonnait la sonatine de Diabelli. Elle lui caressa les cheveux de très près de son visage, aveuglée. L'homme évita de les voir. Puis l'enfant s'en alla.

— Cette maison était donc très isolée, reprit lentement Anne Desbaresdes. Il faisait chaud, vous disiez. Quand il lui disait de s'en aller, elle obéissait toujours. Elle dormait au pied des arbres, dans les champs, comme...

— Oui, dit Chauvin.

— Quand il l'appelait, elle revenait. Et de la même façon qu'elle partait lorsqu'il la chassait. De lui obéir à ce point, c'était sa façon à elle d'espérer. Et même, lorsqu'elle arrivait sur le pas de la porte, elle attendait encore qu'il lui dise d'entrer.

— Oui.

Anne Desbaresdes pencha son visage hébété vers Chauvin, elle ne l'atteignit pas. Chauvin recula.

— C'est là, dans cette maison, qu'elle a appris ce que vous disiez qu'elle était, peut-être par exemple...

— Oui, une chienne, l'arrêta encore Chauvin.

Elle recula à son tour. Il remplit son verre, le lui tendit.

— Je mentais, dit-il.

Elle remit ses cheveux d'un désordre profond, revint à elle avec lassitude et compassion contenue.

— Non, dit-elle.

Dans la lumière du néon de la salle, elle observa attentivement la crispation inhumaine du visage de Chauvin, ne put en rassasier ses yeux. L'enfant surgit une dernière fois du trottoir.

— Maintenant, c'est la nuit, annonça-t-il.

Il bâilla longuement face à la porte, puis il retourna vers elle, mais alors il resta là, à l'abri, fredonnant.

— Voyez comme il est tard. Dites-moi encore, vite ?

— Puis le temps est venu où il crut qu'il ne pourrait plus la toucher autrement que pour...

Anne Desbaresdes releva ses mains vers son cou nu dans l'encolure de sa robe d'été.

— Que là, n'est-ce pas ?

— Là, oui.

Les mains, raisonnablement, acceptèrent d'abandonner, redescendirent du cou.

— Je voudrais que vous partiez, murmura Chauvin.

Anne Desbaresdes se leva de sa chaise, se planta au milieu de la salle, sans bouger. Chauvin resta assis, accablé, il ne la connut plus. La patronne, irrésistiblement, délaissa son tricot rouge, les observa l'un l'autre avec une indiscrétion dont ils ne s'aperçurent pas. Ce fut l'enfant qui arriva de la porte et prit la main de sa mère.

— On s'en va, viens.

Déjà le boulevard de la Mer était éclairé. Il était beaucoup plus tard que d'habitude, d'une

heure au moins. L'enfant chanta une dernière fois la sonatine, puis il s'en fatigua. Les rues étaient presque désertes. Déjà les gens dînaient. Lorsqu'après le premier môle le boulevard de la Mer se profila dans toute sa longueur habituelle, Anne Desbaresdes s'arrêta.

— Je suis trop fatiguée, dit-elle.

— Mais j'ai faim, pleurnicha l'enfant.

Il vit que les yeux de cette femme, sa mère, brillaient. Il ne se plaignit plus de rien.

— Pourquoi tu pleures ?

— Ça peut arriver comme ça, pour rien.

— Je voudrais pas.

— Mon amour, c'est fini, je crois bien.

Il oublia, se mit à courir en avant, revint sur ses pas, s'amusa de la nuit dont il n'avait pas l'habitude.

— La nuit, c'est loin les maisons, dit-il.

VII

Sur un plat d'argent à l'achat duquel trois générations ont contribué, le saumon arrive, glacé dans sa forme native. Habillé de noir, ganté de blanc, un homme le porte, tel un enfant de roi, et le présente à chacun dans le silence du dîner commençant. Il est bien séant de ne pas en parler.

De l'extrémité nord du parc, les magnolias versent leur odeur qui va de dune en dune jusqu'à rien. Le vent, ce soir, est du sud. Un homme rôde, boulevard de la Mer. Une femme le sait.

Le saumon passe de l'un à l'autre suivant un rituel que rien ne trouble, sinon la peur cachée de chacun que tant de perfection tout à coup ne se brise ou ne s'entache d'une trop évidente absurdité. Dehors, dans le parc, les magnolias élaborent leur floraison funèbre dans la nuit noire du printemps naissant.

Avec le ressac du vent qui va, vient, se cogne aux obstacles de la ville, et repart, le parfum atteint l'homme et le lâche, alternativement.

Des femmes, à la cuisine, achèvent de parfaire la suite, la sueur au front, l'honneur à vif, elles écorchent un canard mort dans son linceul d'oranges. Cependant que rose, mielleux, mais déjà déformé par le temps très court qui vient de se passer, le saumon des eaux libres de l'océan continue sa marche iné-

luctable vers sa totale disparition et que la crainte d'un manquement quelconque au cérémonial qui accompagne celle-ci se dissipe peu à peu.

Un homme, face à une femme, regarde cette inconnue. Ses seins sont de nouveau à moitié nus. Elle ajusta hâtivement sa robe. Entre eux se fane une fleur. Dans ses yeux élargis, immodérés, des lueurs de lucidité passent encore, suffisantes pour qu'elle arrive à se servir à son tour du saumon des autres gens.

A la cuisine, on ose enfin le dire, le canard étant prêt, et au chaud, dans le répit qui s'ensuit, qu'elle exagère. Elle arriva ce soir plus tard encore qu'hier, bien après ses invités.

Ils sont quinze, ceux qui l'attendirent tout à l'heure dans le grand salon du rez-de-chaussée. Elle entra dans cet univers étincelant, se dirigea vers le grand piano, s'y accouda, ne s'excusa nullement. On le fit à sa place.

— Anne est en retard, excusez Anne.

Depuis dix ans, elle n'a pas fait parler d'elle. Si son incongruité la dévore, elle ne peut s'imaginer. Un sourire fixe rend son visage acceptable.

— Anne n'a pas entendu.

Elle pose sa fourchette, regarde alentour, cherche, essaye de remonter le cours de la conversation, n'y arrive pas.

— Il est vrai, dit-elle.

On répète. Elle passe légèrement la main dans le désordre blond de ses cheveux, comme elle le fit tout à l'heure, ailleurs. Ses lèvres sont pâles. Elle oublia ce soir de les farder.

— Excusez-moi, dit-elle, pour le moment, une petite sonatine de Diabelli.

— Une sonatine ? Déjà ?

— Déjà.

Le silence se reforme sur la question posée. Elle, elle retourne à la fixité de son sourire, une bête à la forêt.

— Moderato cantabile, il ne savait pas ?

— Il ne savait pas.

Le fleurissement des magnolias sera ce soir achevé. Sauf celui-ci, qu'elle cueillit ce soir en revenant du port. Le temps fuit, égal à lui-même, sur ce fleurissement oublié.

— Trésor, comment aurait-il pu deviner ?

— Il ne pouvait pas.

— Il dort, probablement ?

— Il dort, oui.

Lentement, la digestion commence de ce qui fut un saumon. Son osmose à cette espèce qui le mangea fut rituellement parfaite. Rien n'en troubla la gravité. L'autre attend, dans une chaleur humaine, sur son linceul d'oranges. Voici la lune qui se lève sur la mer et sur l'homme allongé. Avec difficulté on pourrait, à la rigueur, maintenant, apercevoir les masses et les formes de la nuit à travers les rideaux blancs. Madame Desbaresdes n'a pas de conversation.

— Mademoiselle Giraud, qui donne également, comme vous le savez, des leçons à mon petit garçon, me l'a racontée hier, cette histoire.

— Ah oui.

On rit. Quelque part autour de la table, une femme. Le chœur des conversations augmente peu à peu de volume et, dans une surenchère d'efforts et d'inventivités progressive, émerge une société quelconque. Des repères sont trouvés, des failles s'ouvrent où s'essayent des familiarités. Et on débouche peu à peu sur une conversation généralement parti-

sane et particulièrement neutre. La soirée réussira. Les femmes sont au plus sûr de leur éclat. Les hommes les couvrirent de bijoux au prorata de leurs bilans. L'un d'eux, ce soir, doute qu'il eût raison.

Dans le parc correctement clos, les oiseaux dorment d'un sommeil paisible et réconfortant, car le temps est au beau. Ainsi qu'un enfant, dans une même conjugaison. Le saumon repasse dans une forme encore amoindrie. Les femmes le dévoreront jusqu'au bout. Leurs épaules nues ont la luisance et la fermeté d'une société fondée, dans ses assises, sur la certitude de son droit, et elles furent choisies à la convenance de celle-ci. La rigueur de leur éducation exige que leurs excès soient tempérés par le souci majeur de leur entretien. De celui-ci on leur en inculqua, jadis, la conscience. Elles se pourlèchent de mayonnaise, verte, comme il se doit, s'y retrouvent, y trouvent leur compte. Des hommes les regardent et se rappellent qu'elles font leur bonheur.

L'une d'entre elles contrevient ce soir à l'appétit général. Elle vient de l'autre bout de la ville, de derrière les môles et les entrepôts à huile, à l'opposé de ce boulevard de la Mer, de ce périmètre qui lui fut il y a dix ans autorisé, où un homme lui a offert du vin jusqu'à la déraison. Nourrie de ce vin, exceptée de la règle, manger l'exténuerait. Au-delà des stores blancs, la nuit et, dans la nuit, encore, car il a du temps devant lui, un homme seul regarde tantôt la mer, tantôt le parc. Puis la mer, le parc, ses mains. Il ne mange pas. Il ne pourrait pas, lui non plus, nourrir son corps tourmenté par d'autre faim. L'encens des magnolias arrive toujours sur lui, au gré du vent, et le surprend et le harcèle autant que celui d'une seule fleur. Au premier étage, une fenêtre s'est éteinte tout à l'heure et elle ne s'est pas rallu-

mée. On a dû fermer les vitres de ce côté-là, de crainte de l'odeur excessive, la nuit, des fleurs.

Anne Desbaresdes boit, et ça ne cesse pas, le Pommard continue d'avoir ce soir la saveur anéantissante des lèvres inconnues d'un homme de la rue.

Cet homme a quitté le boulevard de la Mer, il a fait le tour du parc, l'a regardé des dunes qui, au nord, le bordent, puis il est revenu, il a redescendu le talus, il est redescendu jusqu'à la grève. Et de nouveau il s'y est allongé, à sa place. Il s'étire, reste un moment immobile face à la mer, se retourne sur lui-même et regarde une fois de plus les stores blancs devant les baies illuminées. Puis il se relève, prend un galet, vise une de ces baies, se retourne de nouveau, jette le galet dans la mer, s'allonge, s'étire encore et, tout haut, prononce un nom.

Deux femmes, dans un mouvement alterné et complémentaire, préparent le deuxième service. L'autre victime attend.

— Anne, comme vous le savez, est sans défense devant son enfant.

Elle sourit davantage. On répète. Elle lève encore la main dans le désordre blond de ses cheveux. Le cerne de ses yeux s'est encore agrandi. Ce soir, elle pleura. L'heure est arrivée où la lune s'est levée tout à fait sur la ville et sur le corps d'un homme allongé au bord de la mer.

— Il est vrai, dit-elle.

Sa main s'abaisse de ses cheveux et s'arrête à ce magnolia qui se fane entre ses seins.

— Nous sommes toutes pareilles, allez.

— Oui, prononce Anne Desbaresdes.

Le pétale de magnolia est lisse, d'un grain nu. Les doigts le froissent jusqu'à le trouer puis, interdits, s'arrêtent, se reposent sur la table, attendent,

71

prennent une contenance, illusoire. Car on s'en est
aperçu. Anne Desbaresdes s'essaye à un sourire
d'excuse de n'avoir pu faire autrement, mais elle
est ivre et son visage prend le faciès impudique de
l'aveu. Le regard s'appesantit, impassible, mais
revenu déjà douloureusement de tout étonnement.
On s'y attendait depuis toujours.

Anne Desbaresdes boit de nouveau un verre de
vin tout entier les yeux mi-clos. Elle en est déjà
à ne plus pouvoir faire autrement. Elle découvre, à
boire, une confirmation de ce qui fut jusque-là son
désir obscur et une indigne consolation à cette
découverte.

D'autres femmes boivent à leur tour, elles lèvent
de même leurs bras nus, délectables, irréprochables,
mais d'épouses. Sur la grève, l'homme siffle une
chanson entendue dans l'après-midi dans un café du
port.

La lune est levée et avec elle voici le commence-
ment de la nuit tardive et froide. Il n'est pas impos-
sible que cet homme ait froid.

Le service du canard à l'orange commence. Les
femmes se servent. On les choisit belles et fortes,
elles feront front à tant de chère. De doux murmures
montent de leurs gorges à la vue du canard d'or.
L'une d'elles défaille à sa vue. Sa bouche est dessé-
chée par d'autre faim que rien non plus ne peut apai-
ser qu'à peine, le vin. Une chanson lui revient,
entendue dans l'après-midi dans un café du port,
qu'elle ne peut pas chanter. Le corps de l'homme sur
la plage est toujours solitaire. Sa bouche est restée
entrouverte sur le nom prononcé.

— Non merci.

Sur les paupières fermées de l'homme, rien ne se
pose que le vent et, par vagues impalpables et puis-

santes, l'odeur du magnolia, suivant les fluctuations de ce vent.

Anne Desbaresdes vient de refuser de se servir. Le plat reste cependant encore devant elle, un temps très court, mais celui du scandale. Elle lève la main, comme il lui fut appris, pour réitérer son refus. On n'insiste plus. Autour d'elle, à table, le silence s'est fait.

— Voyez, je ne pourrais pas, je m'en excuse.

Elle soulève une nouvelle fois sa main à hauteur de la fleur qui se fane entre ses seins et dont l'odeur franchit le parc et va jusqu'à la mer.

— C'est peut-être cette fleur, ose-t-on avancer, dont l'odeur est si forte ?

— J'ai l'habitude de ces fleurs, non, ce n'est rien.

Le canard suit son cours. Quelqu'un en face d'elle regarde encore impassiblement. Et elle s'essaye encore à sourire, mais ne réussit encore que la grimace désespérée et licencieuse de l'aveu. Anne Desbaresdes est ivre.

On redemande si elle n'est pas malade. Elle n'est pas malade.

— C'est peut-être cette fleur, insiste-t-on, qui écœure subrepticement ?

— Non. J'ai l'habitude de ces fleurs. C'est qu'il m'arrive de ne pas avoir faim.

On la laisse en paix. La dévoration du canard commence. Sa graisse va se fondre dans d'autres corps. Les paupières fermées d'un homme de la rue tremblent de tant de patience consentie. Son corps éreinté a froid, que rien ne réchauffe. Sa bouche a encore prononcé un nom.

A la cuisine, on annonce qu'elle a refusé le canard à l'orange, qu'elle est malade, qu'il n'y a pas d'autre explication. Ici, on parle d'autre chose. Les formes

73

vides des magnolias caressent les yeux de l'homme seul. Anne Desbaresdes prend une nouvelle fois son verre qu'on vient de remplir et boit. Le feu nourrit son ventre de sorcière contrairement aux autres. Ses seins si lourds de chaque côté de cette fleur si lourde se ressentent de sa maigreur nouvelle et lui font mal. Le vin coule dans sa bouche pleine d'un nom qu'elle ne prononce pas. Cet événement silencieux lui brise les reins.

L'homme s'est relevé de la grève, s'est approché des grilles, les baies sont toujours illuminées, prend les grilles dans ses mains, et serre. Comment n'est-ce pas encore arrivé ?

Le canard à l'orange, de nouveau, repassera. Du même geste que tout à l'heure, Anne Desbaresdes implorera qu'on l'oublie. On l'oubliera. Elle retourne à l'éclatement silencieux de ses reins, à leur brûlante douleur, à son repaire.

L'homme a lâché les grilles du parc. Il regarde ses mains vides et déformées par l'effort. Il lui a poussé, au bout des bras, un destin.

Le vent de la mer circule toujours à travers la ville, plus frais. Bien du monde dort déjà. Les fenêtres du premier étage sont toujours obscures et fermées aux magnolias sur le sommeil de l'enfant. Des bateaux rouges à moteur voguent à travers sa nuit innocente.

Quelques-uns ont repris du canard à l'orange. La conversation, de plus en plus facile, augmente à chaque minute un peu davantage encore l'éloignement de la nuit.

Dans l'éclatante lumière des lustres, Anne Desbaresdes se tait et sourit toujours.

L'homme s'est décidé à repartir vers la fin de la ville, loin de ce parc. A mesure qu'il s'en éloigne,

l'odeur des magnolias diminue, faisant place à celle de la mer.

Anne Desbaresdes prendra un peu de glace au moka afin qu'on la laisse en paix.

L'homme reviendra malgré lui sur ses pas. Il retrouve les magnolias, les grilles, et les baies au loin, encore et encore éclairées. Aux lèvres, il a de nouveau ce chant entendu dans l'après-midi, et ce nom dans la bouche qu'il prononcera un peu plus fort. Il passera.

Elle, le sait encore. Le magnolia entre ses seins se fane tout à fait. Il a parcouru l'été en une heure de temps. L'homme passera outre au parc tôt ou tard. Il est passé. Anne Desbaresdes continue dans un geste interminable à supplicier la fleur.

— Anne n'a pas entendu.

Elle tente de sourire davantage, n'y arrive plus. On répète. Elle lève une dernière fois la main dans le désordre blond de ses cheveux. Le cerne de ses yeux s'est encore agrandi. Ce soir, elle pleura. On répète pour elle seule et on attend.

— Il est vrai, dit-elle, nous allons partir dans une maison au bord de la mer. Il fera chaud. Dans une maison isolée au bord de la mer.

— Trésor, dit-on.

— Oui.

Alors que les invités se disperseront en ordre irrégulier dans le grand salon attenant à la salle à manger, Anne Desbaresdes s'éclipsera, montera au premier étage. Elle regardera le boulevard par la baie du grand couloir de sa vie. L'homme l'aura déjà déserté. Elle ira dans la chambre de son enfant, s'allongera par terre, au pied de son lit, sans égard pour ce magnolia qu'elle écrasera entre ses seins, il n'en restera rien. Et entre les temps sacrés de la respira-

tion de son enfant, elle vomira là, longuement, la nourriture étrangère que ce soir elle fut forcée de prendre.

Une ombre apparaîtra dans l'encadrement de la porte restée ouverte sur le couloir, obscurcira plus avant la pénombre de la chambre. Anne Desbaresdes passera légèrement la main dans le désordre réel et blond de ses cheveux. Cette fois, elle prononcera une excuse.

On ne lui répondra pas.

VIII

Le beau temps durait encore. Sa durée avait
dépassé toutes les espérances. On en parlait mainte-
nant avec le sourire, comme on l'eût fait d'un temps
mensonger qui eût caché derrière sa pérennité quel-
que irrégularité qui bientôt se laisserait voir et ras-
surerait sur le cours habituel des saisons de l'année.

Ce jour-là, même eu égard aux jours derniers,
la bonté de ce temps fut telle, pour la saison bien
entendu, que lorsque le ciel ne se recouvrait pas trop
de nuages, lorsque les éclaircies duraient un peu,
on aurait pu le croire encore meilleur, encore plus
avancé qu'il n'était, plus proche encore de l'été. Les
nuages étaient si lents à recouvrir le soleil, si lents
à le faire, en effet, que cette journée était presque
plus belle encore que celles qui l'avaient précédée.
D'autant que la brise qui l'accompagnait était
marine, molle, très ressemblante à celle qui souf-
flerait certains jours, dans les prochains mois.

Certains prétendirent que ce jour avait été chaud.
La plupart nièrent, non sa beauté, mais que celle-ci
avait été telle que ce jour avait été chaud. Certains
n'eurent pas d'avis.

Anne Desbaresdes ne revint que le surlendemain
de sa dernière promenade sur le port. Elle arriva à
peine plus tard que d'habitude. Dès que Chauvin

l'aperçut, de loin, derrière le môle, il rentra dans le café pour l'attendre. Elle était sans son enfant.

Anne Desbaresdes entra dans le café au moment d'une longue éclaircie du temps. La patronne ne leva pas les yeux sur elle, continua à tricoter sa laine rouge dans la pénombre du comptoir. Déjà, la surface de son ouvrage avait augmenté. Anne Desbaresdes rejoignit Chauvin à la table où ils s'étaient assis les jours qui avaient précédé, au fond de la salle. Chauvin n'était pas rasé du matin, mais seulement de la veille. Le visage d'Anne Desbaresdes manquait du soin qu'elle mettait d'habitude à l'apprêter avant de le montrer. Ni l'un ni l'autre, sans doute, ne le remarqua.

— Vous êtes seule, dit Chauvin.

Elle acquiesça, longtemps après qu'il l'eut dite, à cette évidence, tenta de l'éluder, s'étonna encore de ne pas y parvenir.

— Oui.

Pour échapper à la suffocante simplicité de cet aveu, elle se tourna vers la porte du café, la mer. Les Fonderies de la Côte vrombissaient au sud de la ville. Là, dans le port, le sable et le charbon se déchargeaient comme à l'accoutumée.

— Il fait beau, dit-elle.

Dans un même mouvement que le sien, Chauvin regarda au-dehors, scruta aveuglément le temps, le temps qu'il faisait ce jour-là.

— Je n'aurais pas cru que ça arriverait si vite.

La patronne, tant durait leur silence, se retourna sur elle-même, alluma la radio, sans aucune impatience, avec douceur même. Une femme chanta loin, dans une ville étrangère. Ce fut Anne Desbaresdes qui se rapprocha de Chauvin.

— A partir de cette semaine, d'autres que moi

— Je peux me taire, s'excusa-t-elle.

— Non.

Il posa sa main à côté de la sienne, sur la table, dans l'écran d'ombre que faisait son corps.

— Le cadenas était sur la porte du jardin, comme d'habitude. Il faisait beau, à peine de vent. Au rez-de-chaussée, les baies étaient éclairées.

La patronne rangea son tricot rouge, rinça des verres et, pour la première fois, ne s'inquiéta pas de savoir s'ils resteraient encore longtemps. L'heure approchait de la fin du travail.

— Nous n'avons plus beaucoup de temps, dit Chauvin.

Le soleil commença à baisser. Il en suivit des yeux la course fauve et lente sur le mur au fond de la salle.

— Cet enfant, dit Anne Desbaresdes, je n'ai pas eu le temps de vous le dire...

— Je sais, dit Chauvin.

Elle retira sa main de dessus la table, regarda longuement celle de Chauvin toujours là, posée, qui tremblait. Puis elle se mit à gémir doucement une plainte impatiente — la radio la couvrit — et elle ne fut perceptible qu'à lui seul.

— Parfois, dit-elle, je crois que je l'ai inventé...

— Je sais, pour cet enfant, dit brutalement Chauvin.

La plainte d'Anne Desbaresdes reprit, se fit plus forte. Elle posa de nouveau sa main sur la table. Il suivit son geste des yeux et péniblement il comprit, souleva la sienne qui était de plomb et la posa sur la sienne à elle. Leurs mains étaient si froides qu'elles se touchèrent illusoirement dans l'intention seulement, afin que ce fût fait, dans la seule intention que ce le fût, plus autrement, ce n'était plus

80

mèneront mon enfant à sa leçon de piano, chez Mademoiselle Giraud. C'est une chose que j'ai acceptée que l'on fasse à ma place.

Elle but le reste de son vin, à petites gorgées. Son verre fut vide. Chauvin oublia de commander d'autre vin.

— Sans doute est-ce préférable, dit-il.

Un client entra, désœuvré, seul, seul, et commanda également du vin. La patronne le servit, puis elle alla servir les deux autres dans la salle, sans qu'ils l'aient demandé. Ils burent immédiatement ensemble, sans un mot pour elle. Anne Desbaresdes parla de façon précipitée.

— La dernière fois, dit-elle, j'ai vomi ce vin. Il n'y a que quelques jours que je bois...

— Ça n'a plus d'importance désormais.

— Je vous en prie..., supplia-t-elle.

— Au fond, choisissons de parler ou de ne rien dire, comme vous le voudrez.

Elle examina le café, puis lui, l'endroit tout entier, et lui, implorant un secours qui ne vint pas.

— J'ai souvent vomi, mais pour des raisons différentes de celle-ci. Toujours très différentes, vous comprenez. De boire tellement de vin à la fois, d'un seul coup, en si peu de temps, je n'en n'avais pas l'habitude. Que j'ai vomi. Je ne pouvais plus m'arrêter, j'ai cru que je ne pourrais plus jamais m'arrêter, mais voilà que tout à coup ça n'a plus été possible, j'ai eu beau essayer. Ma volonté n'y a plus suffi.

Chauvin s'accouda à la table, la tête dans ses mains.

— Je suis fatigué.

Anne Desbaresdes remplit son verre, le lui tendit. Chauvin ne lui résista pas.

possible. Leurs mains restèrent ainsi, figées dans leur pose mortuaire. Pourtant la plainte d'Anne Desbaresdes cessa.

— Une dernière fois, supplia-t-elle, dites-moi.

Chauvin hésita, les yeux toujours ailleurs, sur le mur du fond, puis il se décida à le dire comme d'un souvenir.

— Jamais auparavant, avant de la rencontrer, il n'aurait pensé que l'envie aurait pu lui en venir un jour.

— Son consentement à elle était entier ?

— Emerveillé.

Anne Desbaresdes leva vers Chauvin un regard absent. Sa voix se fit mince, presque enfantine.

— Je voudrais comprendre un peu pourquoi était si merveilleuse son envie qu'il y arrive un jour.

Chauvin ne la regarda toujours pas. Sa voix était posée, sans timbre, une voix de sourd.

— Ce n'est pas la peine d'essayer de comprendre. On ne peut pas comprendre à ce point.

— Il y a des choses comme celle-là qu'il faut laisser de côté ?

— Je crois.

Le visage d'Anne Desbaresdes prit une expression terne, presque imbécile. Ses lèvres étaient grises à force de pâleur et elles tremblaient comme avant les pleurs.

— Elle ne tente rien pour l'en empêcher, dit-elle tout bas.

— Non. Buvons encore un peu de vin.

Elle but, toujours à petites gorgées, il but à son tour. Ses lèvres à lui tremblaient aussi sur le verre.

— Le temps, dit-il.

— Il faut beaucoup, beaucoup de temps ?

— Je crois beaucoup. Mais je ne sais rien. — Il

81

ajouta tout bas : Je ne sais rien, comme vous. Rien.

Anne Desbaresdes n'arriva pas jusqu'aux larmes. Elle reprit une voix raisonnable, un instant réveillée.

— Elle ne parlera plus jamais, dit-elle.

— Mais si. Un jour, un beau matin, tout à coup, elle rencontrera quelqu'un qu'elle reconnaîtra, elle ne pourra pas faire autrement que de dire bonjour. Ou bien elle entendra chanter un enfant, il fera beau, elle dira il fait beau. Ça recommencera.

— Non.

— C'est comme vous désirez le croire, ça n'a pas d'importance.

La sirène retentit, énorme, qui s'entendit allègrement de tous les coins de la ville et même de plus loin, des faubourgs, de certaines communes environnantes, portée par le vent de la mer. Le couchant se vautra, plus fauve encore sur les murs de la salle. Comme souvent au crépuscule, le ciel s'immobilisa, relativement, dans un calme gonflement de nuages, le soleil ne fut plus recouvert et brilla librement de ses derniers feux. La sirène, ce soir-là, fut interminable. Mais elle cessa cependant, comme les autres soirs.

— J'ai peur, murmura Anne Desbaresdes.

Chauvin s'approcha de la table, la rechercha, la recherchant, puis y renonça.

— Je ne peux pas.

Elle fit alors ce qu'il n'avait pas pu faire. Elle s'avança vers lui d'assez près pour que leurs lèvres puissent s'atteindre. Leurs lèvres restèrent l'une sur l'autre, posées, afin que ce fût fait et suivant le même rite mortuaire que leurs mains, un instant avant, froides et tremblantes. Ce fut fait.

Déjà, des rues voisines une rumeur arrivait, feutrée, coupée de paisibles et gais appels. L'arsenal

avait ouvert ses portes à ses huit cents hommes. Il n'était pas loin de là. La patronne alluma la rampe lumineuse au-dessus du comptoir bien que le couchant fût étincelant. Après une hésitation, elle arriva vers eux qui ne se disaient plus rien et les servit d'autre vin sans qu'ils l'aient demandé, avec une sollicitude dernière. Puis elle resta là après les avoir servis, près d'eux, encore cependant ensemble, cherchant quoi leur dire, ne trouva rien, s'éloigna.

— J'ai peur, dit de nouveau Anne Desbaresdes. Chauvin ne répondit pas.

— J'ai peur, cria presque Anne Desbaresdes.

Chauvin ne répondit toujours pas. Anne Desbaresdes se plia en deux presque jusqu'à toucher la table de son front et elle accepta la peur.

— On va donc s'en tenir là où nous sommes, dit Chauvin. — Il ajouta : Ça doit arriver parfois.

Un groupe d'ouvriers entra, qui les avaient déjà vus. Ils évitèrent de les regarder, étant au courant, eux aussi, comme la patronne et toute la ville. Un chœur de conversations diverses, assourdies par la pudeur, emplit le café.

Anne Desbaresdes se releva et tenta encore, pardessus la table, de se rapprocher de Chauvin.

— Peut-être que je ne vais pas y arriver, murmura-t-elle.

Peut-être n'entendit-il plus. Elle ramena sa veste sur elle-même, la ferma, l'étriqua sur elle, fut reprise du même gémissement sauvage.

— C'est impossible, dit-elle.

Chauvin entendit.

— Une minute, dit-il, et nous y arriverons.

Anne Desbaresdes attendit cette minute, puis elle essaya de se relever de sa chaise. Elle y arriva, se releva. Chauvin regardait ailleurs. Les hommes évi-

tèrent encore de porter leurs yeux sur cette femme adultère. Elle fut levée.

— Je voudrais que vous soyez morte, dit Chauvin.

— C'est fait, dit Anne Desbaresdes.

Anne Desbaresdes contourna sa chaise de telle façon qu'elle n'ait plus à faire le geste de s'y rasseoir. Puis elle fit un pas en arrière et se retourna sur elle-même. La main de Chauvin battit l'air et retomba sur la table. Mais elle ne le vit pas, ayant déjà quitté le champ où il se trouvait.

Elle se retrouva face au couchant, ayant traversé le groupe d'hommes qui étaient au comptoir, dans la lumière rouge qui marquait le terme de ce jour-là.

Après son départ, la patronne augmenta le volume de la radio. Quelques hommes se plaignirent qu'elle fût trop forte à leur gré.

« MODERATO CANTABILE »
ET
LA PRESSE FRANÇAISE

UNE VOIE NOUVELLE

... J'ai dit de *Moderato cantabile* en commençant qu'il s'agissait d'un livre rare. Il faudrait dire aussi que ce livre, pour rare qu'il soit, ouvre au milieu du désert du roman une voie nouvelle. Nous sommes las de ces romans où, à la mode d'Hemingway, un « *sous-roman* » psychologique s'écoule sous les propos de table et l'énumération des gestes quotidiens, convenu comme une rivière canalisée. Nous sommes las également du symbolisme imité de Kafka qui donne, au mieux, Beckett, et *la Peste* dans le pire des cas. Ce que Marguerite Duras a tenté et réussi avec son dernier roman, c'est un livre où les gestes et les mots, en même temps qu'ils ne veulent dire que ce qu'ils disent, dénoncent immédiatement leur transcendance. On pense, en la lisant, aux livres magistraux où, par une mystérieuse osmose, chaque événement nous happe au monde des idées. On pense à Proust et à Melville.

Claude DELMONT
L'Heure de Paris, 20-2-58

87

L'ETOUFFANT UNIVERS
DE MARGUERITE DURAS

Le nouveau roman que Mme Marguerite Duras publie aux Editions de Minuit, *Moderato cantabile,* est d'une grande brièveté. A peine plus de cent cinquante pages très aérées, imprimées en gros caractères. D'où vient qu'étant court ce récit nous retienne longuement ? (Non qu'il nous donne l'impression de n'en plus finir : c'est nous qui n'en finissons pas avec lui.) D'où que, se tenant semblait-il à la superficie des êtres, il nous paraisse aller si profond ?

Marguerite Duras a pu être officiellement enrôlée dans l'équipe des pionniers qui tentent d'ouvrir au roman ses voies nouvelles. Réunion d'écrivains assez hétéroclite et ne méritant peut-être pas tous l'honneur d'être nommés en même temps que Nathalie Sarraute et Alain Robbe-Grillet. Mais pour Marguerite Duras (comme au pôle opposé pour Jean Cayrol) de tels rapprochements sont défendables : il faut simplifier avant de comprendre.

L'univers de Robbe-Grillet, c'est celui des hommes parmi les objets. Le domaine de Marguerite Duras, celui des hommes-objets. A l'un et à l'autre je préfère le monde de Nathalie Sarraute avec ses petites planètes les unes aux autres étrangères et communiquant par appels chiffrés (l'auteur s'applique à retrou-

ver les codes). Mais la vision d'un Robbe-Grillet, celle d'une Marguerite Duras n'en arrivent pas moins à s'imposer à nous et à nous en imposer.

Dans le récit précédent de Marguerite Duras, *Le Square,* nous avions, entre deux êtres simples, un vain dialogue qui ne menait à rien, sinon à nous rendre sensibles notre propre solitude et notre inanité : comme ces êtres démunis aussi bien qu'à l'exemple du plus grand des poètes, *nous n'étions pas* au monde. Exclusion qui est de nouveau le thème du dernier roman de Marguerite Duras, *Moderato cantabile.*

La difficulté matérielle de vivre distrait (mais à quel prix !) l'immense majorité des hommes de la difficulté d'être. En outre, chacun joue son personnage, comme le garçon de café de Jean-Paul Sartre : tels sont les jeux les plus constants des hommes, négligés par Roger Caillois dans son passionnant *Les Jeux et les Hommes* (Gallimard). Tel est notre oxygène.

Seuls les romanciers peuvent réaliser les conditions de l'impossible expérience qui consiste à nous en priver. Et c'est, par exemple, l'irrespirable univers de Samuel Beckett, ou celui non moins étouffant de Marguerite Duras où la personne humaine n'est plus personne mais souffre. Il y a dans *Moderato cantabile* un admirable chapitre qui nous permet enfin de situer les personnages et de comprendre le peu qui, en eux, peut être compris. Bien des lecteurs auront fermé le livre avant d'y arriver. C'est que la nouvelle littérature ne flatte pas notre paresse ni nos goûts et qu'elle doit être méritée.

Claude MAURIAC
Le Figaro, 12-3-58

UNE NOIX CREUSE

... De ce *dialogue harassant,* il se dégage bien quelques petites choses : le désarroi de cette femme, la tristesse de sa vie, un vague désir de communiquer, par-delà les mots, avec quelqu'un — et pourquoi pas, après tout, avec ce Chauvin qui s'est trouvé là ? Mais pourquoi ces saouleries au vin rouge ? Ce brusque désir de rompre avec la vie normale ? Il y a une sorte d'outrance qui fait que le lecteur ne peut, derrière ce comportement qu'on nous dit, imaginer qu'un monde superficiel dans lequel vit un être superficiel. Cette *coquille de noix* que Marguerite Duras nous offre ne ressemble en rien à celle dont parlait Joyce lorsqu'il disait vouloir mettre *all space in a nutshell,* car elle est, au départ, aussi faussement bariolée qu'un œuf de Pâques.

<div style="text-align: right">

Anne VILLELAUR
Les Lettres françaises 6-3-58

</div>

LA CAVERNE DE PLATON

De quel poids le destin des autres pèse-t-il sur ceux qui en sont témoins ? Pourquoi le cri soudain d'une inconnue et la vue de son corps en sang ont-ils troublé si fort Anne Desbaresdes, qui est une femme jeune et riche, uniquement attachée à son petit garçon ? Pourquoi retourne-t-elle au café sur le port, où le cadavre de l'inconnue s'était écroulé dans le jour tombant ? Pourquoi interroge-t-elle cet autre inconnu, Chauvin, témoin comme elle ? Une étrange ivresse s'empare d'elle, où les verres de vin qu'elle se fait servir, et qu'elle boit lentement, ne sont au mieux que des prétextes. Sur le lieu du crime commis par un autre elle revient chaque jour. Chaque jour elle interroge plus avant, parle elle-même un peu plus longuement. L'enfant joue dehors pendant qu'elle s'attarde. Mais un jour elle viendra seule. Un jour elle aura la réponse. Que cherchait-elle donc ? L'amour de Chauvin ? La mort des mains de cet homme qu'elle désire, et qui la désire, comme l'avait obtenue de son amant la femme assassinée ? Un immense scandale silencieux s'est enflé autour d'Anne et de Chauvin et se résout dans le silence par leurs mains qui se joignent une seconde seulement, les lèvres posées sur les lèvres une seconde. Adieu. Tout est dit.

A peine si ce livre a cent cinquante pages. Pas une

93

seule de ces pages qui ne soit limpide, pas une seule
où ne figure une phrase qui pourrait figurer aussi bien
dans un compte rendu de faits divers. Pas une obscu-
rité dans le récit. Il est impossible de concevoir des
moyens plus stricts et plus rigoureux. Cette simple
clarté, cette brièveté dure et nue sont pourtant char-
gées de foudre et jettent le lecteur dans un puits sans
fond, dans un interminable labyrinthe sans issue, qui
est en vérité la caverne de Platon. Car ici rayonnent
pour chacun de nous les images de la destinée. Le
mystère des corps et des cœurs, le voilà, non pas
expliqué, non pas résolu, mais saisi dans son essence
par le biais et par le reflet. L'extraordinaire acuité de
l'oreille et du regard, l'extraordinaire discrétion de
l'écriture vont de pair chez Marguerite Duras avec
une intensité presque diabolique, qu'il s'agisse de la
présence des êtres ou de celle des choses. Elle dit en
ne disant pas. Elle impose en éludant. Elle forme une
espèce de creux où ce qu'elle ne décrit ni ne nomme
s'engouffre irrésistiblement, s'établit, éclate avec évi-
dence. Que dit-elle de ces deux personnages dont le
dialogue fait le centre du récit ? Bien peu de choses.
Anne a les cheveux blonds, Chauvin a les yeux bleus.
Il est ouvrier, sans doute, dans ces Fonderies qui
sans doute encore appartiennent au mari d'Anne. Mais
d'eux on sait comme malgré soi tout le reste, sans
que personne ait pris la peine de le préciser. Les
grands couloirs vides inondés de lumière, dans la
grande maison d'Anne Desbaresdes, l'odeur du ma-
gnolia en fleur, le ressac de la mer proche — si le
détail de cet univers paisible et menaçant remplissait
des pages et des pages, il ne pourrait être plus présent
qu'il ne l'est en dix lignes, en vingt lignes. Ce bref
récit a des prolongements de roman-fleuve, et le titre
en est trompeur. Modéré et chantant, peut-être, mais

Moderato cantabile est moins fait de musique et de mélodie que de lumière silencieuse, perçante et brusque comme la lumière des phares tournants ; et comme la tranchante lumière laisse dans l'œil une trace de feu, Marguerite Duras laisse dans l'esprit une sourde traînée de phosphore, qui brûle.

Dominique AURY
La N. N. R. F., 1-6-58

MADAME BOVARY REECRITE
PAR BELA BARTOK

Le nouveau roman de Marguerite Duras, *Moderato cantabile,* pourrait se définir : Madame Bovary réécrite par Bela Bartok — s'il ne s'agissait, avant tout, d'un roman de Marguerite Duras (qui ne ressemble finalement à personne) et de son meilleur livre (ce qui est dire beaucoup).

Dès son troisième livre, *Un barrage contre le Pacifique,* l'écrivain avait atteint pourtant la maîtrise. Quand elle a eu dominé le métier du roman traditionnel, on dirait que cela n'a plus intéressé du tout Duras. Elle a entrepris autre chose, avec des bonheurs inégaux, et une personnalité constante. J'aime beaucoup le début du *Marin de Gibraltar,* trois ou quatre des nouvelles de son recueil de contes. *Les Petits Chevaux de Tarquinia* est un livre qui me laisse toujours à la fois séduit et irrité. *Le Square* est une cérémonieuse et déchirante allégorie, œuvre d'art et d'artifice. Mais tout ce qu'elle avait essayé, tenté, tâtonné, entrevu, dépassé et repris, esquissé et raté dans ses précédents romans, tous remarquables et jamais tout à fait achevés, s'accomplit dans *Moderato cantabile.*

C'est un récit d'un extraordinaire dépouillement, construit avec une rigueur formelle admirable, et qui

pourtant ne laisse jamais le souci d'architecture, la volonté de sécheresse dans l'expression, le métier rigoureux étouffer ou atténuer l'émotion.

. .

Il est bien entendu impossible de parler d'un roman sans « raconter » ce dont il s'agit. Mais si le roman de Marguerite Duras n'était que cette anecdote, il décevrait sans doute. Puisque le titre (et un des thèmes conducteurs) du roman nous invitent à penser à la musique, disons que les modulations, l'harmonisation et les accords de *Moderato cantabile* constituent l'essentiel. J'ai entendu dire et lu, ici et là, qu'il y avait dans le livre je ne sais quoi de systématique et de froid. On comparera Marguerite Duras aux écrivains dont elle tend en effet à se rapprocher, aux phénoménologues du roman « nouveau », acharnés à porter sur le monde et les êtres un regard objectif et froid comme le verre d'un objectif. Ce qui me semble pourtant dominer dans ce livre net et précis, c'est précisément l'émotion, la sensibilité, le murmure savamment réprimé d'une plainte vraiment belle et tout à fait déchirante. Ici un écrivain de tête écrit raisonnablement ce que dicte celui qui a des raisons que la raison ne connaît pas.

Claude Roy
Libération, 1-3-58

LA REGLE DU JEU TRANSGRESSEE

Moderato cantabile, c'est de la littérature d'essai ; un roman-exercice. L'auteur a prouvé précédemment-qu'il sait raconter une histoire ; et même il y fourrait des agréments extérieurs en quantité superflue. Etait-ce une raison de tomber aujourd'hui dans l'excès opposé ? En tout cas, l'aventure d'Anne Desbaresdes, telle qu'elle nous est présentée, passerait difficilement pour un divertissement, fût-ce du type le plus noble. Le lecteur doit à ce point tendre sa pensée, pour comprendre où l'on se trouve, qui est en scène, ce qui se passe, qu'aucun enchantement romanesque ne saurait avoir prise sur elle.

Marguerite Duras n'a pas tort de croire que le même fait peut prendre diverses couleurs et produire des émotions différentes, selon la manière dont il est narré. Encore faut-il qu'il soit narré. En l'occurrence, nous voyons une dame qui revient sans cesse au même endroit pour poser sans cesse les mêmes questions ; et, peu à peu, ce manège assez hagard nous permet de deviner à moitié les événements et les sentiments qui furent à sa source. Hélas, une telle recherche ne s'accorde absolument pas avec le phénomène mental par l'effet duquel la fable littéraire nous séduit et nous égare. En définitive, qu'il soit arrivé telle ou telle chose à Chauvin, à Mlle Giraud, au petit garçon d'Anne, cela nous est bien égal, ces

99

fantômes étant restés pour nous des fantômes, auxquels nulle sympathie ne nous attache.

On nous remontre qu'à ce prix nous ressentons, grâce à ces « dialogues harassants », une « présence éclatante du monde et de la vie ». Erreur manifeste !... Il en faut beaucoup moins ou beaucoup plus.

C'est quand une voix basse et tranquille commence : « Il était une fois » (le petit Poucet, la chèvre de M. Seguin, la princesse de Clèves, le cousin Pons, Arthur-Gordon Pym, Augustin Meaulnes), que le monde et la vie nous semblent tout à coup présents : une vie et un monde toujours nouveaux, à mille lieues des nôtres, et où quand même nous nous trouvons transportés en un clin d'œil avec toute la puissance de notre être. On peut tout faire dans le roman, excepté en troubler les conditions essentielles, excepté y couper le courant, lequel ne passe dans les mots, dans les fictions (on l'oublie toujours), que par miracle.

Proust et Joyce eux-mêmes furent contraints, lorsqu'ils voulurent nous enchanter dans les règles, de prendre, vis-à-vis de Palamède de Charlus ou de Stephen Dedalus, la même attitude que l'aède homérique vis-à-vis du bouillant Achille. Ce récit supporte d'être coupé, suspendu, enfoui sous une magie étrangère, enveloppé de discours et de réflexions, reflété dans la cervelle d'un témoin comme dans une glace, mêlé comme un jeu de cartes ou truqué comme une balance : il ne souffre pas d'être remplacé par autre chose. Une composition décorative et statique où paraissent des personnages imaginaires n'est pas un roman, n'agit pas sur nous comme un roman, quelles que soient ses qualités humaines et ses mérites intellectuels. Surtout, il ne nous rend présents ni le monde, ni la vie.

100

Il y a dans l'art éternel du romancier cent innovations merveilleuses à tenter dont personne ne s'avise. Tout une jeune école s'épuise à modifier précisément ce qui, par nature, doit rester invariable, à savoir : l'illusion narrative. Un accablement sans nom, qu'adoucit le respect des naïfs, s'abat sur ces travaux de laboratoire. Ils s'évanouiraient en une seconde, au premier aspect de cet astre : un tempérament.

Robert POULET
Rivarol, 10-7-58

UN LANGAGE QUI RECUSE
LA QUIETUDE DU SAVOIR

Moderato cantabile amène le lecteur à devenir le témoin d'une aventure métaphysique vécue organiquement, dans l'obscurité, presque dans l'imbécillité. Nous voilà loin des consciences bavardes et des qualifications rassurantes, qui, à force de cataloguer les choses, font croire qu'elles sont à notre portée.

Pour oser s'évader de l'ordre extérieur de son existence, Anne Desbaresdes aura recours au vin. Tremblement, émoi, sourire de délivrance, grimace perplexe, constatation d'une envie inhabituelle de rire ou de ne pas rentrer chez elle, tous ces signes nous montrent que l'auteur se place au plus bas niveau possible, au-dessous du niveau des histoires, des interprétations commodes, des limitations, des fausses compréhensions de l'intelligence, qu'il se refuse aux explications, aux déroulement clairs, aux enchaînements savants.

Il ne s'agit pas d'une démission de la littérature. Jamais livre ne fut plus rigoureusement construit. D'une quinzaine de pages chacun, sept dialogues tâtonnants, — qui pourraient paraître nés du hasard ou de mouvements aveugles ayant échappé au schématisme de l'intellect, — et un dîner d'une perfection formelle presque irritante tant elle est concertée, nous mettent en face et de la nuit intérieure et de l'éclat des

apparences sur lesquelles le regard glisse sans pouvoir pénétrer. Nécessaire, juste, presque contrôlé, dirait-on, au dictionnaire, le mot joue son rôle strict, qui n'est pas de suggérer par des artifices le mystère, mais d'en faire constater l'existence.

Ici le langage garde toute sa beauté, toute sa magie aussi, mais il est dépouillé de ce qu'on lui accorde si volontiers, la confiance en ses pouvoirs de saisie. Il lui est ôté cette facilité qui consiste, en nommant les choses, à les faire disparaître derrière un écran de familiarité. La quiétude du savoir est troquée contre l'inquiétude, l'étonnement, l'émotion presque religieuse où doit nous plonger une réalité rétablie dans sa distance par rapport à nous.

Par la place qu'elle fait au silence en refusant de nommer, de raconter, de distraire, de meubler les blancs, Marguerite Duras force le lecteur attentif à se réveiller, à écarter les explications habituelles ou du moins à les vérifier. Ce livre ne nous permet pas de nous laisser glisser de geste en geste, d'événement en événement ; avec lui nous sommes forcés de constater l'inconnu, qui est peut-être, qui demeurera peut-être l'inconnaissable.

Dans l'œuvre déjà importante de Marguerite Duras, chaque livre est une nouvelle recherche. On se souvient sans doute que dans *Le Marin de Gibraltar,* à travers des dialogues touffus, sans directions apparentes, de multiples aventures géographiques, un homme et une femme s'aimaient dans la poursuite sans terme d'un marin mythique. *Le Square,* dont le propos paraît l'inverse de *Moderato cantabile,* traitait à peu près le même sujet, la rencontre de deux êtres et leurs tentatives de communication jusqu'à son point le plus extrême, l'amour, en utilisant au maximum les possibilités de formulation du langage.

Plus que l'apport d'un procédé nouveau, une habileté technique, le dernier livre de Marguerite Duras, — et il faut espérer que le Prix de Mai qui vient de lui être attribué incitera les lecteurs à l'attention qu'il nécessite, — représente une attitude d'esprit qui contient peut-être pour le roman une de ses plus réelles chances de renouvellement.

Madeleine ALLEINS
Critique, 1-7-53

UN ESSAI
NON UNE ŒUVRE ACHEVEE

Mme Marguerite Duras a rejoint aux Editions de Minuit où paraît son nouveau livre, *Moderato cantabile,* MM. Butor, Robbe-Grillet et Claude Simon, la jeune et intéressante équipe de ces romanciers-enregistreurs, pour qui l'écrivain doit être rigoureusement absent de son récit et se borner à rapporter, en vrac, comme elles lui parviennent, ses sensations à l'état brut.

Mme Duras ne fait pas figure de tardive recrue dans ce groupe. Son livre, *Le Square,* paru il y a trois ans je crois, ressortissait déjà à la même esthétique, les rendez-vous sur un banc de jardin public de son terne héros et de sa médiocre héroïne étaient, dans la lenteur et la banalité voulues de leur conversation, comme une première épreuve de *Moderato cantabile.*

Le critique est en droit de se demander pourquoi ce second essai, car il ne peut s'agir que d'un essai en vue de créer plus tard une œuvre achevée. En voici le thème : Anne Desbaresdes a assisté par hasard à un crime passionnel dans un café du port, pendant que son petit garçon prenait sa leçon de piano. Elle ira à plusieurs reprises dans ce café et elle interroge un homme qu'elle y retrouve chaque fois. Nous avons

l'impression que l'homme n'en sait pas plus long qu'Anne et que d'ailleurs elle n'écoute guère ce qu'il lui raconte. Après cinq ou six rencontres, aucune action ne se sera engagée, mais nous sentons vaguement que les positions psychologiques se sont transformées. Malheureusement, cette évolution qui nous intéressait tant dans *La Modification* de Michel Butor ne réussit guère ici à nous retenir. Je crois très sincèrement que Mme Duras s'enfonce dans une impasse et je le déplore, car elle sait peindre, à touches menues, des scènes vivantes et vraies, par exemple la leçon de piano du gamin qui met toute la mauvaise volonté du monde à jouer une *Sonatine* de Diabelli et ne veut pas se rappeler que *moderato* veut dire modéré et *cantabile,* chantant.

Jean MISTLER
L'Aurore, 12-3-58

L'ART DE NE RIEN CONCLURE

... Le propre des solutions imaginaires est de demeurer constamment ouvertes et, précisément, de ne rien conclure. Anne et Chauvin se reverront-ils ? Deviendront-ils amants ? La tragédie qu'ils ont mimée dans l'ivresse des possibilités offertes par l'envoûtement du sang versé, du vin bu, des paroles échangées, la vivront-ils, eux-mêmes ou avec d'autres partenaires ? La voie que voulait se frayer Anne conduit-elle à l'amour, à l'indépendance, ou à la frustration ? Quel rôle joue l'enfant dans les déterminations d'Anne ? Nous n'en saurons rien. L'auteur se referme sur ses secrets et, après nous avoir tendu divers fils d'Ariane, nous abandonne à la sortie du labyrinthe. C'est sans doute de sa part une ruse supplémentaire. Libre à nous, au grand jour, de nous frotter les yeux ou de retourner aux rêves de la nuit. Si quelque irritation nous visite, elle est encore le fruit de la parfaite science de Marguerite Duras, de sa maîtrise. Sa réussite voulait l'inaccomplissement.

Maurice NADEAU
France Observateur, 6-3-58

« MODERATO CANTABILE »
DANS L'ŒUVRE
DE MARGUERITE DURAS

C'est un beau récit que ce *Moderato cantabile* que vient d'écrire Marguerite Duras. Mais il ne prend toute sa force que si nous le situons dans l'œuvre de son auteur, déjà considérable, et à la fois vigoureuse, intelligente, émouvante : l'une des premières d'aujourd'hui.

Dans *Moderato cantabile,* non seulement ce qui se passe n'est pas dit, mais il ne se passe peut-être rien. On hésite à parler d'un art de la suggestion, car il n'est pas certain que cet art prenne appui sur une réalité que le romancier connaîtrait, et qu'il dissimulerait au lecteur à seule fin de le contraindre à l'initiative. Sans doute faut-il dire que cette réalité n'existe pas, du moins que son existence est problématique. Suggestion, élision sont ici mots douteux. Il faudrait parler d'un art d'appel, d'un art créant par son vide même une sorte d'appel d'air. Le récit dessine des contours que n'emplit aucune forme réelle ; il ne suggère pas, au moyen d'un silence concerté, un vrai récit tenu secret : plein de son vide, sourd de son silence, il semble vouloir se dépasser vers un événement, une signification, une parole ;

mais l'objet vers lequel il est tendu lui fait défaut. S'il y a ici un art de la suggestion, il s'agit d'une suggestion sans objet.

Rien ne se passe, en effet, bien que le prétexte du livre soit le fait-divers le plus dramatique : un crime passionnel. Dans un bar, un homme a tué une femme. Mais ce geste n'existe que par la fascination qu'il exerce sur un autre homme et sur une autre femme qui n'en furent même pas les témoins directs et qui n'en approchent la signification qu'en l'inventant peut-être, à travers l'étrange rêverie qui les possède désormais. Arrachés par le cri d'agonie à l'ordre quotidien, à cette « vie tranquille » où il n'y a plus de respiration pour l'espoir, l'homme et la femme se rencontrent chaque jour dans le bar qui reçut le sacre de l'événement. Ils se parlent ; ils imaginent que ce fut le vœu de cette femme d'être tuée par l'homme qu'elle aimait, et le sentiment qui, entre eux, prend naissance retrouve, assume ce désir. Peut-être vont-ils revivre la même légende de la mort et de l'amour. Peut-être... Mais le romancier lui-même n'en sait rien. Qui peut donner un nom à ce qui s'est passé entre les inconnus, à ce qui se passe maintenant entre Anne Desbaresdes et Chauvin ? Qui peut savoir la forme que le destin donnera à cette complicité indéchiffrable ? Peut-être n'ont-ils pas d'autre histoire que celle d'avoir un ins-tant échangé ces paroles, posé leurs mains l'une sur l'autre, mêlé une seule fois leurs bouches. Tout est suspendu à l'attente d'un événement qui ne vient pas, d'un événement inimaginable. Tout fléchit sous le poids d'une passion qui n'accouche pas d'elle-même, qui ne sait pas même son nom.

Le récit précédent, *Le Square,* témoignait de la même technique et reposait sur la même situation. Un homme et une jeune fille se rencontrent sur le

112

banc d'un jardin public, un samedi après-midi ; et leur dialogue fait toute la matière du livre. Ils tentent non seulement de s'échanger, mais de s'accoucher d'eux-mêmes. Mais rien ne vient vraiment à la lumière, et ce qui bouge dans l'ombre, on ne sait si c'est l'espoir, ou le désespoir, l'amour possible ou l'ineffaçable solitude. Se retrouveront-ils le samedi suivant ? On l'ignore, comme on ignore tout de l'avenir des complices du *Moderato cantabile*.

Devant ces deux récits, l'impression dominante est celle de l'art qui parvient à nous tenir en haleine avec des silences et des vides. C'est un monde violent où la vie remue pour déboucher à la lumière, accéder à sa propre naissance. Mais elle n'y accède pas ; rien ne reçoit de forme ni de nom. Par ailleurs, dans ces deux récits implacablement dénudés, rigoureusement épurés, l'auteur se garde d'ajouter quoi que ce soit à la simple présence des choses : nul récit ne relie entre eux les gestes accomplis, les paroles prononcées pour leur donner un sens autre que celui de leur manifestation ; rien ne survole les personnages pour leur donner un passé, une conscience ou un destin. Sur ce vide, dans ce désert, l'art seul se détache, attire sur lui la lumière : admirable d'animer cette immobilité, de faire parler ce silence. C'est le ton des voix que nous avions retenu du *Square,* leur tristesse et leur pathétique ambigus, et c'est bien cela que nous retrouvons dans le dernier récit, cette voix chantante et modérée qui lui donne si justement son titre, cette discrète incantation. Nous ne retenons que sa courbe mélodique : admirable structure d'un récit absent.

C'est dire que nous avons le sentiment d'une remarquable prouesse technique. Pourtant, il s'agit de bien autre chose. Autour de ces branches dénudées toute

une végétation se presse ; mais elle demeure invisible pour qui ne connaît pas les livres précédents de Marguerite Duras. Cette végétation n'est aucunement celle du récit lui-même, dissimulée pour que nous soyons contraints de la reconstituer, comme c'est le cas dans certains romans d'Henry James où l'ambiguïté et l'incertitude sont telles que nous nous sentons d'abord requis par la logique de la narration, attentifs à la main qui dessine plus qu'à la forme qu'elle dessine en blanc : non point tant cependant que nous n'ayons aussi le sentiment que dans ce blanc se dissimule réellement une forme et que nous ne fassions effort pour l'entrevoir. (Par exemple, nous ne savons pas ce qui s'est passé entre Mme de Vionnet et Strether, mais nous savons que quelque chose s'est passé). Mais, ici, ce n'est pas à la réalité et à la signification d'une histoire que nous renvoie la voix modérée et chantante ; c'est à une expérience globale dont les autres romans nous livrent les signes, les symboles les plus agissants.

Signes que nous retrouvons ici, mais il faut les connaître pour les reconnaître. Aussi la lecture d'un tel récit est difficile. Car nous risquons de prendre pour un signe précis et déchiffrable ce qui est pure manifestation de l'ambiguïté ou même de l'irréalité, et, à l'inverse, de prendre pour de simples prétextes, pour des détails sans intérêt ce qui est signe personnel chargé de sens. Par exemple, nous aurions tort de chercher des paroles précises au-dessous des paroles vagues ou des silences, le nom des sentiments derrière l'étrange opacité des gestes ; nous aurions tort de vouloir deviner une histoire qui n'existe pas, du moins qui n'existe pas encore. En revanche, les choses mêmes qui nous sont présentées sous l'aspect de la pure contingence, et que nous sommes portés à prendre

rapidement pour des détails et des prétextes, témoignent de l'univers secret du romancier. C'est par les marges du récit qu'il se révèle à nous.

Ainsi il faut prendre garde à l'enfant qui accompagne l'héroïne, et qui ne parvient pas à apprendre ce morceau de musique : il y a aussi un enfant dans *Le Square,* dans *Les petits chevaux de Tarquinia,* et nous retrouvons le rapport mère-fils ou mère-fille dans *Un Barrage contre le Pacifique* et dans *Des journées entières dans les arbres.* Il faut prendre garde à cette vedette qui passe, pendant la leçon de piano, dans le cadre de la fenêtre ouverte : le bateau dans *Les petits chevaux de Tarquinia,* et dans *Le Marin de Gibraltar,* est le symbole de la liberté, de l'évasion. Il faut prendre garde au vin dont Anne ne parvient pas à se rassasier, ce vin qui a « la saveur anéantissante des lèvres inconnues d'un homme de la rue » : à l'alcool (whisky, champagne ou bitter-campari), les personnages des autres livres demandent la même libération, la même torpeur ou la même audace. Il faut prendre garde à ce repas bourgeois où Anne fait scandale, car la distance sociale, comme dans chaque livre, y est accusée : dans le *Barrage,* c'est l'auto de M. Jo, le yacht d'Anna dans *Le Marin de Gibraltar,* le personnage de la bonne dans *Les petits chevaux de Tarquinia.* Mais, bien entendu, le signe essentiel (et le lecteur le plus distrait ne saurait l'ignorer), c'est celui de la rencontre. Tous les livres de Marguerite Duras sont l'histoire d'une rencontre : rencontre des deux personnages anonymes du *Square,* de Sara et de l'homme au bateau, des deux clients de l'hôtel dans *Les Chantiers,* même de Mme Dodin et du balayeur ; rencontre qui, cette fois, répond à une rencontre primordiale, mythique, des deux personnages de *Moderato cantabile,* sur le lieu même du sacrifice, rencontre d'Anna et du narra-

teur après celle (peut-être imaginaire) d'Anna et du *Marin de Gibraltar*.

« Délivré d'une réalité qui, si elle n'avait concerné que lui seul, l'aurait soumis à elle, l'homme avait de plus en plus tendance à ne plus voir dans les choses que des signes. Tout devenait signe d'elle ou signe pour elle. » C'est en termes obscurs, mais révélateurs, qu'est commentée dans *Les Chantiers* la rencontre de l'homme et de la femme. La communication humaine : seul moyen de supporter la réalité, et peut-être d'en changer. Car la vie est étouffante comme cette chaleur qui gâte les vacances des estivants sur la côte italienne, comme la misère de cette concession stérile d'Indochine ; le monde et la société sont des prisons. A l'horizon passent des images de liberté : bateaux de plaisance, autos de luxe. Et, à portée de la main, il y a l'alcool. Mais c'est avec un autre être que l'on imagine la vie en mer ; et l'alcool donne avant tout le courage de chercher cet autre être, d'entamer avec lui un dialogue... L'amour est l'objet fondamental de l'attente, de l'espoir ; à lui est suspendue la possibilité d'une autre vie. Et la rencontre a lieu, toujours. Mais est-ce la vraie rencontre ? On ne sait jamais ce qu'il adviendra du couple à peine formé ; et, dans *Les petits chevaux de Tarquinia,* on le voit renoncer à lui-même. Ce sont là les romans de l'attente et du désir, jamais de l'accomplissement. C'est sans doute qu'aucun amour ne peut tenir lieu de l'amour, comme le dit un personnage ; c'est aussi que l'autre n'est que notre semblable, et se débat dans le même vide étouffant. L'amour n'est pas une possibilité capable de changer réellement un destin. Il apparaît comme l'impossible, une fulguration qui ne peut qu'anéantir la vie qu'elle éclaire ; et, dans *Moderato cantabile,* l'amour est explicitement uni à la mort.

Si nous songeons aux possibilités d'expression de cette expérience, nous voyons que les récits suspendus et vides que l'auteur vient d'écrire sont fidèles à sa logique. Sans doute, en renonçant à la technique qui est celle d'*Un barrage dans le Pacifique,* du *Marin de Gibraltar* et des *Petits chevaux de Tarquinia,* technique qui, selon le mixte traditionnel, unit le récit rétrospectif et la prise de vues, l'organisation et la présence, le regard divin du romancier sondant la conscience de ses créatures, rappelant leur passé, pressentant leur destin et l'œil innocent de la caméra, Marguerite Duras obéit à l'impulsion majeure du roman contemporain inquiet de l'impureté de ce mixte et soucieux d'une perspective cohérente. Mais, dans son cas, il y a plus. Si se trouve écarté le point de vue de l'auteur historien, psychologue et prophète, ce n'est pas qu'il soit seulement facilité ou tricherie : c'est que l'existence qui nous est ici présentée se réduit à sa pure manifestation. Ce monde de l'attente et de la rencontre sans lendemain est un monde immobile et sans profondeur, sans dessous dramatique ni psychologique : c'est l'histoire d'un monde sans histoire. Aussi lorsque l'auteur, qui conte remarquablement, cède à la tentation de raconter une histoire possédant un sens par elle-même, comme dans le *Barrage* et surtout *Le Marin de Gibraltar,* elle dérive quelque peu de son expérience profonde ; ici, l'anecdote dépersonnalise les signes, les orientant vers elle-même, alors qu'ils sont orientés vers l'expérience qui transcende toute anecdote. Mais, à l'inverse, dans *Le Square* et dans *Moderato cantabile,* les signes risquent de passer inaperçus, parce que l'auteur se tient si bien en retrait que nous ne voyons plus le lien qui les unit à son expérience ; nous risquons de prendre des aveux pour des détails contingents, des signes pour de simples

faits. Le problème technique qui se pose à cette œuvre, et dont les deux derniers récits révèlent l'inquiétude, n'est pas seulement un problème de rigueur ou d'exigence : il s'agit surtout de savoir sous quel éclairage les signes qui la constituent agiront avec le plus d'efficacité. Certes, la direction personnelle d'un récit autonome peut affaiblir et éteindre les signes en faisant d'eux les éléments d'une histoire extérieure. Mais « céder l'initiative aux choses » ne va pas non plus sans danger ; car les signes risquent justement de se transformer en choses, en réalités contingentes. *Moderato cantabile* est-il un simple essai, ou bien l'ouverture d'une technique à laquelle l'auteur va rester fidèle ? Pour que le livre s'anime et s'approfondisse, il faut que le lecteur puisse le nourrir et le vivifier avec le souvenir des autres œuvres. C'est beaucoup demander ; et peut-être même n'est-ce pas de jeu. Je crois qu'il faut que, d'une certaine manière, l'auteur intervienne plus directement ; qu'il rattache lui-même ce chant qui s'élève dans un espace dénudé à l'expérience dont il vient. C'est à cette condition que les choses, comme les anecdotes, se manifesteront comme signes.

Gaëtan PICON
Mercure de France, juin 58 [1]

1. Etude recueillie dans *L'usage de la lecture* (tome 2), Mercure de France.

ŒUVRES DE MARGUERITE DURAS

LES IMPUDENTS (1943, *roman,* Plon).

LA VIE TRANQUILLE (1944, *roman,* Gallimard).

UN BARRAGE CONTRE LE PACIFIQUE (1950, *roman,* Gallimard).

LE MARIN DE GIBRALTAR (1952, *roman,* Gallimard).

LES PETITS CHEVAUX DE TARQUINIA (1953, *roman,* Gallimard).

DES JOURNÉES ENTIÈRES DANS LES ARBRES, *suivi de :* LE BOA — MADAME DODIN — LES CHANTIERS (1954, *récits,* Gallimard).

LE SQUARE (1955, *roman,* Gallimard).

MODERATO CANTABILE (1958, *roman,* Editions de Minuit).

LES VIADUCS DE LA SEINE-ET-OISE (1959, *théâtre,* Gallimard).

DIX HEURES ET DEMIE DU SOIR EN ÉTÉ (1960, *roman,* Gallimard).

HIROSHIMA MON AMOUR (1960, *scénario et dialogues,* Gallimard).

UNE AUSSI LONGUE ABSENCE (1961, *scénario et dialogues,* en collaboration avec Gérard Jarlot, Gallimard).

L'APRÈS-MIDI DE MONSIEUR ANDESMAS (1962, *récit,* Gallimard).

LE RAVISSEMENT DE LOL V. STEIN (1964, *roman,* Gallimard).

THÉÂTRE I : LES EAUX ET FORÊTS — LE SQUARE — LA MUSICA (1965, Gallimard).

LE VICE-CONSUL (1965, *roman,* Gallimard).

LA MUSICA (1966, *film,* co-réalisé par Paul Seban, distr. Artistes Associés).

L'AMANTE ANGLAISE (1967, *roman,* Gallimard).

L'AMANTE ANGLAISE (1968, *théâtre,* Cahiers du Théâtre national populaire).

THÉÂTRE II : SUZANNA ANDLER — DES JOURNÉES ENTIÈRES DANS LES ARBRES — YES, PEUT-ÊTRE — LE SHAGA — UN HOMME EST VENU ME VOIR (1968, Gallimard).

DÉTRUIRE, DIT-ELLE (1969, Editions de Minuit).

DÉTRUIRE, DIT-ELLE (1969, *film,* distr. Benoît-Jacob).

ABAHN, SABANA, DAVID (1970, Gallimard).

L'AMOUR (1971, Gallimard).

JAUNE LE SOLEIL (1971, *film,* distr. Films Molière).

NATHALIE GRANGER (1972, *film,* distr. Films Molière).

INDIA SONG (1973, *texte, théâtre,* Gallimard).

LA FEMME DU GANGE (1973, *film,* distr. Benoît-Jacob).

NATHALIE GRANGER, *suivi de* LA FEMME DU GANGE (1973, Gallimard).

LES PARLEUSES (1974, *entretiens avec Xavière Gauthier,* Editions de Minuit).

INDIA SONG (1975, *film,* distr. Films Armorial).

BAXTER, VERA BAXTER (1976, *film,* distr. N.E.F. Diffusion).

SON NOM DE VENISE DANS CALCUTTA DÉSERT (1976, *film,* distr. Benoît-Jacob).

DES JOURNÉES ENTIÈRES DANS LES ARBRES (1976, *film,* distr. Benoît-Jacob).

LE CAMION (1977, *film,* distr. D.D. Prod.).

LE CAMION, *suivi de* ENTRETIEN AVEC MICHELLE PORTE (1977, Editions de Minuit).

LES LIEUX DE MARGUERITE DURAS (1977, *en collaboration avec Michelle Porte,* Editions de Minuit).

L'EDEN CINÉMA (1977, *théâtre,* Mercure de France).

LE NAVIRE NIGHT (1978, *film,* Films du Losange).

LE NAVIRE NIGHT, *suivi de* CÉSARÉE, LES MAINS NÉGATIVES, AURÉLIA STEINER, AURÉLIA STEINER, AURÉLIA STEINER (1979, Mercure de France).

CÉSARÉE (1979, *film,* Films du Losange).

LES MAINS NÉGATIVES (1979, *film,* Films du Losange).

AURÉLIA STEINER, *dit* AURÉLIA MELBOURNE (1979, *film,* Films Paris-Audiovisuels).

AURÉLIA STEINER, *dit* AURÉLIA VANCOUVER (1979, *film,* Films du Losange).

VÉRA BAXTER OU LES PLAGES DE L'ATLANTIQUE (1980, Albatros).

L'HOMME ASSIS DANS LE COULOIR (1980, *récit,* Editions de Minuit).

L'ÉTÉ 80 (1980, Editions de Minuit).

LES YEUX VERTS (1980, Cahiers du cinéma).

AGATHA (1981, Editions de Minuit).

AGATHA ET LES LECTURES ILLIMITÉES (1981, *film,* prod. Berthemont).

OUTSIDE (1981, Albin Michel, rééd. P.O.L, 1984).

LA JEUNE FILLE ET L'ENFANT (1981, *cassette,* Des Femmes éd. Adaptation de L'ÉTÉ 80 par Yann Andréa, lue par Marguerite Duras).

DIALOGUE DE ROME (1982, *film,* prod. Coop. Longa Gittata. Rome).

L'HOMME ATLANTIQUE (1981, *film,* prod. Berthemont).

L'HOMME ATLANTIQUE (1982, *récit,* Editions de Minuit).

SAVANNAH BAY (1ᵉʳ éd. 1982, 2ᵉ éd. augmentée, 1983, Editions de Minuit).

LA MALADIE DE LA MORT (1982, *récit,* Editions de Minuit).

THÉÂTRE III : LA BÊTE DANS LA JUNGLE, *d'après Henry James, adaptation de James Lord et Marguerite Duras* — LES PAPIERS D'ASPERN, *d'après Henry James, adaptation de*

Marguerite Duras et Robert Antelme — LA DANSE DE MORT, *d'après August Strindberg, adaptation de Marguerite Duras* (1984, Gallimard).

L'AMANT (1984, Editions de Minuit).

LA DOULEUR (1985, P.O.L).

LA MUSICA DEUXIÈME (1985, Gallimard).

LA MOUETTE DE TCHÉKOV (1985, Gallimard).

LES ENFANTS, *avec Jean Mascolo et Jean-Marc Turine* (1985, *film*).

LES YEUX BLEUS CHEVEUX NOIRS (1986, *roman,* Editions de Minuit).

LA PUTE DE LA CÔTE NORMANDE (1986, Editions de Minuit).

LA VIE MATÉRIELLE (1987, P.O.L).

ÉMILY L. (1987, *roman,* Editions de Minuit).

CET OUVRAGE A ÉTÉ ACHEVÉ D'IMPRIMER LE PRE-
MIER SEPTEMBRE MIL NEUF CENT QUATRE-VINGT-
SEPT DANS LES ATELIERS DE NORMANDIE IMPRES-
SION S.A. 61000 ALENÇON (ORNE) ET INSCRIT DANS
LES REGISTRES DE L'ÉDITEUR SOUS LE N° 2252

Dépôt légal : septembre 1987